Arctic Flight

Adventures Amongst Northern Birds

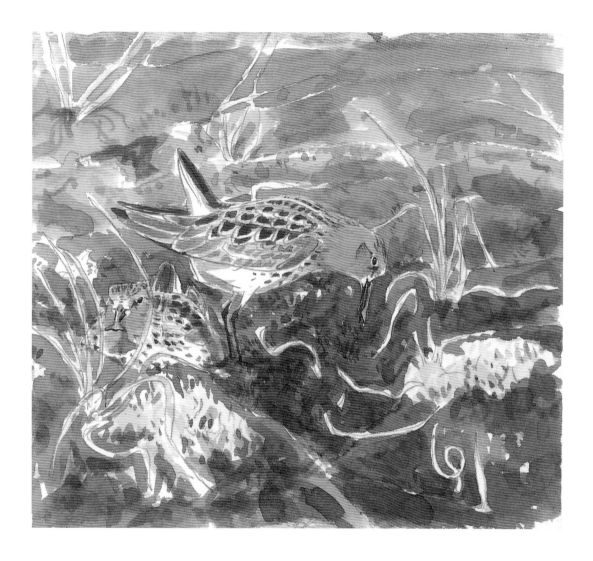

James McCallum

Langford Press 2007

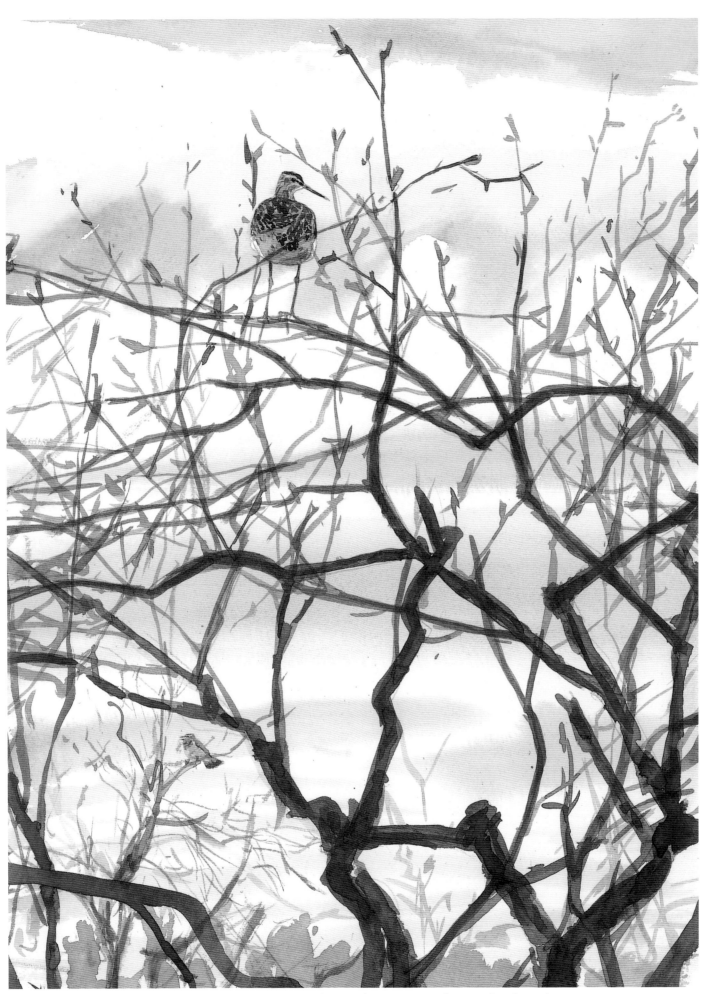

Small clumps of birches help to break up the vast open bogs. These trees are frequently adopted as song-posts; here a wood sandpiper watches over his territory whilst, further back, a bluethroat sings his rich song, full of expert mimicry. Pieran Marin Jänkä, Inari Lapland, 31st May 2000

Arctic Flight

Adventures Amongst Northern Birds

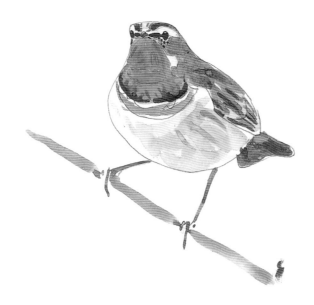

James McCallum

Langford Press 2007

For Natasha, Mum,
Heikki and Sinikka

Contents

Text and Illustrations © James McCallum 2007
www.jamesmccallum.co.uk

Introduction Inari Lapland © Heikki Karhu 2007
Introduction Chukota © Pavel Tomkovich 2007
Introduction Yukon-Kuskokwim © Brian McCaffery 2007

Langford Press
10 New Road
Langtoft
Peterborough
PE6 9LE

Telephone/Fax 01778 341132
www.langford-press.co.uk

Designed by John Walters
www.johnwalters.co.uk

Printed by Healeys Printers, Ipswich 01473 461122

Preface

Arctic Flight is a book about a lifelong ambition to visit northern regions of the world in search of birds. It is a written and visual record of visits to Inari Lapland in Finland, Varanger Fjord in Finnmark, Chukotka in easternmost Siberia and the Yukon-Kuskokwim Delta in Alaska.

My diaries and sketchbooks span the six years from my first visit to Inari Lapland in May 2000. The written accounts are taken from my diaries, which were completed at the end of each day or from descriptions entered in notebooks as events unfolded before my eyes. The sketches and paintings were made almost exclusively outdoors, from life, at the time of observation.

In some cases it may be possible to see a progression in style and in others some of the images may be hastily made sketches. I make no excuse for this as these were my reactions to fleeting moments when time or weather made it impossible to make more detailed studies. I do, however, hope that such pictures may convey a little of the great excitement I felt when encountering exciting species and situations for the first time.

In my previous books, I have written about my local area and birthplace in north Norfolk, England, where I have long-standing ties and much first-hand experience. During this latest project, I was very much a visitor, experiencing new sights and sounds on a daily basis. To help introduce each region, I have invited a local expert or authority to write a few words about their area and my involvement with it.

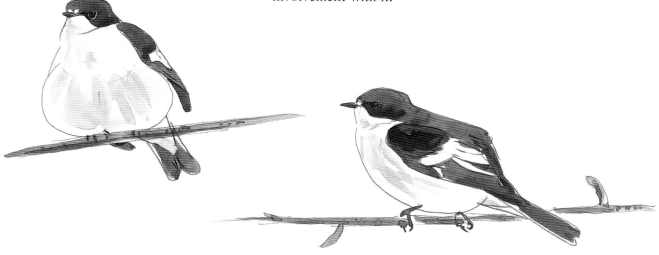

Pied flycatcher, painted during a light snow shower. Akujävri, 25th May 2006.

Introduction

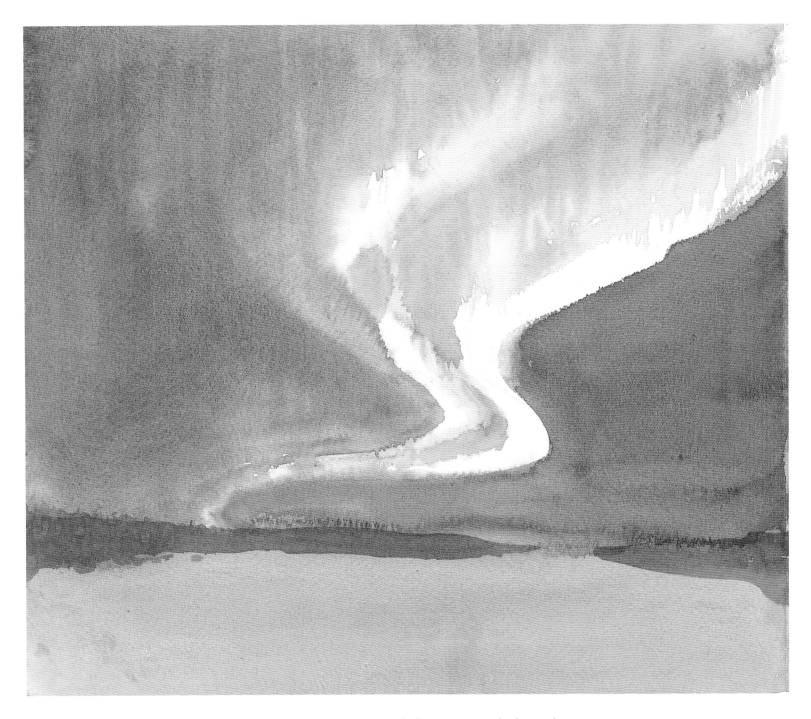

The Northern Lights, or aurora borealis, is an awe-inspiring natural phenomenon, which is only seen regularly in northern and arctic regions. It is occurs when electrically-charged particles enter the earth's atmosphere. Its constantly changing patterns take on many forms including, flickering curtains and winding snakes of light. Pale green is the most common colour but, during intense displays blues, reds and magentas can also be witnessed. The aurora is impossible to describe in words and it is something that must be experienced first-hand. Not surprisingly this phenomenon has been of great significance for northern peoples and is tightly woven into their folklore, mythology and religions. Petsikko, January 2001.

At a surprisingly early stage in my birdwatching, the journeys of migrant birds captured my imagination. I grew up on the north Norfolk coast where it was difficult to ignore the arrival and departure of summer and winter visitors and the seasonal movements of passage migrants. Like many other people, I marvelled at the enormous journeys made by our summer visitors, such as, swallows and warblers to and from places as far away as southern Africa. But it was the birds which moved north to breed that really fired my imagination and fuelled my daydreaming.

Just prior to their departure in late spring and on their return in early autumn, wading birds, clad in dull greys and browns during the winter months, can be encountered in a striking array of colours and markings. At these times, grey plovers are transformed into a handsome and striking pattern of black, white and silver, bar-tailed godwits are dressed in a deep red-chestnut and the smaller turnstones are a tortoiseshell mix of chestnut and black above, silky white below with a complex jigsaw pattern of black and white around their heads and breasts. Furthermore the birds are also heard to utter less familiar calls an occasional snatches of song. This is a glimpse of another part of these birds' lives, but I could only imagine what their summer home was like and how they behaved there.

At this stage of my birdwatching these thoughts were flights of fancy and there was so much to see and explore close to home. I do remember, however, following much searching of second-hand bookshops, building up a set of Lars Jonsson's five volumes of bird books. I had developed an interest in drawing and was inspired by the postures of his birds and his rendering of their plumage. One volume was called *Birds of Mountain Regions* which not only covered alpine birds but also included northern and arctic species. Much was written about habitats with such exciting names as tundra, taiga and the birch and conifer zone. There were paintings of bar-tailed godwits beside dwarf birches and broad-billed sandpipers amongst cloudberry flowers, Temminck's stints singing and snow and Lapland buntings in plumages I had never seen before. This volume was to fuel further my dreams and longing to experience some of these sights and situations.

About the same time I discovered the work of two bird-painters which were to change completely my way of looking at and drawing birds. These were John Busby and Eric Ennion. I was impressed with their ability to banish unnecessary detail and distil birds into essential lines and washes. They both had the skill to capture movement and

their emphasis on fieldwork resulted in many original compositions and unconventional poses.

Inspired by the life and freshness of their work, I set out to draw wildlife outdoors, directly from life. Although their pictures sometimes appeared so simple and effortless I soon realised just how difficult this approach was and that it would take much time and energy learning how to look and record accurately and quickly. I soon appreciated how important it was to learn as much as possible before I could begin to understand what can be left out.

All the long hours spent in the field made it possible to see unfamiliar bird postures such as stretching and scratching and begin to tackle them. Threat postures and, during the breeding season, courtship displays provided new challenges and opened up new possibilities for sketching.

I was given the opportunity to help warden nesting terns and waders on Blakeney Point, close to my home in Norfolk. The long hours spent looking after these birds enabled me to take advantage of quiet periods, learn about their behaviour and record it quickly and accurately. Watching and recording the terns' daily routine, from the time of their arrival, display, rearing young to the time of their departure, was very rewarding. I tried to imagine them on their journey to Africa. I had been reading Rob Hume's monograph on the common tern, which showed photographs of groups of mixed terns on their wintering grounds in Ghana.

Fired by these images, I made a rash decision and booked a flight to Ghana to see some terns in winter. I was somewhat naïve of the wider world and there was much that I had to learn quickly. But, I did find terns in all sorts of situations and often amongst unfamiliar species.

Further summers spent on Blakeney Point led to a second trip to watch terns in Africa, this time in Namibia, where huge numbers gather to fish in Walvis Bay together with huge congregations of pelicans and flamingos. There were many arctic-nesting waders here too, familiar birds such as curlew sandpipers and whimbrels. Even whilst here in southern Africa, as I watched these birds picking along the shore, I found myself thinking about their remarkable journeys and my mind began to wander to the north again.

The Beginnings of a Northern Adventure

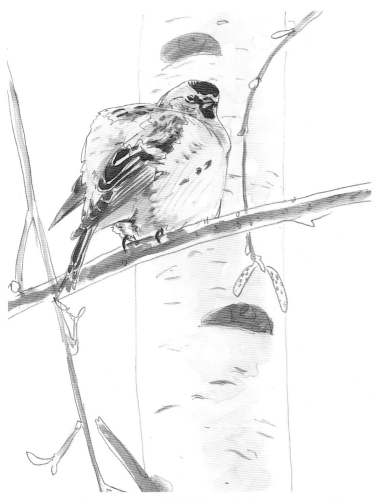

Arctic redpoll - inactive and fluffed up during extreme cold.

It is often difficult to pinpoint the precise moment when years of daydreaming become a reality. The gateway to the north opened for me, by chance, one rainy morning on the north Norfolk coast.

In 1999, following an absence of several summers, I had returned to Blakeney Point to help warden its terns and wading birds. Much time is spent trying to minimise human disturbance to these remote nesting colonies. However, inspite of these efforts, they are still at the mercy of the elements, food availability and predators. Each year we pray for a successful nesting season and it is a very tense time from when the birds first show an interest in nesting through to their producing healthy, flying young. Unfortunately disasters can occur right up until the time young birds take to the wing.

This particular year was no exception. On the 30th June westerly gales, heavy rain and rough seas were pounding the nesting colonies. It was an anxious time and we were left feeling quite helpless; as all we could do was sit indoors and wait for the gales to ease. There was no point even in going near the colonies as this would only disturb the adult birds and result in the eggs and young being exposed to the cold and wet and in danger of being chilled. The following morning was still wet and windy but there was a look about the weather that indicated that the worst might have passed. Then the telephone rang. It was Bryan Bland, the well-known ornithologist living in Cley, to say that two birdwatchers from Finland were coming over by ferry and he asked whether I would show them around. I agreed and, at the arranged time, I saw John Bean, one of the ferry operators, leaving Pinchen's Creek collar up, cap pulled down, heading back through the rain and spray to Morston, having left two wet figures standing on the beach. This was to be my first meeting with Heikki and Sinikka Karhu, who were to turn out to be two of the kindest and most hospitable people I have ever met.

We headed back towards the Lifeboat House, which the National Trust had acquired and converted into living quarters for the wardens. I put the kettle on and wondered what on earth I was going to show them, since it was so wet and windy outside. Nothing looked particularly inspiring and it was unfair to the birds to go anywhere near their nesting areas. I need not have worried as Heikki and Sinikka were very relaxed, good company, their English was excellent and conversation flowed freely. It became quickly apparent that Heikki was a very keen birdwatcher with a particular interest in bird migration and bird observatories and clearly knew much about Blakeney Point's long history of recording bird migration. He was excited just to be on the Point, learning about the famous birdwatching landmarks and hearing of my experiences with migrant birds. We talked about the nesting birds and their protection and I showed them some of my sketches of nesting terns and waders. Before the conversation turned to their home and the bird life there. I mentioned a few of my day-dream scenarios, wood sandpipers singing from trees, Temminck's stints song-flighting and, one of my big ambitions, to hear the song of one of my favourite wading birds, the jack snipe.

I was quite taken aback when, to each of my many examples, replies came such as, "these are common around us", "they nest close to the house" or, "you can see them on bogs two kilometres from the town". I was even more taken aback when they suggested that I should go and stay with them and see for myself. I smiled and said thank you but Heikki made it clear this was not an idle invitation and it was strongly reinforced by Sinikka. I couldn't really believe that there might actually be a genuine opportunity to visit Lapland and

experience first-hand the situations that I had tried to imagine for so long. I then began to think more practically and try to see what potential problems there might be. I explained that I would have to spend long periods in the field in order to produce paintings and couldn't sacrifice a summer wardening contract for a short holiday. Heikki and Sinikka had already understood and anticipated this and explained that, if I was able to occupy myself, I could stay as long as I wanted. Furthermore there were summer cottages and fishing/hunting cabins that I could use. I was left feeling a little shocked, for it really did seem possible that I was, at last, heading north.

With all the talking, time had passed quickly and, glancing out of the window we could see that the sky to the west looked much brighter and the front was passing through. The tide was dropping and so it was time to head out and examine the extent of the storm-damage. I needed to check to see if all the fencing was still intact; I didn't need to ask if Heikki and Sinikka would like to join me. As we headed down the outer ridge towards Far Point, the sun burst through. The fence was largely intact but some of the nests of terns, ringed plovers and oystercatchers had been washed away. As the tide receded, large numbers of whitebait had become trapped in shallow pools and hundreds of terns began to converge on the mass of tiny, trapped fish as the water quickly drained away. A spectacular feeding frenzy followed, with terns diving repeatedly and large numbers of gulls frantically pecking and squabbling. It was a perfect way to say goodbye as Heikki and Sinikka headed off down the shingle towards Cley. The next time we would meet was inside the Arctic Circle at their home in Ivalo in Inari Lapland!

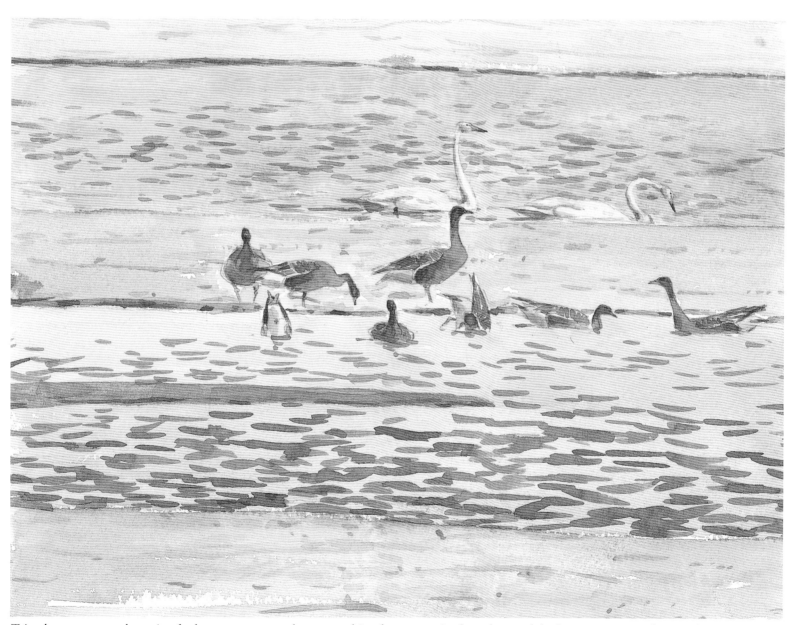

Taiga bean geese and a pair of whooper swans gather around ice-free water, in the colours of the late evening sunshine. The geese frequently up-ended, like dabbling ducks, in order to feed. 11.30pm, 6th May 2000

INARI LAPLAND and VARANGER FJORD
An introduction by Heikki Karhu

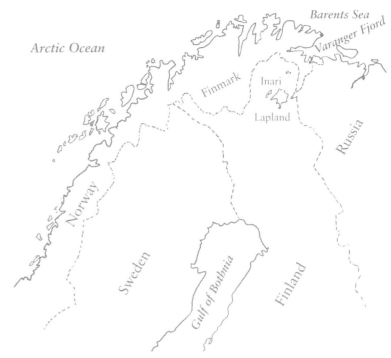

The northernmost part of Finnish Lapland is called Inari Lapland. This subarctic inland area is almost the same size as Belgium, but it has fewer than ten thousand human inhabitants. One third of these are Lapp or Sami people. Its landscape is a mixture of coniferous boreal forest, large bogs and open fells. In northern parts of the region there are also birch forests and open tundra. Of the thousands of lakes, the biggest is Lake Inari, which is at its widest about a hundred kilometres across.

In all other areas of the world, at these latitudes, the ecosystem and climate are arctic. Here the Gulf Stream keeps the climate relatively warm. The bird fauna is rich with some 145 breeding species and there is also a good variety of large mammals such as moose, lynx, brown bear and wolverine. With the wolf now virtually extinct the remaining carnivores have negligible effect on the oversized population of reindeer which numbers about 70 000. Their over-grazing is a growing threat to the balance of nature especially in the delicate fell areas, where there is a serious shortage of lichen and virtually no regeneration of young birch forests.

The winter in Inari Lapland is long, but it is not as dark as often believed. From late November until late January when the sun doesn't show itself above the horizon the presence of snow helps to make the surrounding world light enough to see. Even on the shortest days before Christmas there are a few hours of 'daylight' outside and you can go birdwatching. Although the winter temperature may often be well below zero centigrade there is little problem so long as one takes the necessary precautions. It is only when the temperature falls below -35° centigrade that life becomes less comfortable. However, in most years such periods of extreme cold seldom lasts more than a few days. During March and April when daylight is lengthening but is still very cold, the so-called 'spring-winter', pine grosbeak, snow bunting and whooper

swan are the first to return from their wintering areas. The real spring, and also the spring migration are, short and rapid. More migrants begin to arrive from late April onwards, but the main rush doesn't usually occur until the first warm days in mid-May. Then it seems that all the birds are returning at same time with little difference between 'early' and 'late' migrants. Cuckoo, spotted redshank and red-necked phalarope sometimes arriving just a few days after the first redwing and brambling.

People from further south always find the summer in North Lapland too short. Local people have a more practical attitude. When I asked a Fell Sami reindeer herdsman what summer meant for him he answered, "Summer what's that? Oh, you mean when the snow gets changed" Likewise the autumn does not last long. Most migrant birds fly south during September and the snow and frost are back again in October.

Nowadays the main livelihood of local people comes in the form of leisure and tourism, but forestry, reindeer husbandry and fishing are also important. The biggest 'town', Ivalo, is little more than a village, but has good road connections both north and south and an airport with daily flights to and from Helsinki. Inari village is the center of Sami culture in Finland. The nearest real town is Vadsø on Varangerfjord in Norway, and the nearest Finnish, Rovaniemi, is 300 km to the south on the Arctic Circle. A similar distance in eastwards, albeit much less accessible, lies the biggest city in the Arctic, Murmansk, Russia.

I myself moved to Lapland from the south in the 1980s. Like many other romantics, I was attracted by the possibility of getting a job in this area, with its exotic birds and opportunities to experience wilderness. I worked there for twenty years as a Police Chief and Sheriff Officer, but lived

for birds and birding. As a former keen twitcher it felt good to find my own birds. After past, often hectic, rarity chases I rediscovered the delight in finding my own birds, such as, the first spring wheatear. One important advantage of living in Ivalo was that it only took two and a half hours to reach the, permanently ice-free, Barents Sea coast. Even as a schoolboy, when living by the coast on the Gulf of Finland, I had been reading exciting stories about hunters´ adventures in the Arctic. Now, on my birding trips to Varangerfjord I could let my mind wander and imagine all sorts of unusual birds turning up.

A total of 255 bird species have been recorded in Inari Lapland of which 145 breed. Of these breeding species 110 are summer visitors, seven are partial migrants and just 28 are resident. The rest are more or less accidental or occasional. The number of species in this area is restricted by the fact that it is effectively at the edge of the world. The high proportion of species regarded as scarce is in part due to the lack of observers in the area. No doubt birds like pomarine skua, little auk and grey plover, together with some other arctic waders, would be found to be regular rather than occasional passage migrants, if there were more local observers. On the other hand, some migrant birds are attracted to lonely Lapp houses and small villages. As an example, most of the hoopoes are reported to birdwatchers by ordinary people and the records probably reflect the actual numbers more closely.

Of the breeding birds long-tailed duck, common scoter, rough-legged buzzard, gyrfalcon, ptarmigan, dotterel, Temminck's stint, bar-tailed godwit, red-necked phalarope, long-tailed skua, red-throated pipit, ring ouzel, arctic redpoll, Lapland bunting and snow bunting belong to the Arctic faunal type. Additionally, snowy owl breeds in good rodent years, little stint is a very rare and local breeder, shore lark is nearly extinct, but maybe recovering, and lesser White-fronted Goose has recently become extinct as a breeding bird.

Breeders of the Siberian faunal type are represented by whooper swan, smew, arctic warbler, Siberian tit, Siberian jay, pine grosbeak, rustic bunting, and little bunting. In addition two-barred crossbill probably nests in some years in the spruce forests. Other mostly boreal or taiga species are bean goose, jack snipe, willow grouse, great grey owl, hawk owl, pygmy owl, Tengmalm's owl, three-toed woodpecker, waxwing and bluethroat. A significant proportion of the broad-billed sandpiper and spotted redshank populations in Western Europe also breeds in Inari Lapland.

There was still a metre of snow on the ground when James arrived in Ivalo in early May 2000. A few days later the bird migration burst into full swing. After my son Olli left home the previous autumn my own birding had become desultory. The first outings to help James orientate himself here, got me going again. Our first Saturday trip produced two shore larks at ten past three in the morning. They were in entirely the wrong place: feeding on a small road in the middle of taiga spruce forest. In the evening we stopped by an ice-clad lake with a small area of open water and amongst a flock of bean

geese was a pinkfoot and Inari Lapland's third ever greylag. Spring was advancing swiftly that day. In the afternoon we had been compelled to leave the sledge in thick wet snow, whilst returning by snowmobile from a tundra hut.

James had Olli's room but, after the first few days, we did not see him very much at the house. He spent his time outside watching, sketching and painting, in all weathers. Ivalo is a small community and although people here are used to tourists, the presence of newcomers will be noted. James either on his bicycle with all his equipment, or sitting and working by roadside or visiting the village shops was quickly accepted. He soon became part of the small local birding community. During the time he spent here he was the most active member. He brought us up-to-date with the bird world outside Ivalo, found a lot of good birds and increased the delight of birding to us all.

Of all the birding outings we made together, a quite special one was a two-day walk in June in the Sarmitunturi wilderness area near the Russian border. We found fine birds such as golden eagle, peregrine, capercaillie, hazel hen, black woodpecker, Siberian jay and Siberian tit, but the best was a wren! which we heard singing in spruce forest at four o'clock in the morning. In no time James had found the nest, the first ever found in Inari Lapland. The following night we spent birding and looking for brown bears and so had very little sleep. On our way back I made the mistake of going ahead of James and we became separated. He had no compass or map, but to my great relief, he emerged, smiling from the forest an hour after me. He had also added tree pipit to our list for the walk.

Later in June we headed for Lemmenjoki National Park to see if the arctic warbler was back. We walked to a riverside forest, to a reliable territory. James said he could hear a song, but the phrases sounded like a lesser whitethroat. "There are no lesser whitethroats here", I said, "There's your arctic warbler". I switched on my microphone and started to listen and record the warbler song, but to my great astonishment I found that it really was a lesser whitethroat. The third for Inari Lapland and a first for the National Park! A little further on we did find a singing arctic warbler.

In late spring James spent a couple of weeks alone on the cold and still partly snowy tundra at Petsikko, one hundred km north of Ivalo, sleeping in a wilderness hut. My wife Sinikka and I visited him once to see that he was still alive and to take some warmer clothing. We found him well and in good spirits. At the end of June James then headed, with a tent, for Varangerfjord. We next met him in mid-July at Helsinki airport on his way home, and heard his exciting news from the Arctic Coast.

Heikki Karhu, Lahti, February 2007

Lapland Adventure

When I arrived in Ivalo in early May 2000, the first thing to hit me as I got off the plane was the cold. It was late evening and far colder than I had ever experienced before. One of my first sensations was to feel moisture inside my nose freezing as I breathed in. I soon adjusted to the weather conditions and started to familiarise myself with my new surroundings. I began by drawing birds at the garden feeder in the early mornings then walked around the woods nearby. It was hard going at times, for as the spring progressed the snow began to thaw. Ther snow was between one to two metres deep in places and I frequently dropped in to my knees which made progress slow. A useful tactic was to follow snowmobile tracks where the snow had been compressed and was hard.

Typical garden birds were arctic and mealy redpolls, blue and great tits, and occasionally willow tits. The recent increase in popularity of garden feeders had also enabled greenfinches, woodpigeons and yellowhammers to over-winter successfully. Migrant birds, such as redwings, fieldfares and bramblings, began to arrive and their numbers and variety increased day by day.

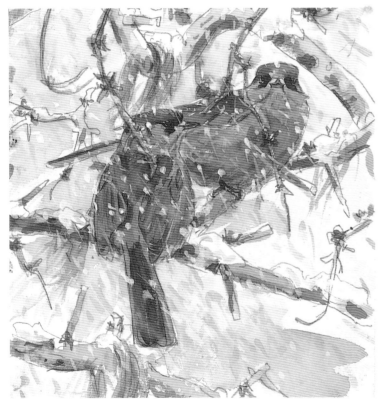

A pair of Siberian jays waiting to be fed outside a Lapland cottage. During the breeding season they can be very secretive. However, at other times of the year, they form small parties and are then exceedingly tame and inquisitive. They often come to inspect people during forest walks and will regularly visit campfires in search of food. This makes them a favourite bird of many local people. -7°C, 26th January 2001.

I stayed until mid-July and was to make further visits in January and March 2001 and again in May and June 2006.

I have arranged the pages in a seasonal progression from winter to summer rather than chronologically. Short texts and captions will hopefully help to explain the situations shown in the paintings and sketches. A series of diary extracts should give a flavour of my time in Inari Lapland and some of the people I met there.

6th May 2000 - *north winds, snow showers, heavy at times drifting over some roads on the top of the fells.*

Heikki introduces me to Inari Lapland. We left early, just after 2am, heading for a wilderness road beyond Saariselkä that eventually leads to the Sami reindeer village of Kuttura. As it began to get light we saw many willow grouse displaying by the roadside and a beautiful male black grouse sitting in roadside spruce. Further along we stumbled across two shorelarks sitting beside the road, fluffed up into huge balls of feathers as they faced into the icy wind. They looked strangely out of place on this forest road. The northerly wind felt incredibly cold, freezing solid any bare ground and puddles. We moved on towards Inari, stopping off at Kettujoki (Fox River), which, in the spring, has some of the first big areas of open water. Here whooper swans, a few bean geese and small numbers of goosander, goldeneye and mallard gathered on the ice-free waters.

We then headed north on the road towards Utsjoki, and the Norwegian border, stopping near Petsikko, some 60 kilometres short of the Norwegian border, to visit a small lake, Säytsjärvi. There, in a low birch forest on the shore, Heikki and friends have a small cabin. We arrived there by snowmobile with a sledge attached to the back. Having eaten some dried reindeer meat and drunk some coffee Heikki took me out on to the frozen lake to show me how to ice-fish. Using a tool like a giant corkscrew, we cut a hole through the ice. Then, using a short rod, with bait, hook, spinner and weight attached, we tried our luck. The technique was to let the tackle hit the lake-bottom, wind up the slack, then reel in 10 to 15 cm of line. Occasional upward flicks would hopefully attract the fish. I had one bite but lost the fish and eventually we gave up empty-handed.

On the way back to Ivalo we saw more bean geese, a pink-footed goose, a young greylag, more whoopers and goldeneye, a group of snow buntings and a great grey shrike.

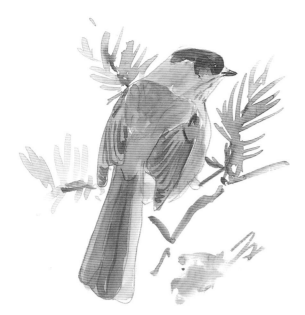

Siberian Jay

7th May 2000 - *sunny spells fresh south-west wind.*

We visited Kiilopää Fell to the south of Ivalo. I used skis for the first time, Heikki patiently teaching me how to walk up fells with them and I also did some skiing down gentle slopes. It was great fun and a new birdwatching experience. We searched some small, snow-free areas of gravel, rock and vegetation for ptarmigan. Initially we found old tracks, then fresher ones. On the top of the fell there was a snow-covered rock pile, which marked the summit. On the sheltered side, a ptarmigan had dug a small depression which contained some droppings and a feather. It had either roosted here or sat out a blizzard. Later we saw a male, all-white except for two tiny grey flecks on the top of its head. It was feeding where a small group of reindeer had been digging in the snow for lichen. Sketching and painting it on the snow-covered fell was excellent fun. Apart from the reindeer and ptarmigan, a fine, mature white-tailed eagle passed overhead and a great grey shrike paused briefly on top of a small pine before heading off strongly in a northerly direction. I lost count of how many times I fell over but it was a very enjoyable day.

28th May 2005 - *bright but rain and drizzle, bright sun by evening.*

Heikki introduced me to a friend of his, Olli Osmonen who took me on a forest walk to show me some areas of virgin forest. We saw some fine old pines, many covered with an impressive array of lichens. Olli picked up a pair of pine grosbeaks by their occasional, very faint, double-note contact calls. They were incredibly fearless and not bothered by us. This actually made them quite difficult to locate and it was only when one flew up almost from underfoot that we found them. They were busy feeding on crowberries, which had been covered by autumn snow, deep-frozen all winter, then exposed once more after the snow had thawed. They were so tame that, at times, it was possible to draw and paint them without having to use optics. Flying up into small birches they began to feed on fresh buds before moving on to Scots pines where they ate the small clusters of new needles. Here in the pines they were joined by a pair of

Siberian tits. Suddenly there was a clatter of wings and branches from a large pine nearby and a huge male capercaillie launched itself into flight. Siberian jays were calling and a three-toed woodpecker began to drum. Olli was quite excited by this combination of simultaneous sights and sounds for these were, as he put it, Lapland's 'big five', the forest birds that all visitors hope to see and this was the first time he had recorded them all at the same time. We hiked on, enjoying lots of bird-life and beautiful scenery before stopping to build a fire and enjoy the classic campfire meal of sausages and coffee.

19th June 2006 - *light rain showers, some heavy, occasional sun. Cool, moderate south-south-west wind.*

Sarmitunturi Wilderness area

This wilderness area is right on the Russian border between Ivalo and Nellim. We left Ivalo at 1.30am, stopping on the way to check one of Heikki's nest boxes, which contained eight Siberian tit nestlings close to fledging. We hiked and birdwatched for thirty-one hours with three campfire-stops to eat, drink and to have short naps. This is a beautiful area of mixed habitats, of deep canyons with tall candle spruces and birches, dense mixed forests, areas of aspens, open fell tops and spring-fed bogs. There was plenty of fresh evidence of bears in the form of droppings and diggings.

The area is quite rich in bird species and we found several scarce Lapland species including the first ever recorded wren's nest in Inari Lapland. A hen capercaillie flew up from underfoot but there was no sign of a nest. We had fantastic views of a pair of hazel hens, the male all puffed up with crest raised, wings drooped and tail fanned and cocked. It gave a rapid succession of warning calls, which sounded like water dripping into a pool. Siberian jays called and came gliding through the Scots pines to investigate us. Three-toed woodpeckers drummed and a black woodpecker was heard calling close to the Russian border. On the fell tops we had good views of a rough-legged buzzard and a young golden eagle. Several merlins flashed by and whimbrel and golden plover were nesting on the tops.

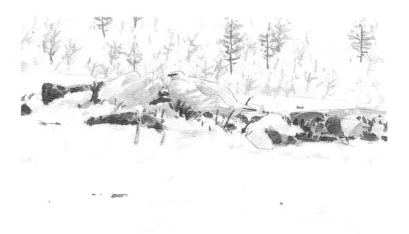

A male ptarmigan painted whilst skiing. Kiilopää, 7th May 2000

Arctic or Hoary Redpolls

These remarkable little finches are able to remain within the Arctic Circle throughout the year and have been recorded at temperatures as low as -67°C. They are known to roost in burrows under the snow in order to survive such extreme temperatures. Presumably they must also find food under the snow during the day for, in Finland, locals have heard accounts of skiers seeing redpolls burst out of the snow ahead of them. They are very common at garden feeders during the winter and can gather in large flocks, easily outnumbering mealy redpolls. They make interesting and bizarre shapes to draw when they are inactive or fluffed up in the cold. They often move to the extreme north to breed and I have found their nests in low willow clumps on the open tundra. The incubating birds frequently sit quite tightly, allowing close approach if you are careful.

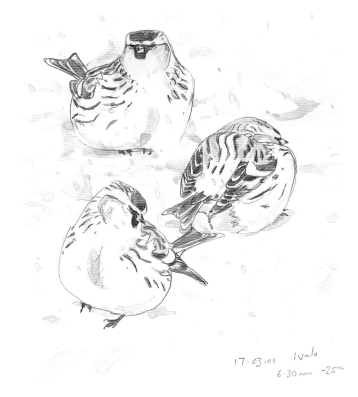

17.03.01 Ivalo
6.30 am -25°c

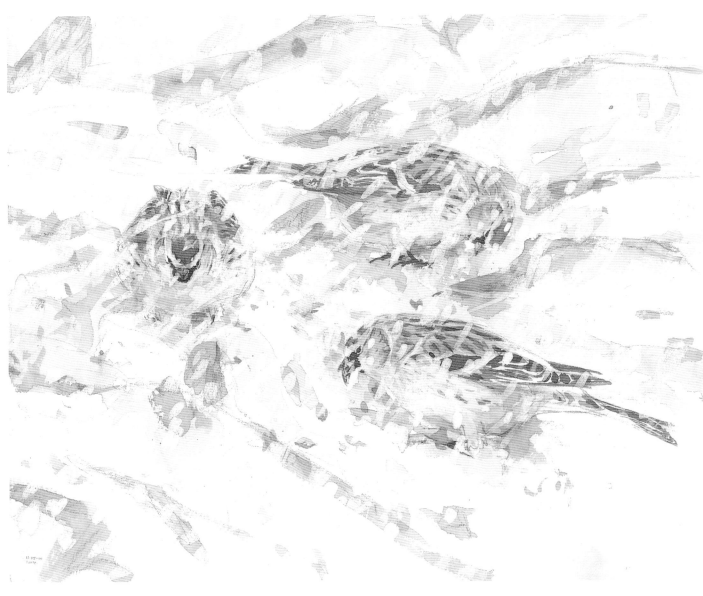

14

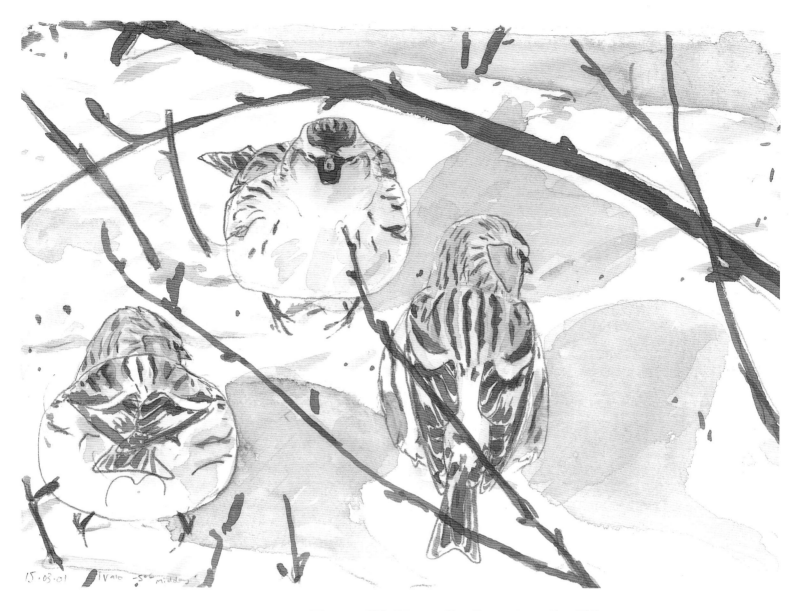

In Lapland during mid-winter arctic redpolls are often the commonest birds at garden feeders. These birds were painted from a kitchen window in various weather conditions and temperatures down to -25°C. During inactive periods, they would fluff themselves up so much that they appeared almost square-shaped! In the March sunlight, their blue shadows accompanied them as they hopped across the snow in search of food. Hukkaperä 4, Ivalo, 2000 & 2001.

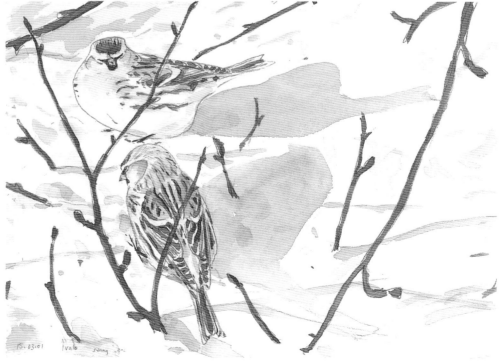

Hazel Hen

An encounter with Hazel Hens.
Ivalo, 15th March 2001.

It was late afternoon when I entered a small area
of mixed birch and spruce woodland, broken by the
occasional Scot's pine and rowan. There wasn't a
breath of wind and, although the temperature was
around -15°C it felt relatively warm and comfortable.
There was high pressure over Lapland so the sun was
out and the sky cloudless. As I followed bird calls
and tried to familiarise myself with them I often found
myself wandering across, or sometimes wading
through, snow that was half-a-metre deep.

Calls that had seemed unfamiliar had often come from
the northern populations of familiar birds such as willow
tits and bullfinches, not to mention that infamous trickster,
the great tit. On one occasion it was a bullfinch that had caught
me out, fooling me into hoping that it might be one of the
recently-returned pine grosbeaks. This particular bullfinch's
chattering, warbling song was interspersed with its loud nasal call-
notes and it also included phrases that sounded remarkably like
the croak of a raven and the loud whistle of a Siberian jay. My
attempts to locate the source of these calls had taken me through
a beautiful landscape full of yellow, pink and blue-toned snow
patterns created by the sun, as it dropped lower in the sky. The
pale bark of the birches looked surprisingly dark-cream against the
snow and in the places where the dappled sun struck their trunks
they shone as gold.

A dark shape in one of the highest birch crowns halted my
progress. I peered up and saw a lovely female hazel hen rapidly
eating the buds. I then heard a series of calls, which sounded
rather like a dripping tap and I soon located her mate, high up in
the neighbouring birch. I spent the last of the daylight watching
them feeding. They looked a bit out of place, high up in the fine,
feathery canopy. They moved along the thin branches by taking
nimble steps, one foot over the other, whilst all the time stretching
their necks in all directions in order to reach the birch-buds.
Occasionally, one of them would lose its footing and would shoot

The pair
feeding.

out a wing or fan its tail in order to regain its
balance. They moved from one tree to another
by free-falling from the high, outer branches of
one tree and landing halfway up another.
There they would work their way through the
new canopy, feeding constantly.
As the sun dropped below the tree-line, the
male became less active and I assumed he was
thinking about heading to roost.

Indeed he was, but not quite in the way I
had expected. Having had a good look
around he parachuted down from the high
branches, using his spread wings to slow his
descent. Just before he hit the snow he
closed his wings and landed directly in it, with
only half his body visible and then he shuffled
forwards towards a slight hummock and
proceeded to burrow under the snow. This action
took me by surprise but it was highly amusing to watch, as
all that could be seen of him were his head and shoulders, which
wobbled from side to side as he presumably dug with his feet until
he had totally disappeared. Just before he disappeared beneath
the snow he popped his head back out and had a good look
around to make sure he was safe.

The female remained feeding high above. However, a slight
movement of my feet unnerved the male who popped out of the
snow, a couple of metres from where he had disappeared. He
then walked nervously away, with his tail half-cocked, before
crouching on a branch that protruded from the snow. The female
was still busily feeding in the half-light as I left them in peace.

The following day I returned to the same area and found several
signs of their activities, including an 'impact crater' where one of
them had dropped down and landed in the snow. Close by there
were some short, trial burrows where one had tunnelled through
the snow then come out again. I found a roosting burrow a short
distance away. This roosting burrow had been dug in the snow on
top of a hummock on the other side of which was the exit hole.
Inside there was a cavity containing a frozen mass of pale
droppings.

The male, going to roost, digs down with his feet then, after a
last, quick look around, disappears under the snow.

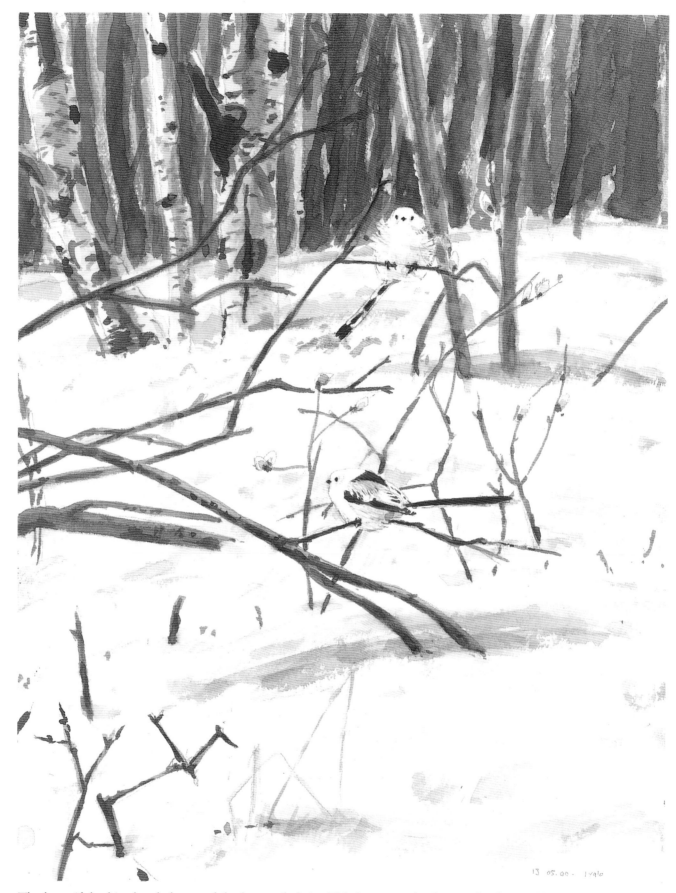

13 05.00. Ivalo

The beautiful white-headed race of the long-tailed tit. This is a scarce bird in Lapland most likely to be seen during autumn irruptions. In spring 2000, I saw several pairs in birches and willows on the edges of frozen rivers and ox-bow lakes. At least one pair stayed to breed and was the first recorded nesting pair in Inari Lapland. Fluffed up against the snow, these birds were some of the most beautiful I had ever seen. Ivalo 13th May 2000.

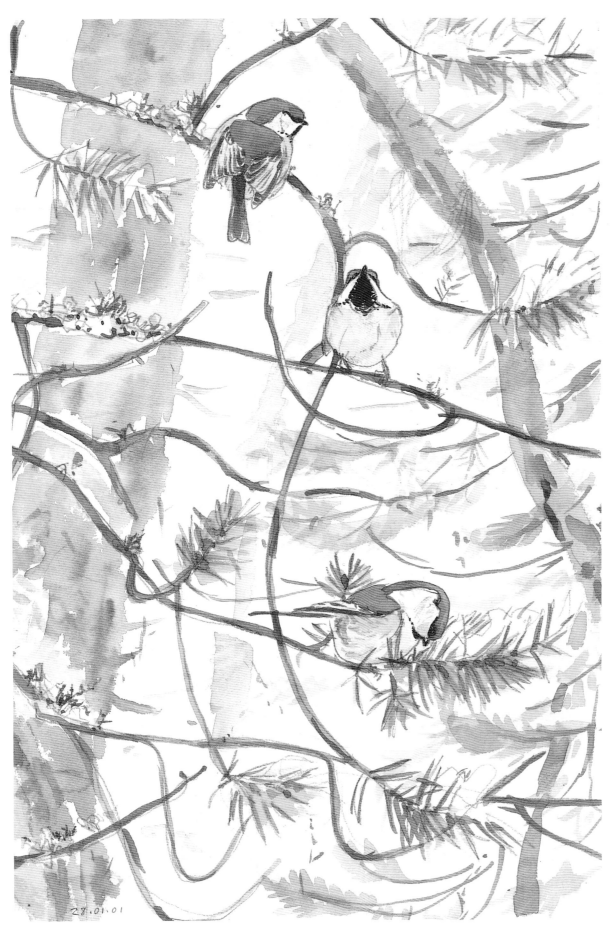

28.01.01

Siberian tits are a northern speciality. Their heavy, dense plumage helps them to survive extremely low winter temperatures. They are very much a forest bird, shying away from towns, although they will regularly visit forest feeders where they can be exceptionally tame. I have had them sitting on my hands eating seeds. In common with many tits they raise their heads to show off their black bibs as a threat-display. Road to Nellim, Lapland, 28th January 2001.

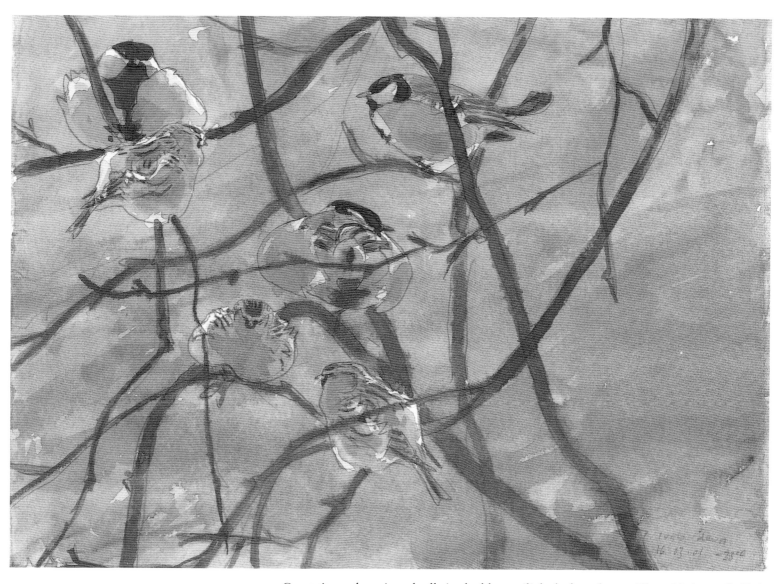

Great tits and arctic redpolls in the blue twilight before dawn. These birds are fluffed up in a temperature of -23°C. The great tits' tails are slightly bent to one side as a result of having been huddled up together at a roost in a tree-hole or nest-box. Ivalo, 16th March 2001.

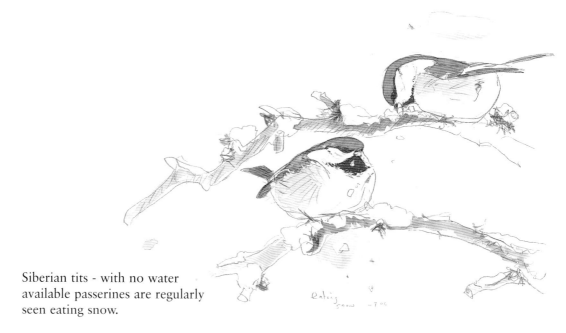

Siberian tits - with no water available passerines are regularly seen eating snow.

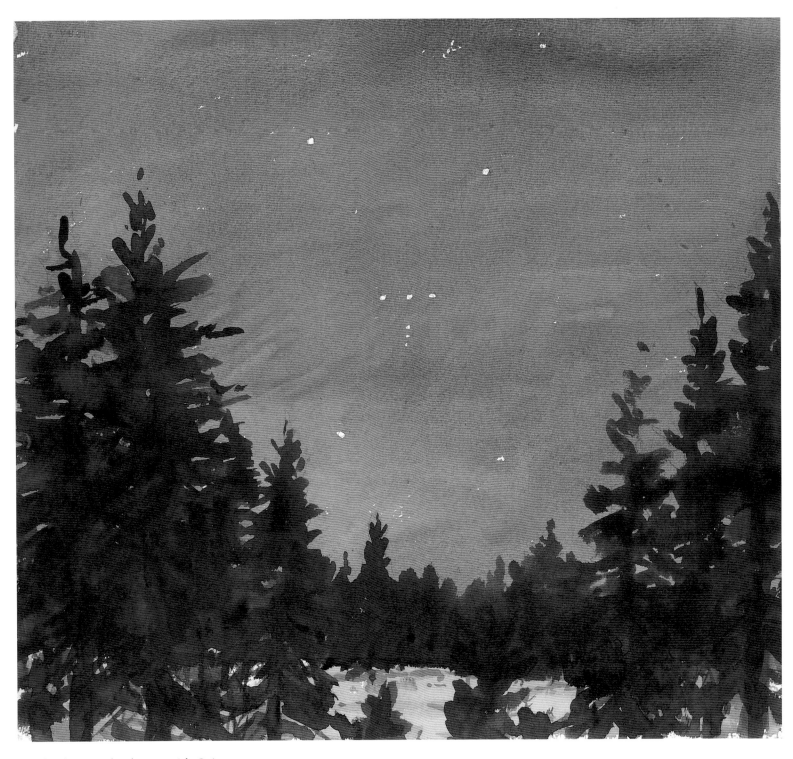

Lapland winter landscape with Orion.

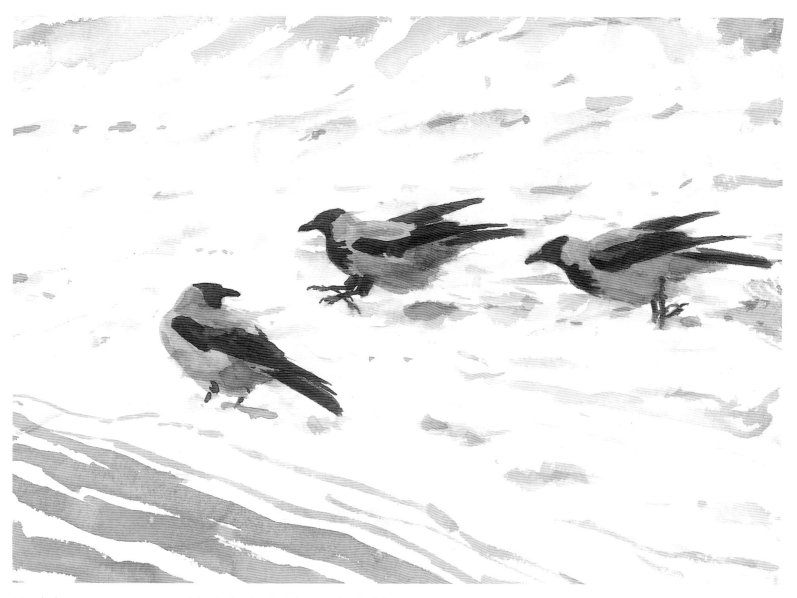

Hooded crows are a common sight in Lapland. They are birds full of character; this trio was bounding along over the frozen waters of the Ivalojoki, searching for food as the snow melted. Ivalo, May 2000.

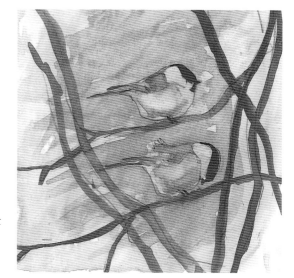

Willow tits of the northern race 'borealis' prior to going to roost in the blue twilight around dusk. Ivalo, March 2001.

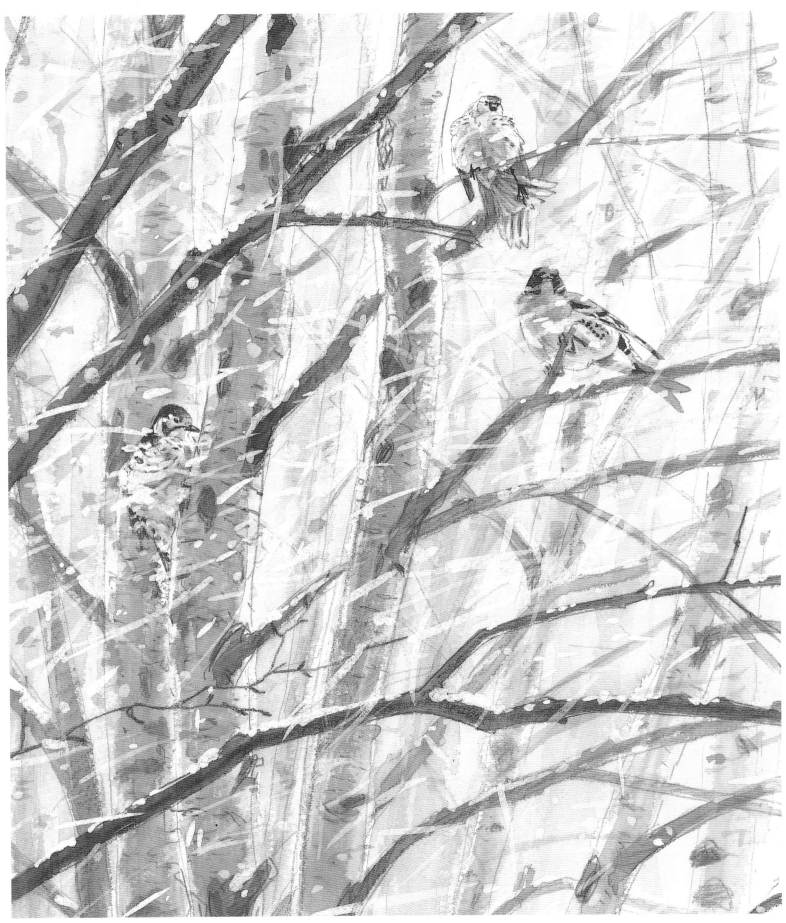

Bramblings are one of the first summer migrants to arrive. Here, in an Ivalo garden, a newly-arrived male joins a wing-stretching arctic redpoll and a lesser spotted woodpecker. Hukkaperä 4, 15th May 2000.

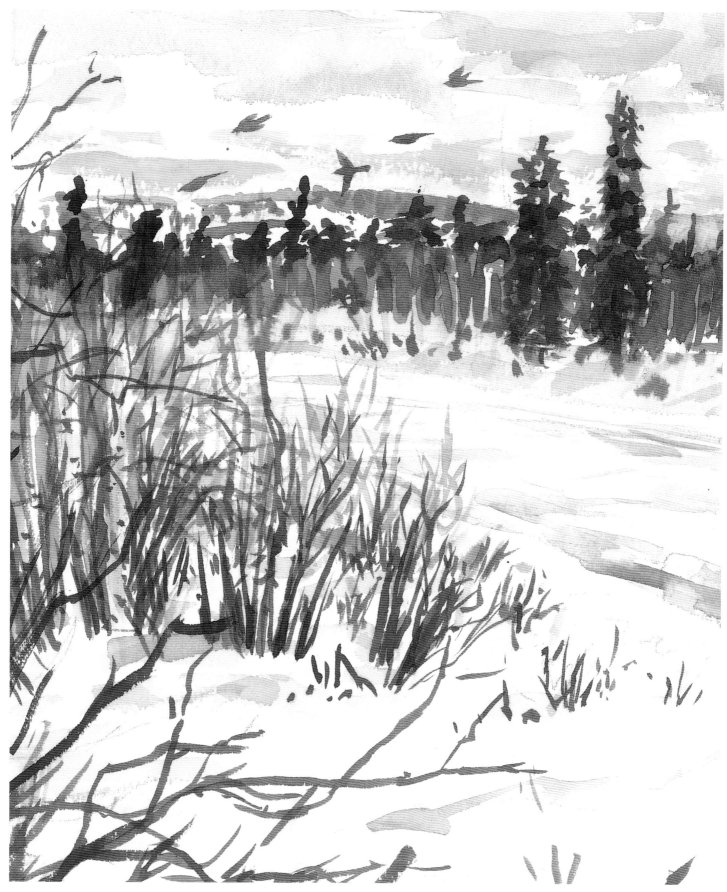

My arrival in Lapland coincided with some of the first redwings and
fieldfares of the spring. Ivalo, 5th May 2000.

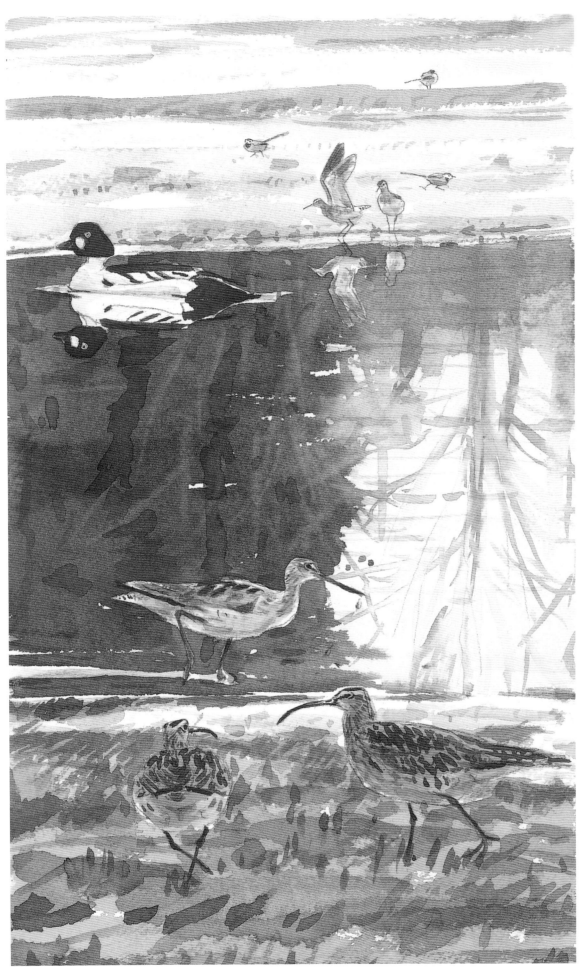

Summer migrants gather together on open water and snow-free shores to feed. Goldeneyes are a common breeder and local people put up nest-boxes for them. Here, white wagtails and wood sandpipers gather on the ice, whilst a greenshank feeds in the shallows and a pair of whimbrel feed on the shore. Ivalo, 23rd May 2000.

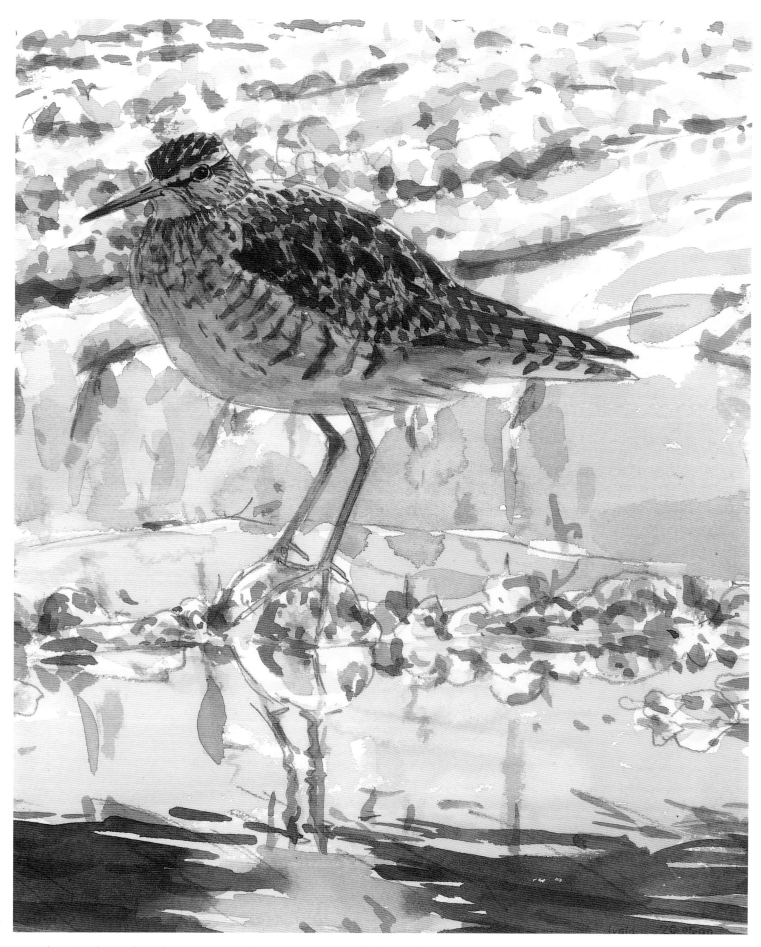

A newly-arrived wood sandpiper rests on the ice at the edge of a frozen lake. Ivalo, 20th May 2000.

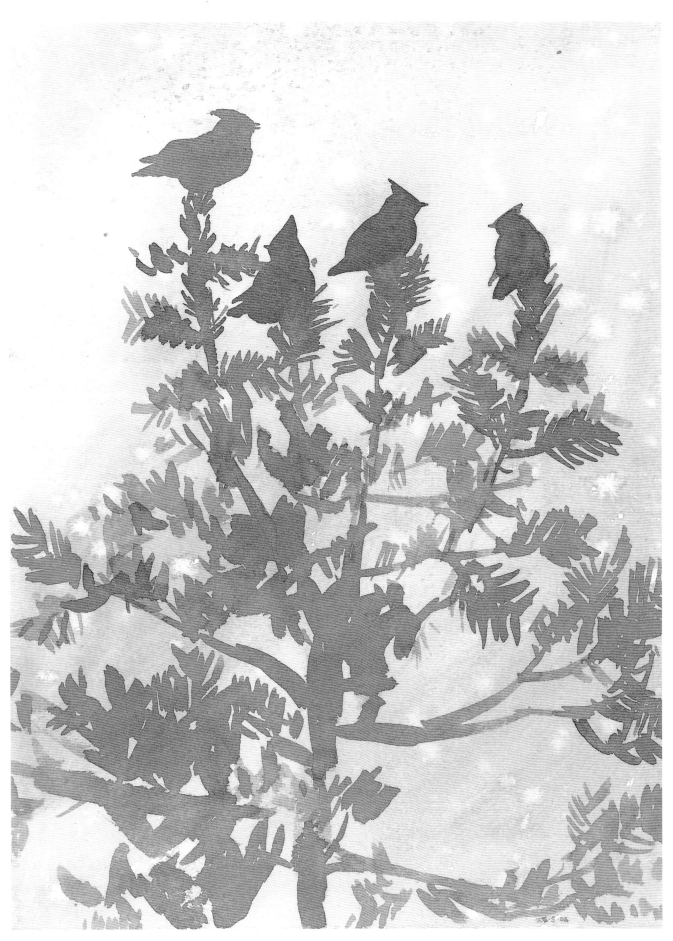

On a day of mist and drizzle, waxwings alight on top of a Scots pine. As the drizzle turns to rain, I have to shelter the painting underneath my coat until the paint dries. Mielikköjänkä, 25th May 2006.

14th May 2000

The night-frost had hardened the surface of the remaining snow and this enabled me to move through birch and Scots pine-covered slopes with relative ease. On the crests of the lower hills, especially those facing south, there were many areas of open vegetation. Here the snow was thinner and it was easier to move around. I paused for a while on a southeast-facing slope and sat down on a lichen-covered granite outcrop, to rest and absorb the atmosphere. A redstart was singing continually from the pine tops. Earlier I had watched it perched and flying against the open snow; its colours looked fantastic and almost out of place.

Occasionally a Siberian tit moved through the taller pines and when not in view its progress could be followed by its willow tit-like, three-note, buzzing call. It was an attractive bird with its heavy feathering, which gave it a bulky appearance. Its brown upper parts and cap looked as if they had been dusted with cocoa powder. Its cheeks were white and fluffy and contrasted with its black bib, which became broader and mottled on its breast. Often its rusty-yellow flank-feathers were fluffed over its wings.

The landscape beyond consisted of low birch bog, which gave way to birch and pine on the hillsides. These drew the eye upwards to the white-capped fell-tops in the distance. I enjoyed this 'spring-winter' scenery with its subtle blue-grey shadows and yellow highlights and the muted greens of the pines which gradually turned pale blue the closer they came to the white fells on the horizon.

There was an arctic hare on the valley floor. Except for a couple of freckles of its summer colours on its face, it still had its white, winter coat. As I watched it feed on some recently exposed yellow grass I noticed my first returning song thrush. I found myself thinking of the newly-fledged song thrushes I had seen back home in Norfolk only ten days previously and was reminded of how much further north I was. Redwings were increasing in numbers with each day that passed and many birds were singing from the tops of high pines. A Lapland bunting and a fieldfare called high overhead and then, suddenly, I heard my first waxwings of the spring as a group of four came bounding through the forest. One bird landed for a few seconds on top of an old silver-grey 'kelo' pine, then joined the others and their calls melted away through the trees.

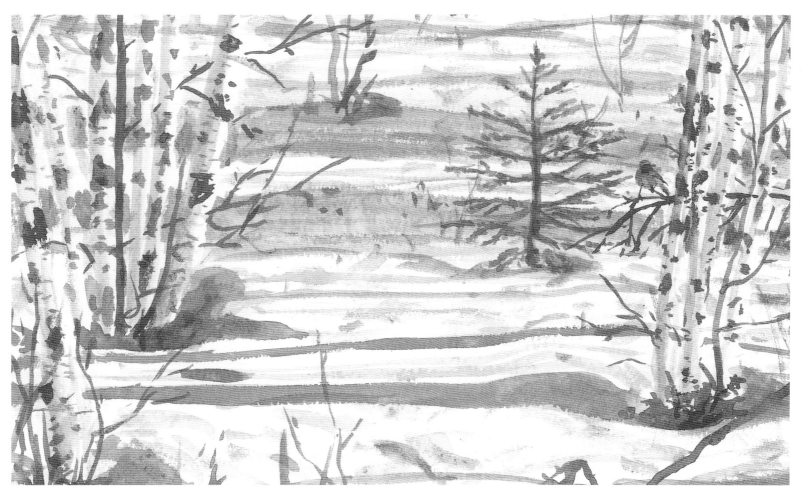

The colours of a newly-arrived redstart look strangely out of place against the snow and the ice-blue shadows, cast by the evening sun. The temperature falls rapidly and the paint freezes as the sun nears the horizon. Ivalo, 11th May 2000.

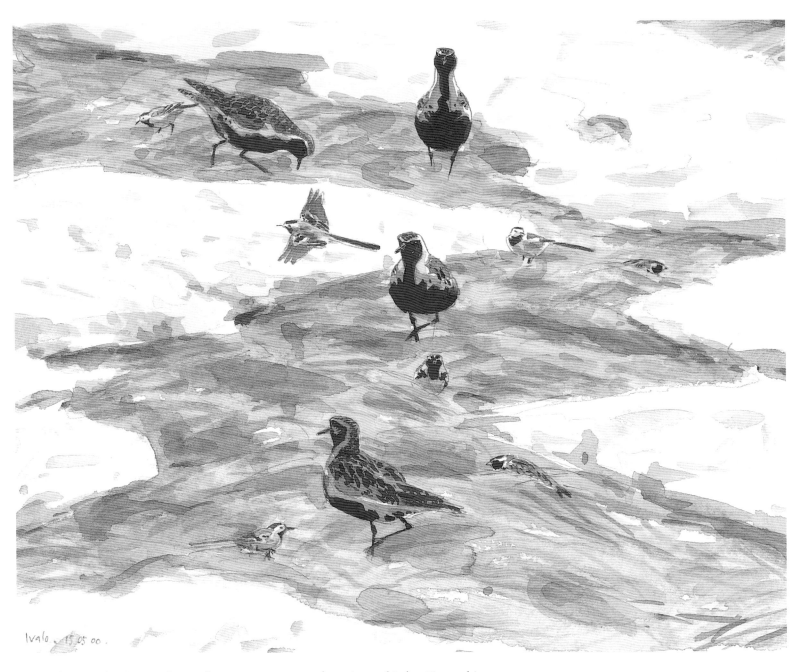

Ivalo. 15.05.00.

Snow-free patches in meadows often prove a magnet for migrant birds. Here white wagtails, Lapland buntings and golden plover stop off to feed before continuing northwards. On this particular morning, over seventy buntings and fifty wagtails were feeding with the four plovers. As they fed in the patchwork of open grass, their movements produced a fluid pattern of striking markings and colours, contrasting with the stark, white snow. Ivalo 15th May 2000.

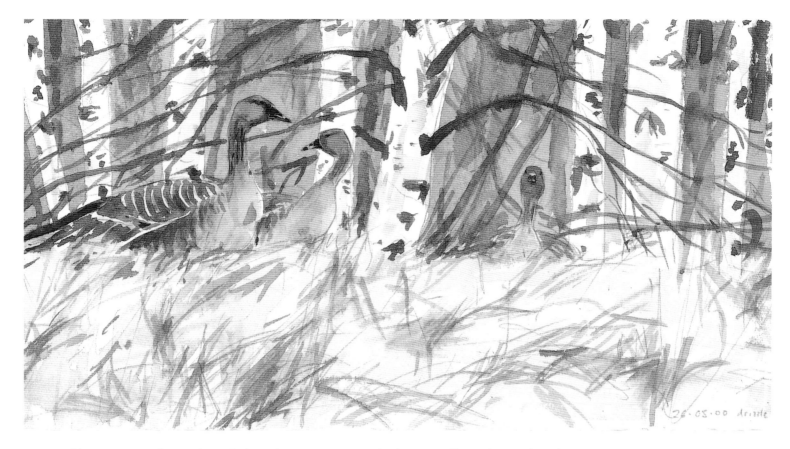

A pair of bean geese and a single pink-footed goose rest up to feed in a small meadow at the edge of a birch wood. The bean geese will go on to nest in forest bogs. The pinkfoot, however, has taken a wrong turn and should be on the way to Svalbard to breed. Ivalo, 26th May 2000.

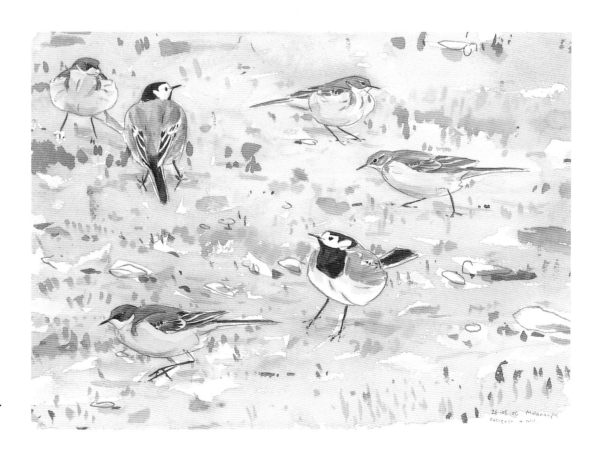

Grey-headed and white wagtails gather to feed, in the late evening cold. Mellanaapa, 26th May 2006.

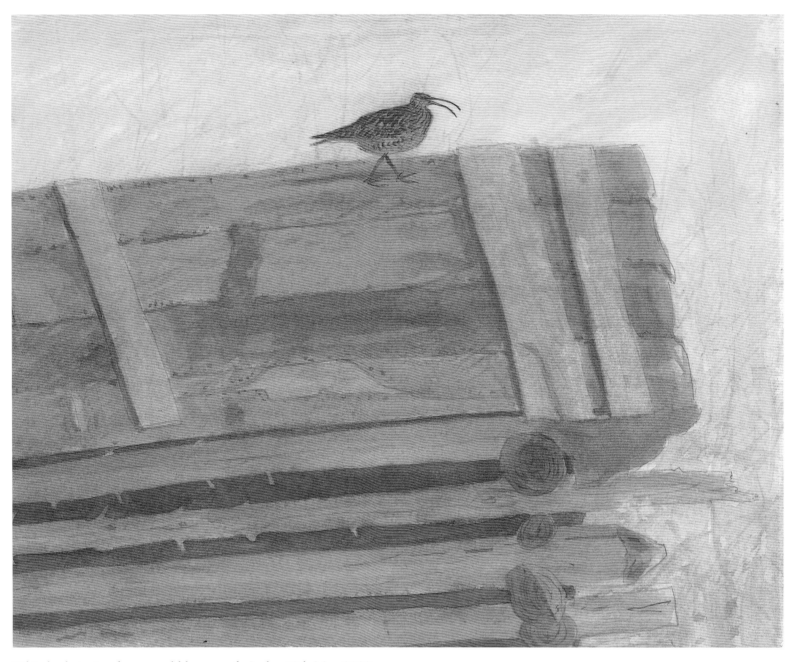

Whimbrel singing from an old barn roof. Ivalo, 18th May 2000.

Newly-hatched whimbrels.

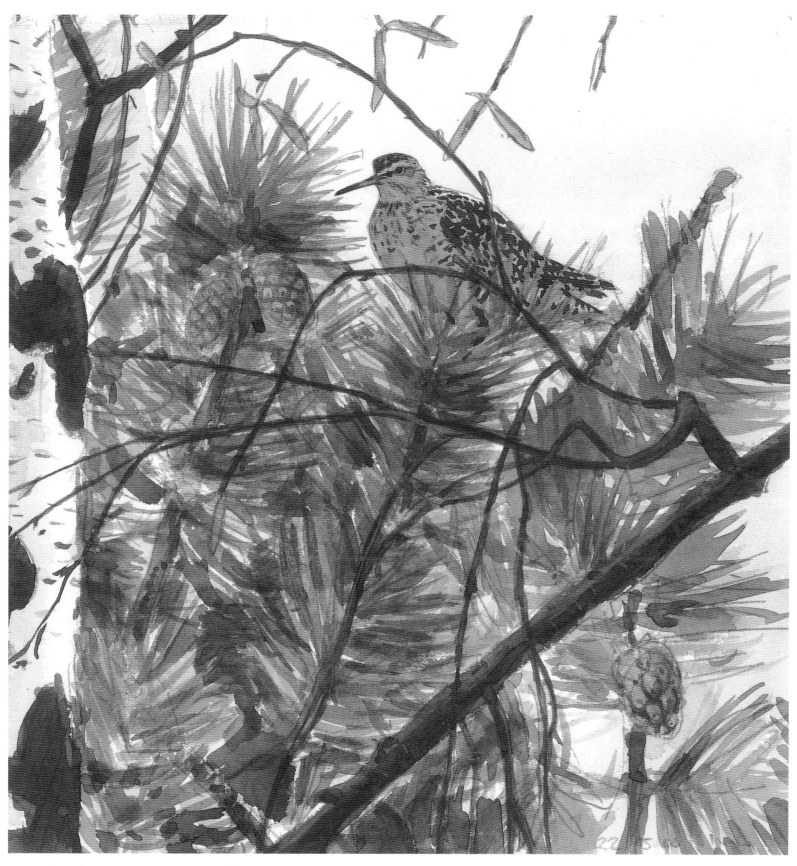

A wood sandpiper surveys its territory from the top
of a pine tree. Ivalo, 22nd May 2000.

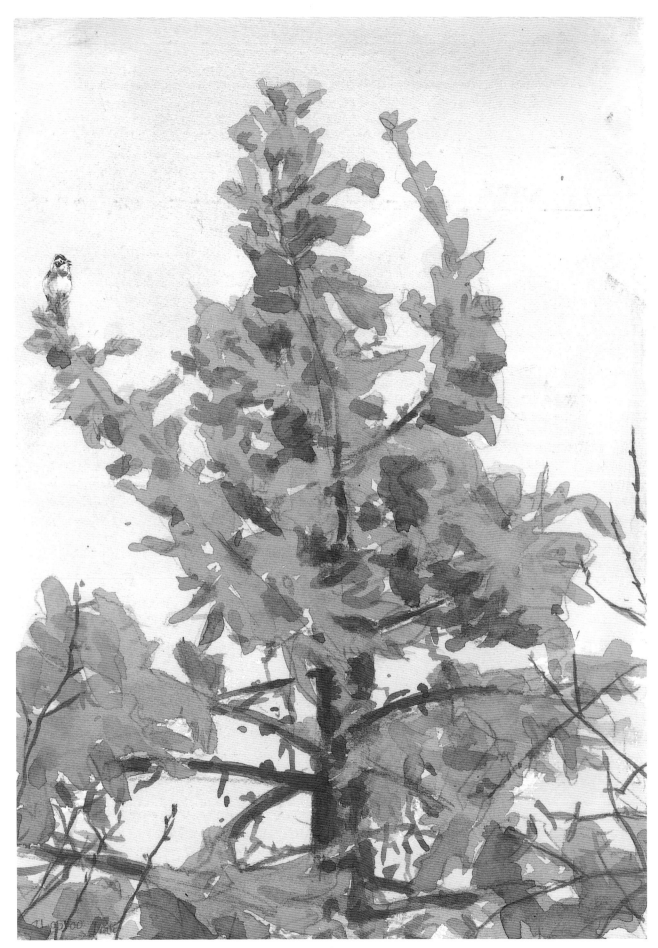

A rustic bunting sings from the top of a tall spruce. Ivalo, 21st May 2000

Rustic buntings nest over much of Sweden and central and southern Finland. They nest in smaller numbers in northern Lapland where they favour mixed, marshy forests containing mature spruces. Their breeding range continues across Russia to eastern Siberia.

The little bunting is very much a Siberian species. Finnish Lapland and parts of Finnmark represent the westernmost part of their breeding range, which extends to easternmost Siberia. This species holds a special place in my heart, as it was the first rare vagrant I found and identified, when a schoolboy in England, without the guidance of my older and more experienced peers. They have a watch-like 'ticking' call and their neat, clear-cut patterns and colours render them an attractive small bird.

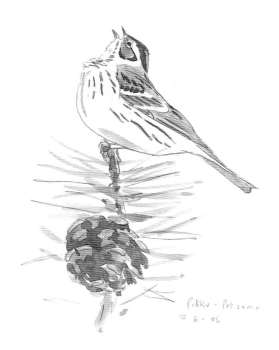

There were four or five different males singing in the general area and working out which were the preferred song perches was a worthwhile tactic. It gave me a better chance of quickly locating one to sketch.

Earlier in the week, it had been still and sunny and, as I sat trying to draw the buntings I was eaten alive by mosquitoes. Today it was much colder, with a good breeze that tended to keep the insects grounded; I took the opportunity to make lots of drawings and watercolours. I had a satisfying day learning more about this charming bird and had relatively few bites and bumps to show for it.

The following diary extract, dated 10th July 2006, helps to illustrate their behaviour and favoured habitat in Inari Lapland:

They seemed to favour scrubby areas of marshes containing birches and Scots pines, with a good understorey of dwarf birches. Scots pines were the favoured song-perches and the males fly up to the top of one and, immediately on landing, throw their heads right back and sing. They had a series of favourite pines where they sat and sang for several minutes at a time. Their songs were rather brief, lasting only a few seconds: a series of three short, high, thin notes followed by a short jangle. Nothing too special but not unpleasant and following a short pause, the song would be repeated several times before the bird flew down or on to another pine.

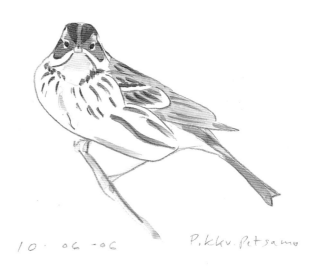

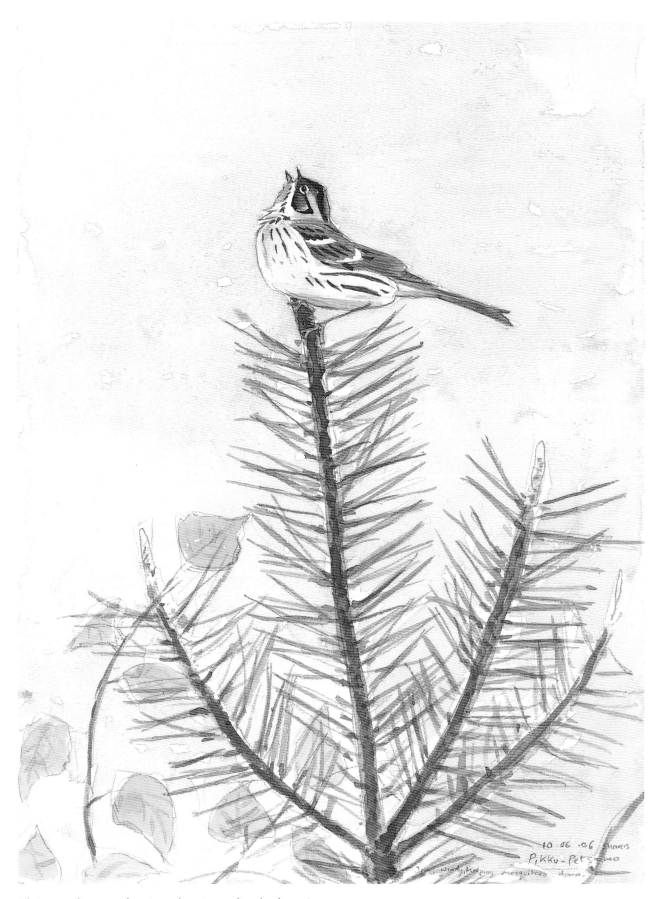

10.06.06 showers
Pikku-Petsamo
very windy, keeping mosquitoes down.

Flying to the top of a pine, then immediately throwing
its head right back and breaking into song, is
characteristic behaviour of the male little bunting.
Pikku-Petsamo, 10th June 2006.

Nesting Fieldfares

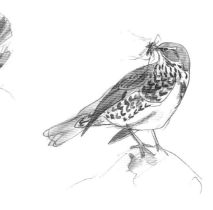

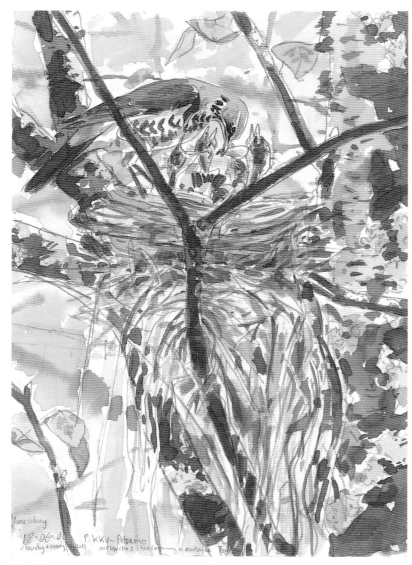

Fieldfares often nest in loose colonies and will club together to help drive away predators. One day, as I was cycling through the village of Pikku-Petsamo, I saw a group of hooded crows gathering around a tall pine, calling frantically. I tried to work out what was upsetting them but couldn't see anything. I decided to cycle around the back of the clump to try and get a better view. I still couldn't see anything; suddenly I noticed the big, elongated shape of a goshawk sitting in a small birch tree. Then it stretched its head out then launched itself through the trees. I quickly cycled back around the clump and found the hawk sitting on the ground, having caught a young fieldfare. The adult fieldfares all gathered around the hawk and repeatedly dive-bombed and some tried to defecate on it. In amongst all the noise and chaos I made a quick picture which, if nothing else, helps to capture the moment.
Pikku-Petsamo, June 2000.

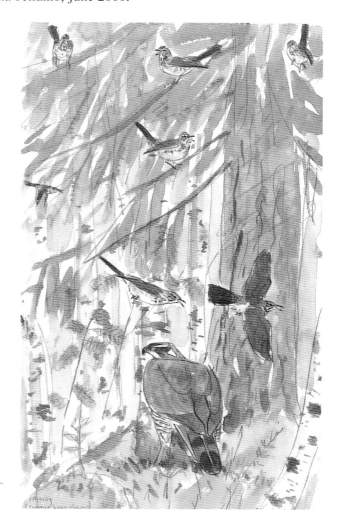

Fieldfares are common summer visitors to Lapland. Soon after their arrival, the males can be heard singing their chattering song from treetops in forests and towns. They also have another slightly different song that is delivered during a short display-flight, often from one treetop to another. It is a speeded-up, more explosive, almost crazed variant of its normal song. I really like these aerial songs for, although they are not as rich or as musical as those of most other thrushes, they are passionate and exciting. Here, a parent, having fed its nestlings, removes a faecal sac. These neatly-sealed parcels contain waste from the young and their removal prevents the nest from becoming soiled.

In another instance a parent waits to feed its fledglings and is not happy about my presence nearby. It postures by repeatedly cocking its tail and flicking its wings, as it produces a harsh, rattling warning-call. Sometimes the wings and tail are half-spread.

Arctic Hares

In common with many northern and arctic species, these animals have evolved to adapt their colouration to suit their seasonal surroundings. In the winter their coats are pure white but, as spring approaches, they begin to moult into their grey-brown summer coats. These paintings were made in Lapland and on the shores of Varanger Fjord.

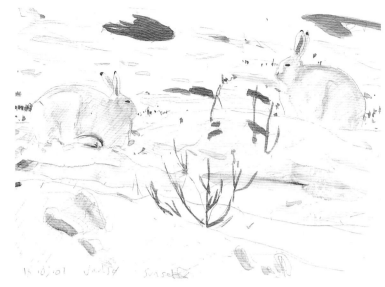

Arctic hares on Vadsøya, painted as the sun began to drop. Despite the plummeting the temperature, it is at this time of day that the hares become most active.

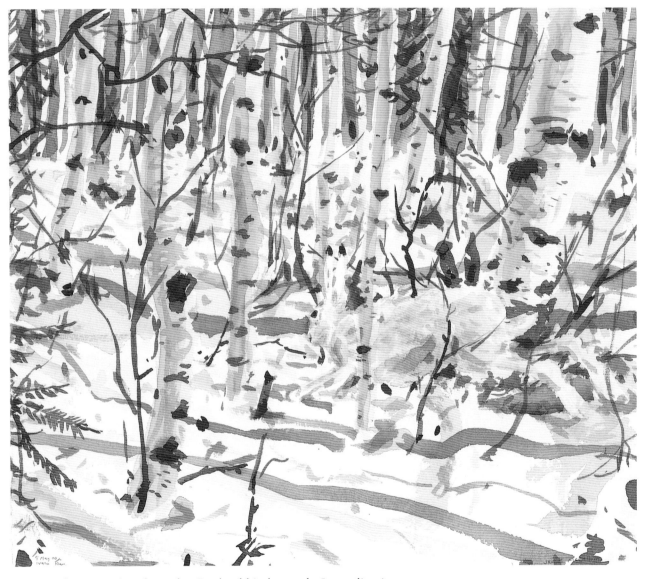

An arctic hare running through a Lapland birch wood. Its outline is broken up by the birch trunks and snow. Ivalo, 8th May 2000.

During the daytime the hares were really difficult to see. They favoured hiding amongst the branches of dwarf willows rather than lying up in depressions or 'forms' in the snow. Vadsøya, Varanger, 24th March 2001.

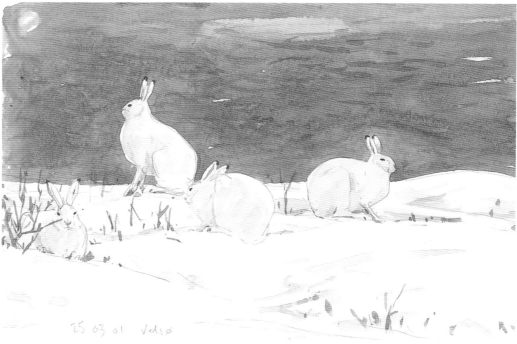

They became much more active in the late evening and stood out really well against the dark steel-blue fjord. Vadsøya, Varanger, 25th March 2001.

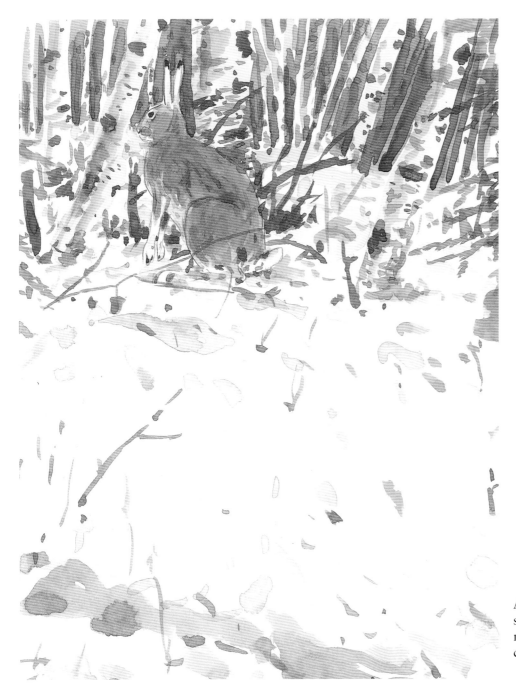

As the spring progressed and the snow began to melt, they started to moult into their grey-brown summer coats. Ivalo, 9th May 2000.

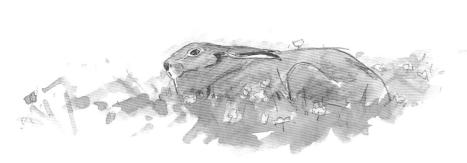

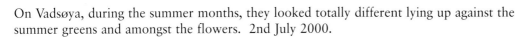

On Vadsøya, during the summer months, they looked totally different lying up against the summer greens and amongst the flowers. 2nd July 2000.

Hawk Owl

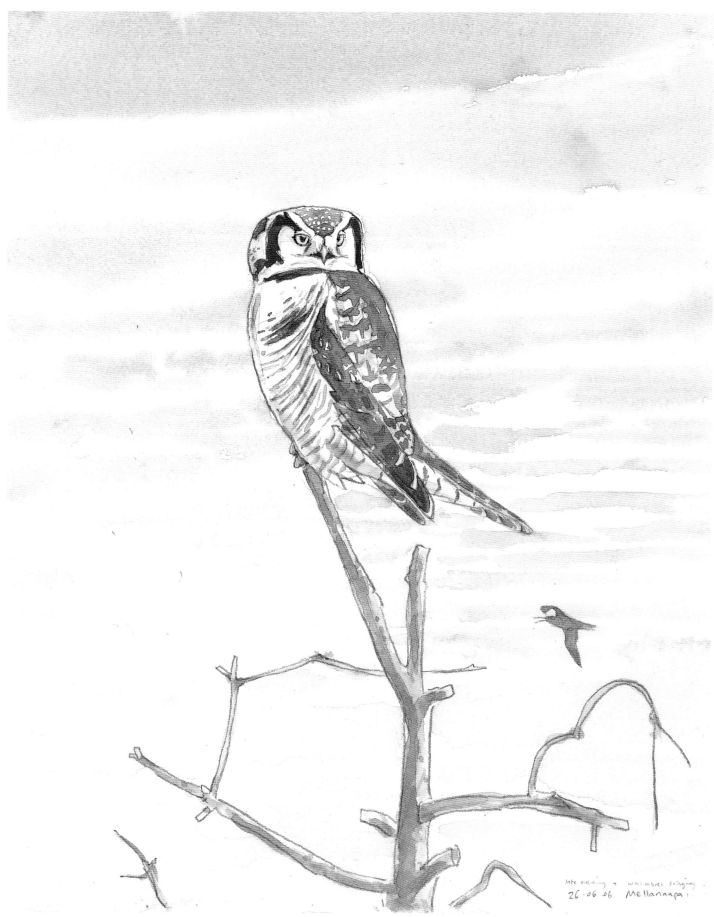

The male hawk owl surveys his hunting territory from the top of an old grey 'kelo'
pine whilst a whimbrel song-flights over its forest-marsh nesting grounds.
Mellanaapa, late evening, 26th May 2006.

In mid-May 2006, I returned to Lapland for a month's drawing and painting. Heikki had moved south but he had arranged for me to stay with some of his equally kind and hospitable friends. Initially I stayed for a few days with Olli, Riitta and Miia Osmonen, a family whom I had met on my first trip in 2000. Olli is a skilled naturalist and we had previously spent several days in the field together. We made a rough plan of what I wanted to do, I borrowed a bicycle from one of his neighbours, Juhani Honkola, a former border-guard who, since his retirement, had developed a keen interest in birds. He and his wife had built an impressive bird feeding station in their garden and had even planted patches of currant bushes for autumn migrants. Now, armed with a bicycle, complete with a rack on the back, I was independent enough to find my way around and plan my own schedules. I was introduced to some more of Heikki's friends and former neighbours, Esko and Annikki Sirjola. They lived at Akujävri, just outside of Ivalo, on the road to Nellim and they very kindly allowed me to live in their lovely, small lakeside cabin for the duration of my stay.

It was essentially a traditional log cabin, close to their home, which Esko had largely built himself and was fully equipped and beautifully finished. Esko and Annikki were both former schoolteachers in Ivalo. They were great company and would just let me get on with my daily routines. Esko was a former biology teacher, a very active person with many interests and skills ranging from birdwatching, ice-hockey and photography to hunting and fishing and was very skilled in the making of both knives and leather goods. I learned many things from him about

outdoor life. From time to time we would take a trip out in his boat on the lake, Akujärvi. We watched arctic terns and the beautiful little gulls with their neat, full-black heads, dark-red bills and bright salmon-pink legs. There were sometimes up to eighty present, skimming the lake's surface or taking part in noisy displays and chases. There were many tufted duck and goldeneye with smaller numbers of smew mixed in. He had a series of fish traps, which we used to check. These often held perch and pike. Esko showed me how to prepare the larger of the catch for smoking. These were gutted, de-gilled and salted; the pike was also filleted. We left them overnight then smoked them in a log oven for three quarters of an hour using alder chips. Fresh from the smoker the perch, in particular, were delicious.

One of the highlights of my stay in this area was its close proximity to a hawk owl's nest. Annikki had found it when out walking with her dog. I was shown the site on my first day. I had been prepared for a long hike through the forest and was wondering how practical the area would be for watching without causing disturbance. We left by bicycle so I guessed it could not be far. After only about ten minutes, we came to an open gravelled area with some small industrial buildings. I imagined that we would leave our bicycles here and begin to walk but I was amazed when Esko pointed to a two-metre high tree stump right beside the track and announced that this was the nest-site. I thought he was joking and had simply found a place to leave our bikes but he was serious, although he was not sure whether the nest was still active. Suddenly the male began warning from a nearby pine,

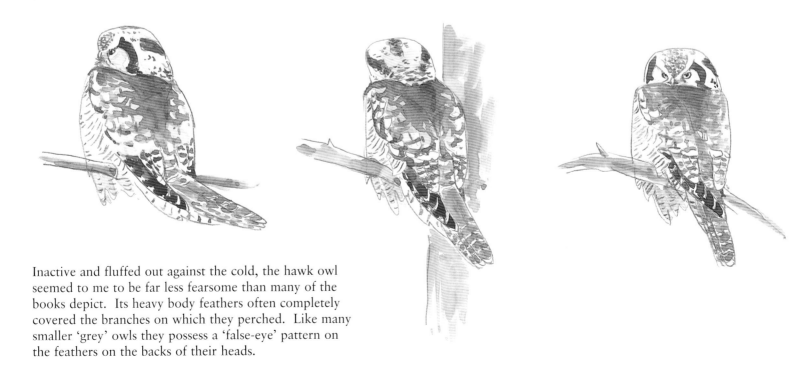

Inactive and fluffed out against the cold, the hawk owl seemed to me to be far less fearsome than many of the books depict. Its heavy body feathers often completely covered the branches on which they perched. Like many smaller 'grey' owls they possess a 'false-eye' pattern on the feathers on the backs of their heads.

confirming that it was still active. I couldn't believe it, my first hawk owl sitting only a few metres away! Esko asked how close I needed to be to make drawings and was relieved when I said I only watch from a distance and didn't need to be anywhere near the nest.

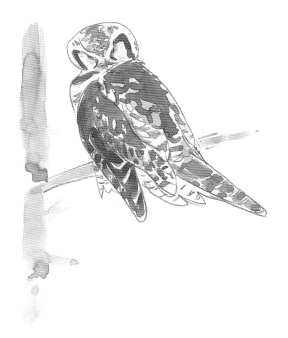

Using a telescope I drew the male on one of his favourite lookout points without causing any disturbance. The male was inactive so the female was obviously still incubating eggs. I was surprised by how different he looked from the pictures I had seen, which were usually of very alert birds. He was often very fluffed up and his eyes half closed. From time to time he would sing to his mate and stretch his head upwards, closing his eyes. He puffed out his throat, ruffling his throat and bill feathers as he called. It was a rather pleasing sound 'woo-woo-woo-woo-woo-woo-woo-woo', tailing off slightly at the end and strangely reminiscent of a slowed down version of the noise children make when playing 'cowboys and indians'.

Sunday 21 May 2006

I stumbled upon the male sitting on a forest track. He had clearly just finished washing or drinking, as his belly feathers were very wet. He allowed close approach as he sat preening. After coughing up a pellet, he flew to another area of pines, showing signs of wing moult with gaps in his wings where the inner primary and secondary feathers should have met. The pellet contained vole remains. Later on I heard him calling closer to the nesting area and caught sight of him flying in with a bird, probably a fieldfare, in his talons. The female began calling nearby and he flew over to her and gave her the plucked prey. He sat above her as she sat tearing off, then eating, pieces of flesh before swallowing the rest whole. She was a fraction bigger than her mate with slightly bolder markings. After eating she flew back to the nest to incubate the eggs, for the young had clearly not yet hatched.

The following day I saw him again. He would hunt over large distances and on his return, feeling there was no danger, called to his mate to come and take the prey.

Tuesday 23 May 2006
Sunny, wind picking up around midday
then becoming cloudy, +16°C.

Hawk owl sightings were particularly good today. I found the male hunting; he was sitting in a 'classic' pose on top of a small pine. He caught a vole and took it to the nesting area for his mate. A pattern in his behaviour had become clear.

He sang as he entered the nesting area. Then he would move closer to the nest, call to his mate, and she would answer him before coming out of the nest to meet him. Having given her the prey, the male would frequently watch over her as she ate.

Later that day, however, she didn't answer as usual, giving only a couple of brief calls in reply to her mate. Eventually the male flew over to the nest and presented her with the prey. He then stood looking down into the hollow trunk for almost a minute and I wondered whether the first young might have hatched.

Wednesday 24 May 2006
Sunny with light winds, rain in the
afternoon and feeling colder.

The male came in with a lizard today and again the female remained sitting on the nest, so he took it to her.

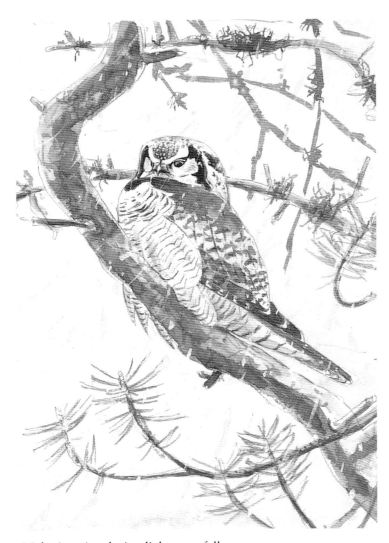

Male, inactive during light snowfall.

Sunday 28 May 2006
Overcast, cold then suddenly warmer, up to 12°C at midday, with sunny spells and light rain showers.

The male was calling from a pine tree near to the nest-site as I cycled by. Having located him I decided to stop to draw and paint him. At one point, a great spotted woodpecker landed below him, each bird simultaneously catching sight of the other and both birds looked startled. The birds sat gazing at one another for almost a full minute before the woodpecker flew off, calling nervously. After a few more minutes the owl also left and I carried on, quickly laying the final washes on the painting I had been making. I was sitting at the base of an old, dead, weathered pine and heard a slight rustle of branches above me. I was concentrating on the painting and thought little of the noise as I too had been 'visited' by the woodpecker and also by a Siberian tit. Suddenly my concentration was interupted by loud shrieks, which made me jump out of my skin. I looked up to see two pairs of bright-yellow eyes glaring at me. They belonged to the hawk owls, the female all puffed up, rattling her wings with the male

above her, holding prey, and both shrieking. Having been deep in concentration, I was totally surprised and instinctively covered my head with my small paint-mixing palette and cowered beneath it. Looking back it was quite amusing; the owls were obviously equally surprised and moved to another pine.

Whilst I was painting, the male came in with prey, called the female off the nest to collect it and she had chosen the very tree under which I was sitting as the place for the male to deliver it to her. I headed back to the cabin to pack my belongings for a spell watching and painting in the bogs and marshes further north.

Olli Osmonen arrived to invite me to eat at his home as Riitta and Miia were heading south to see relatives and, as I was heading north, we might not see each other again during this visit. Olli had found a waxwing's nest which he was keen to show me. He had found it the previous day and had watched the pair collecting feathers for the finishing touches. The nest was only about a mile or so from his house, so we had a quick walk to see it before eating. The nest was in a

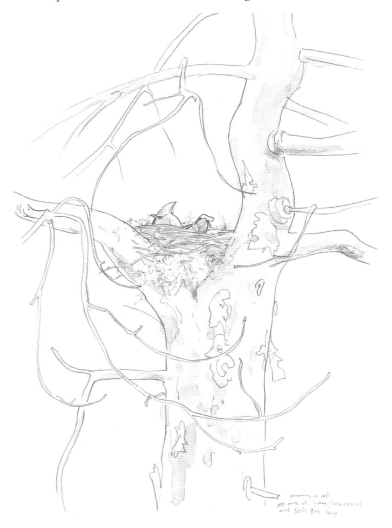

Waxwing on nest. 28th May 2006.

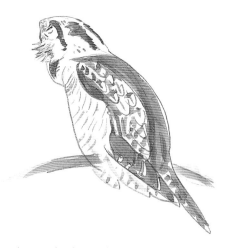

With his head stretched out, his breast expanded and throat feathers ruffled, the male would sing to his mate, who was incubating nearby.

fork in the branches of a small Scots pine only about three metres from the ground. It appeared to be made of lichen and small sticks. One of the pair was perched beside the nest and the other was sitting in the cup keeping a low profile. Until it looked over its shoulder and raised its crest, all that was visible of the sitting bird was its yellow-tipped tail. We watched from a distance and stayed for only a very short while, as we didn't want to disturb it. Nevertheless it was a superb sight and a rare one at that.

There were lots of waxwings in the area, many more than I'd seen on my previous trip. Judging by the single white bar running through the middle of the primary feathers many seemed to be year-old birds. The adults having a more yellow bar and fine white edges to the tip of each primary resulting in a much more elaborate pattern. They frequently have many more small, bright-red 'sealing-wax' type blobs on the ends of their secondary feathers.
After the meal, Olli dropped me off at Melanaapa Bog to draw some ruff lekking. It was already 11pm but it was a great time of day. A stunning male blackcock flew across the marsh, landed in the top of one of the many old, dead spruces and began to call.

Surprisingly there were no ruff at their traditional lek, which seemed a little odd. A jack snipe was 'galloping' high overhead but I was unable to pick him up. Then I noticed the male hawk owl sitting on top of a telegraph pole; maybe this was the reason why there were no ruff to be seen. I made a painting of him before he flew off over the bog, landing briefly on top of a dead spruce before disappearing out of view. It was already past midnight and the sun was still well above the horizon when I decided to walk back. The hawk owl flashed past me once more, heading in the direction of the nest-site, still without prey. I finally climbed into bed at 1.30 am, having had a very long and eventful day.

After my trip further north, I returned to Ivalo on the 8th of June. I was looking forward to seeing the hawk owls once more and wondered how their behaviour would have changed once the eggs had hatched. I learned that the nest had been checked four or five days previously and the young had hatched so I was puzzled when I could not see or even hear the owls in the general area. I visited nearby woods but there were no warning calls nor signs of them anywhere. I started to suspect that something had gone wrong with this year's breeding attempt. I noticed too that many of the rough-legged buzzards, which had shown signs of setting up territories in the local area, had also dispersed. It seemed possible that the vole population had not built up to a sufficiently high level to sustain nesting for these predators. I relayed my fears to Esko. He suggested that I check the actual nest stump, which I did. There were no signs of owls or owlets, just a few stray feathers from the hen bird, moulted during incubation or brooding.

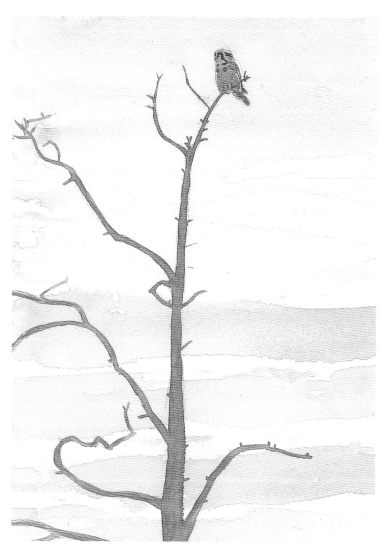

The characteristic shape of a hawk owl perched high on a dead pine.

Like most owls, hawk owls begin to incubate their eggs as they are laid. An egg is laid every two days, so there will be considerable variation between the sizes of the young. In years of poor food supplies or if prey suddenly becomes scarce, the smallest owlets are known to be fed to their older siblings. This may seem an extreme measure but it gives the species the best chance of survival. If food remains scarce the whole brood will inevitably perish.

Bearing in mind the observations of the male bringing in birds and a lizard it is likely that the problem laid with the scarcity of voles. It is also possible that when both parents were away from the nest the young were discovered by a crow and taken. Either way, it was a sad end to my first, and what was to be my last, encounter with these particular hawk owls.

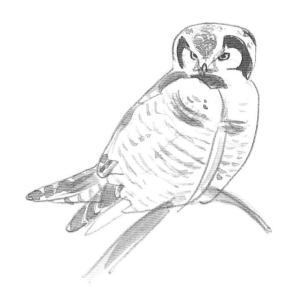

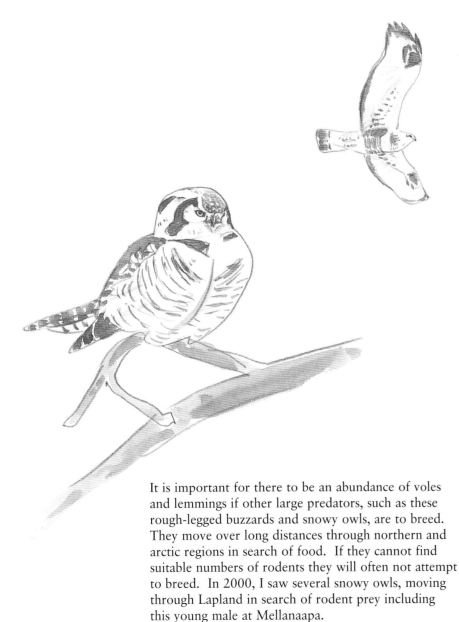

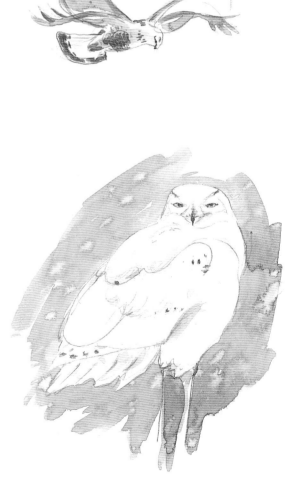

It is important for there to be an abundance of voles and lemmings if other large predators, such as these rough-legged buzzards and snowy owls, are to breed. They move over long distances through northern and arctic regions in search of food. If they cannot find suitable numbers of rodents they will often not attempt to breed. In 2000, I saw several snowy owls, moving through Lapland in search of rodent prey including this young male at Mellanaapa.

Northern Bogs

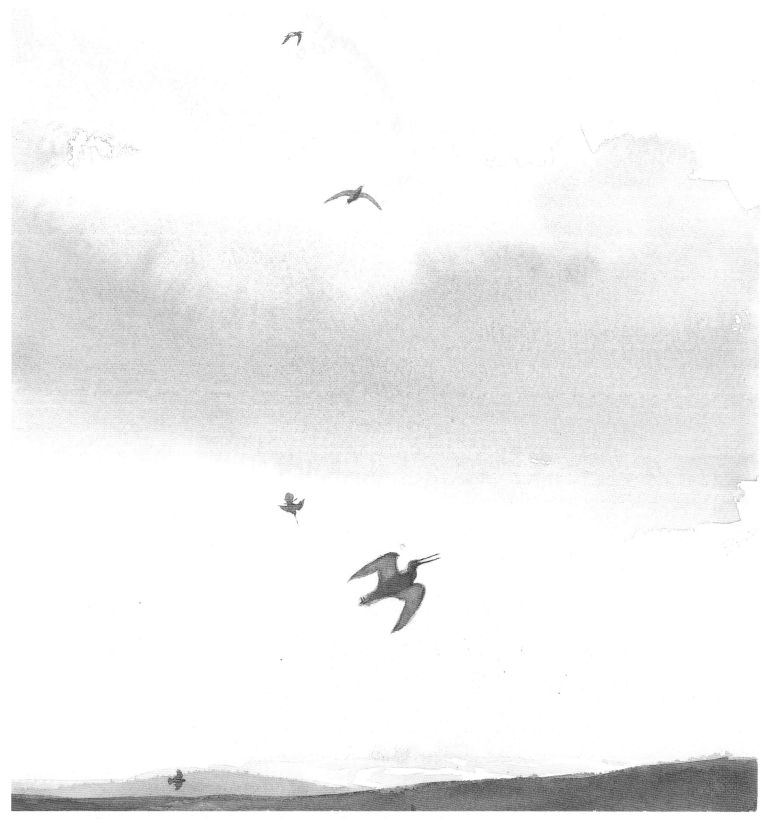

Very occasionally there are magical moments when particular conditions such as temperature, time of day or the arrival of warm air, combine and provide a catalyst for birds to sing and display in unison. I experienced one of these dream-like moments in the middle of Pieran Marin Jänkä in 2000; suddenly in front of me a wood sandpiper began yodelling, a golden plover, sounding its mournful cries, passed overhead on slowed-down wing beats, a snipe was drumming and a male godwit rose up as a Lapland bunting sailed down. But these were not the only sounds I could hear for, in the distance, a jack snipe was singing and the songs and calls of bluethroats, willow warblers and grey-headed wagtails could be heard all around. 1st June 2000.

Close to Petsikko, between Inari and Utsjoki, Heikki, Esko and friends share a small hut on the south-western shores of a lake called Sätytsjärvi. They kindly let me stay there for a week or so both in 2000 and 2006. Part of the attraction of this hut is its close proximity to the vast bog called Pieran Marin Jänkä. The hut is built in an idyllic situation on the shores of the lake amidst a mountain birch forest. The edge of the bog can be reached by a short walk of about a mile through the low birch forests. In the summer the birches are full of bramblings, willow warblers and redwings with smaller numbers of redstarts, arctic and mealy redpolls, willow grouse, cuckoos, meadow pipits and, wherever a small stream trickles through, the beautiful bluethroat.

My first view of Pieran Marin Jänkä, on a bitterly cold overcast day. The marsh was still half-frozen and had a good covering of snow. The only visible sign of life was a lonely long-tailed skua. 25th May 2000.

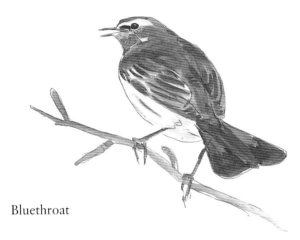

Bluethroat

The bog itself hosts a wonderful array of breeding species. Golden plover and whimbrel favour the higher, drier areas, while wood sandpiper, snipe, jack snipe, ruff, spotted redshank, Temminck's stints, red-necked phalaropes, and bar-tailed godwits nest on the marsh itself. Mallard, teal, pintail, wigeon and bean geese are scattered across the marshes, whilst grey-headed wagtails, bluethroats and Lapland buntings add a touch of colour. The area also holds some of the northern-most nesting cranes in Finland. In years with good numbers of rodents, long-tailed skuas may stay to breed. During the two summers I was there, they arrived, displayed and set up territory but, finding that there were no voles, moved on. Despite this impressive list of breeding species, I found it a moody place, greatly influenced by the weather. It could frequently be overcast, grey and cold and the bog could seem desolate and devoid of life. Yet on sunny days, especially around the midnight hours, the bog and nearby birches were transformed by a wealth of bird-song and displays.

At times like these it was a joy to paint and easy to find a constant stream of subjects. The cold, wet, windy and overcast days could, unfortunately, outweigh the fine ones and could be both physically and mentally taxing, especially when trying to locate and draw birds that were doing their best to keep their heads down.

Tuesday 30 May 2006
Moderate to strong north wind, steady rain +4°C

This was the first time for six years that I had been back to Pieran Marin Jänkä in the summer. Despite the weather it was great to be back there and to revisit many of the corners with which I had become familiar before I headed back to the hut to dry off, to get warm and to eat. That evening at about eight o'clock the rain had eased so I went out again in the hope of getting some drawing done. Eventually the rain stopped completely so I tried stalking some singing redwings and brambling in the birch forests. They were quite tricky to watch in the low, continuous forest so I decided that the best tactic was to find an area with a good vantage point overlooking their territories, and wait. I found a very comfortable seat in the form of a large crowberry clump at the base of a birch tree.

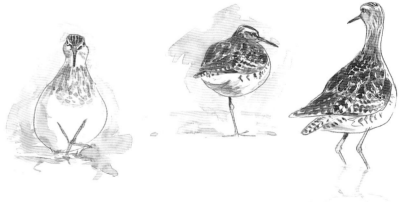

Wood sandpipers

As I waited it began to rain once more. Here, in spite of the rain, it was relatively warm, sheltered from the cold, north wind, and it was nice just lying back in the comfy vegetation watching and listening to willow warblers, bramblings and redwings. Occasionally a bluethroat would throw in a few notes. A noisy group of arctic redpolls was flying around displaying and chasing each other, their plumage looking really pale and frosty against the dark hillsides on the far shore of Sätytsjärvi. Their song sounded very similar to that of the mealy redpoll but was perhaps a fraction slower. The rain was heavier now; low, thick, grey clouds darkened the landscape and the bird-song became much quieter and less frequent. I decided to head back to the hut to get some sleep in the hope of better luck the next day.

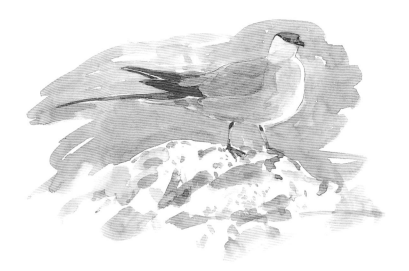

Long-tailed Skua

Thursday 1 June 2006

2°C overcast with drizzle, then clearing up with light showers but still overcast and cold with moderate N. wind.

During persistent wet, cold and overcast weather it is easy for morale to drop. The bog seemed empty and desolate. All the birds were keeping their heads down. Everything I found and stalked stayed only for a few seconds. On my previous summers' visit in 2000 the bog had been teeming with life. Had I come too early this year? Even, Lapland buntings seemed quite scarce. I tried to sketch a male sitting up on a dwarf birch but no sooner had I drawn a few lines than he was off, flying up high, calling, seemingly moving northwards before changing his mind and heading back again, breaking into his gliding song-flight.

His music was a pleasing jangle, which cheered me up. Small groups were regularly moving northwards, drawing attention to themselves by their contact calls, a hard, rattling, 'tric-a-tic' and a lovely clear, ringing, 'teu'. Most were males, which meant that many were not yet on territory yet so maybe I was too early this year.

Willow warblers seemed to be the only bird in good numbers and there were many in the small stands of birches and clumps of stunted willows that broke up the open bog. Clearly some were either males passing through or newly-arrived females since the territorial singing birds would either chase them off or court them. These birds looked very similar to the birds that nest back home in England. None had the pale, washed-out or grey-toned plumage that I had expected of these northern populations. Their song has always been one of my favourite summer bird songs and in the grey, desolate landscape it sounded sweeter than ever.

Suddenly wood sandpipers broke into song and four separate birds were up song-flighting. One bird continued high over the bog and the others settled again as this intruder continued his northward migration. A long-tailed skua, a male judging by his extra-long tail-streamers, was sitting up on a crowberry hummock so I got into a good position to draw it. I began to draw his outline whilst he pecked at a few remaining berries. Suddenly, without warning, he was off far across the marsh; it didn't seem to be my day.

I worked my way through the floating rafts of sedges by keeping to the firmer peat edges and headed towards the palsas to see what the ruff were up to. A palsa is created when permafrost forms an ice-core deep below the peat and, over hundreds of years, these ice-cores swell and grow in size to form peat-covered mounds. The highest one here was around four metres high and formed a focal point above the relatively flat bog and was favoured by the lekking male ruffs. I could see the usual two dark males sleeping on top of the highest palsa, but there were no other males or females in evidence. I decided to make a few drawings but, in the wind, it was difficult to make much sense of the sleeping males' plumage as their elaborate 'ruffs' were constantly being blown about.

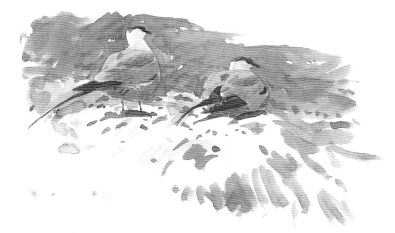

A pair of long-tailed skuas. Some of the males' tail streamers have to be seen to be believed.

High up in the southern sky I could hear the distant, but unmistakeable, 'galloping horse' song of the jack snipe. It was getting rapidly nearer but it was very difficult to pinpoint the sound and locate the bird. This phase of the display-flight sees the bird make an accelerating dive at a forty-degree angle from a great height. This 'galloping' sequence only lasts about ten seconds so it is a great feat to observe it clearly. Suddenly the bird burst into view; it was weaving slightly from side to side, its wings held out stiffly with the primaries sharply angled downwards and its bill pointing at right angles to the horizon.

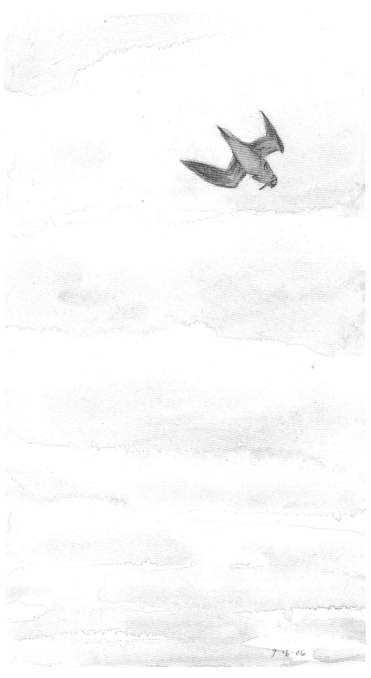

Overhead a jack snipe dives steeply out of the sky. At close range, it is possible to see its cheeks puffed out as he sings his peculiar 'galloping' song.

As it passed overhead, I could clearly see its upper neck distended and puffed out as it produced this peculiar 'galloping' sound. As this phase of the display came to a conclusion, the jack snipe instantly pulled out of its dive and hung in the air with its wings fully outstretched and its tail tightly closed. Strange, gurgling sounds and other peculiar noises, reminiscent of radio interference, could be heard. Then it began to flutter its wings and immediately fanned its short diamond-shaped tail as it scribed a smooth upward curve. It hung motionless once again, before it suddenly fluttered upwards in the same manner as before. This sequence was repeated several times more, covering large distances in the process. Without warning, this pattern was broken by the start of a rapid upward flight and the bird headed off into the distance until it looked like a tiny speck. Having gained considerable height, it broke into a dive once more. I could just make out the 'galloping' sounds as the enigmatic bird disappeared from sight.

Glancing back to the palsas, I saw that a female ruff or reeve had landed on the lek. The two black-plumaged males had been joined by other males and they had begun their bizarre courtship displays to try and win her attention. Within moments, my fortunes that day changed. I quickly made some drawings in an attempt to capture and understand some of the aspects of their behaviour and continued sketching until my hands became numb with cold and the rain began to set in once more.

Just as I decided to head back, a short-eared owl glided past and a broad-billed sandpiper whizzed overhead singing, the first for the season here. I tried to cross an area of open mud and sedges. On my previous spring visit in 2000, I had become used to there being a thick ice-layer beneath the silt that easily took my weight. In 2006 this was not the case and I dropped through up to my knees and was firmly stuck. By remaining calm I was able to free myself. There had been a spell of warm weather in April, which had resulted in an early thaw, and I was forced to find a safer, longer route through, since many of the silty areas had no ice beneath and the open sedges were floating on open water. Relieved to be on firm ground again, I began to walk through drier ground where there were sedges forming large hummocks. A depression in the centre of one caught my eye and revealed a wood sandpiper's nest with three eggs. I felt their temperature with the back of my hand; they were stone cold. This didn't concern me too much since waders delay incubation until a clutch, usually of four, is complete. This delayed incubation helps to ensure that the young all hatch at the same time and can move quickly as a unit to better feeding or away from danger. What was unusual here was that the nest had been left with the eggs exposed, so I wondered if it had been deserted. I pulled sedges over it and decided to check it the following day.

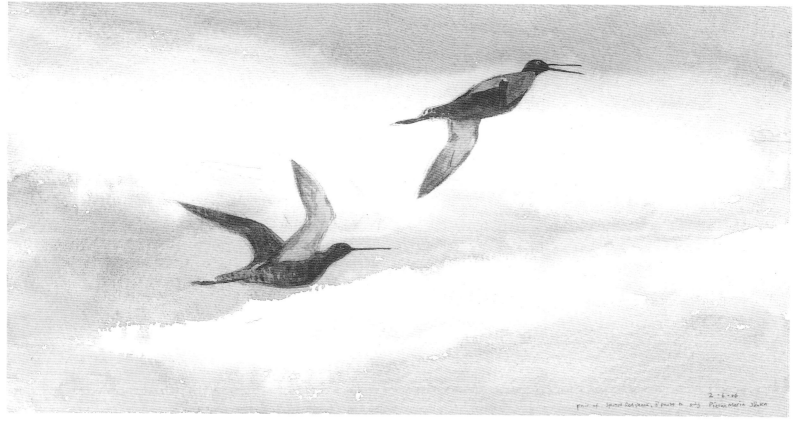

In the low light around midnight, a pair of spotted redshanks passes high over the bog. The male breaks into a glide on downward-angled wings and commences his lovely, almost 'churring', song. Pieran Marin Jänkä, 2nd June 2006.

Having reached higher ground, I began to work my way through the birch scrub towards the cabin. A redwing flipped up from the ground ahead of me and landed in the birches. There was something in the manner of its exit that intrigued me so I went towards the spot from which it had risen and as I did so it gave an anxious warning rattle. There on the ground, placed between two birch trunks, amongst a carpet of crowberries, was its neatly woven nest. A glance inside revealed five, finely speckled eggs. I was surprised how small they looked compared to those of song thrushes and blackbirds. The female's warning calls soon attracted the attention of her mate who, along with several pairs of brambling and mealy redpolls, scolded me as I began to retreat from the immediate area.

The redwing returned quite quickly and, on landing, began to preen nervously. Then she made a sudden swoop low over the nest in order to check that its precious contents were unharmed before she landed and preened once more. In the blink of an eye she dropped down, then sank neatly and swiftly into her nest. Although I had already retreated some distance away I waited for her to shuffle down into the cup; she then looked very comfortable and relaxed. Her mate, along with the mealy redpolls and brambling, felt that everything was back to normal and continued about their business. Only then did I dare to take my drawing book out of my bag and began to make some drawings and quick watercolours.

This region, which is about three hundred kilometres north of the Arctic Circle, is beyond the northern limits of conifer belt so there is not much evergreen cover. The birches here were still in bud yet further south in Ivalo, which I had left four days earlier they were already in leaf. Building nests on the ground may increase the chances of ground predators finding them but this must be a better tactic than building a nest in a bare, open canopy. During the following week I encountered a total of six redwing nests during my walks to and from the cabin. Four were on the ground, of which three were at the bases of birch trunks and one at the base of a juniper bush. The other two were situated in the sparse but evergreen cover of the shrubby junipers, both less than a metre above the ground.

Having finished my sketching, I carefully cleared my things into my bag and before I slipped away, I made a few mental notes of the area, for I hoped to return to make a further painting. It had been another long, but in the end satisfying, day leaving me eagerly awaiting the next. It was already ten o'clock when I finally got back. By the time I'd made coffee, lit the fire, cooked food and written my notes it was past midnight. The cloud had begun to thin and break and, amazingly, it was brighter then, as I climbed into bed, than when I had originally set out at six-thirty the previous morning!

2 June 2006

Despite the fine end to yesterday, this morning the weather was back to cold and grey. I returned to locate the redwing's nest, finding it with surprising ease and was able to make a painting without disturbing the hen bird. It was great watching her through the telescope, sitting deep in her nest. All that was visible was her head and bill at one end and her fully-cocked tail and puffed out undertail-feathers at the other. The warning calls of a group of brambling and willow warblers indicated that they had located a cuckoo further down the slope. Immediately the hen redwing became very alert and anxious and pulled her feathers in tightly. The sound of her mate's warning call caused her to leave the nest unobtrusively and they began to scold together. However, the persistence of the other birds had already pushed the cuckoo out of their territories and the redwing slipped back onto her eggs as quickly and smoothly as she had left them.

Having had a look around the marsh, I checked the wood sandpiper's nest on my way back. I located the exact sedge hummock quite quickly but scanning through binoculars I could see little except sedges. This left me feeling quite content, for this nest had been covered up far more expertly than in my previous, crude but effective attempt. When I looked more carefully I could make out part of a wood sandpiper's spangled back feathering. After repositioning myself slightly, I was able to see the tip of its bill and its beautiful large, dark, pale-rimmed eye staring back at me through the sedges. It was little more than a metre away and sat so tightly that I quickly savoured the moment, then left it in peace.

By then I was tired and hungry, so I headed back to the cabin. Frustratingly, as I arrived back at the cabin the clouds cleared completely and the wind dropped away to nothing. I cooked

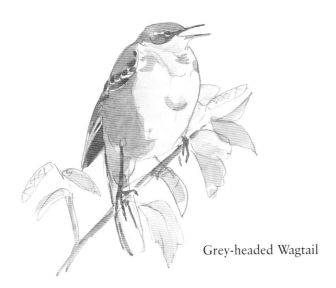

Grey-headed Wagtail

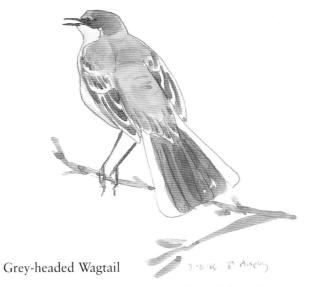

Grey-headed Wagtail

some food, then sat down at the edge of the lake to eat and watched two pairs of black-throated divers with perfect reflections, the only ripples on the water caused by their occasional dives.

3 June 2006

Another wet and windy start followed by cloud and occasional sun in the evening. A definite pattern was developing in the weather, so I began to adapt to it by getting up later and staying out later.

Short-eared owls were much more in evidence this year. Subtle changes in the owls' behaviour proved interesting. I noticed that when hunting, the birds tended to glide with their wings held out-stretched in a higher 'V' than usual. This posture was retained for a fraction longer than in typical gliding flights and the whitish underwing became surprisingly eye-catching. I was treated to my first experience of their wing-clapping display. Initially as a single bird was gliding steadily overhead another owl suddenly appeared, much lower and heading towards me. The upper bird headed off whilst the second bird started to glide downwards. It stalled suddenly and by smacking its wing tips together beneath its body produced a series of five rapid claps before landing nearby. Looking directly into its piercing yellow eyes as it performed this ritual was a brilliant experience. Whether this was an early sign of territorial or courtship display I was not sure.

As it was raining, I spent the rest of the day exploring some of the other areas of the marsh. I saw the northern-most nesting pair of cranes in Finland. Several Temminck's stints were busy displaying and a broad-billed sandpiper flew high overhead at typical high speed until it disappeared from view. I sat for a while watching four moose, one a magnificent male with fantastic, huge, velvet-covered antlers. Then, as the rain eased, I began to sketch the ruff lek on the highest palsa.

I was so engrossed in drawing and painting their displays that I failed to notice that one of the female moose had come very close. The wind was blowing my scent away from her and I had the impression that she may be curious about me. I found it difficult to concentrate, as I wasn't sure how these animals behave. Raising my head from my telescope and sketchbook made her realise what I was and she performed a rapid 'U-turn'. Despite their ungainly appearance and huge bulk, I have always found that moose move with great elegance and beauty.

Before heading back I made a painting of the ruff lek. Having warmed up and eaten a hot meal, I was writing up the day's events when a cuckoo, or 'käki' as they are called in Finland, began calling nearby. Its calling became louder as it moved through the birch forest, stopping at regular intervals. Bramblings are their favourite host-species here. Its next flight took it right up to the cabin and I couldn't believe my eyes

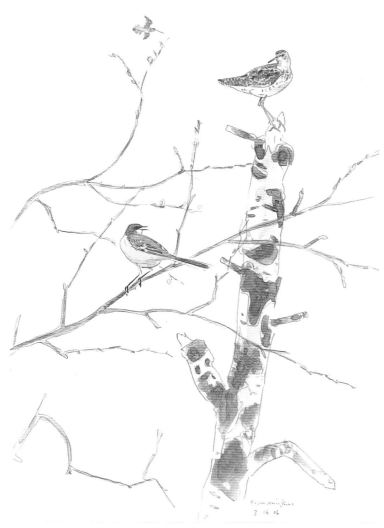

A wood sandpiper, grey-headed wagtail and a drumming snipe. This old, dead lichen-covered birch stump must be a favoured perch for birds; when I looked through my sketchbooks I realised I had painted Temminck's stints singing from this very same perch six years previously. Pieran Marin Jänkä, June 2006.

when it landed right outside the window. With its wings drooped and its tail half-cocked and half-fanned it began calling once more. After calling it would take a slow, careful look around, often with its head slightly on one side, watching with one of its large, yellow-rimmed, hazel eyes and its dark, staring pupil. After a few minutes it was off again, producing a strange, abrupt bubbling call before landing, 'cuckooing' again and carefully watching.

4 June 2006

It was barely two degrees above freezing with low cloud and a north wind blowing which made it feel much colder. I needed a change of routine. Esko had shown me some fishing nets and a small fibreglass boat which I could use, so I decided to try netting for the first time. There were no oars but it was possible to paddle kayak-fashion using a plank of wood I had found in the wood store. Paddling was difficult in the wind, but with a bit of effort it was possible to leave one end of the net anchored to a boulder out in the lake and to move across the wind to a small island where the other end was attached to a small birch. The water was crystal clear so I paddled back to check if the net was set properly. There seemed to be as many holes as there was net but Esko had warned me of this. No doubt there were some fresh ones too, due to my first clumsy efforts, but it was good experience nonetheless. I got back to shore, pulled the boat up and then set off to the marsh. I returned to the cabin around 2 o'clock in the morning and decided to check the nets. To my amazement, up came a beautiful trout, followed by two large grayling and a further trout. I pulled in the net, for there was plenty of fish here to last the rest of my stay and I paddled back to the cabin.

Thrilled with the whole experience I cleared up all the gear, pulled the boat ashore and set about de-scaling the grayling, then gutting all four fish. I salted the two trout and the largest grayling ready for smoking the next day, then fried up the other grayling for supper. The following day I used alder chips to smoke the three remaining fish in a homemade fish smoker made from an old oil drum over a birch log fire. After three quarters of an hour the fish were ready. I ate one of the trout straight away together with some of Esko and Anikki's homegrown potatoes. It was absolutely lovely sitting in the porch listening to willow warblers, redwings and bramblings singing. It was one of those memorable meals, simple and delicious, with the additional satisfaction of having caught and prepared it oneself. This, combined with the atmosphere and beauty of the place, would have been impossible to order from a menu!

On still, warm evenings in the bogs and marshes of northern Lapland, the hours around midnight can be a magical time. Many birds, especially waders, rise up into the air and begin their courtship and territorial songs. Here, a jack snipe, high in the sky, dives through the air on rigid, downward-arched wings. With his bill pointing directly downwards, he produces his strange mechanical song, which does sound remarkably like a galloping horse. Below, is his larger cousin, the common snipe, which is also performing a diving display-flight. His peculiar whirring music is not produced vocally, but by the air flow passing over a pair of tail feathers held taut on either side of its fanned tail.

To complement this medley of sounds, a male Lapland bunting, singing his jangly song, glides downwards in a wide arc. Pieran Marin Jänkä, 6th June 2006.

6 June 2006

The best weather during the last few days had been at around 4 o'clock in the morning so I adjusted my sleeping pattern further and headed off at about 2am. It was very cold and overcast. I sketched and painted bluethroats until 4 o'clock but the weather deteriorated and, as I began to head back at around 7.30am it began to hail; so much for my weather forecasting. I decided that it might be time to head back to Ivalo. However, by the evening, the sky had totally cleared so I decided to stay and see if the weather would hold.

As I headed back to the bog that evening I found the area transformed both in regard to activity and colour. Lapland buntings were passing through once more and several red-necked phalaropes had arrived, with females busily courting males. Grey-headed wagtails were song-flighting and a bean goose was flying around calling. Snipe were drumming and up to three jack snipe were 'galloping'. On my way back, a reeve popped up by my feet, revealing four dark, blotched eggs in a clump of sedges. It was so satisfying to see the marsh full of life once more. That evening I sat out by the lake and ate the last of the fish, together with boiled potatoes. Black-throated divers and red-breasted mergansers were fishing. Some of the drake mergansers were chasing a single duck around and giving loud barking calls. Cuckoos were very much in evidence, 'cuck-ooing', 'bubbling' and making some hysterical 'cackling' noises. Often one bird would call from one side of the lake and another would reply from the other. Occasionally there was a high-speed chase between two birds as they noisily weaved through the birches by the cabin. This was another priceless mealtime.

The fine weather continued right through to the next day. There was an obvious green cast to the birches as many of them responded to the sudden change in temperature and came into leaf. It was a perfect way to spend my last, full day. The temperature reached seventeen degrees and it was the first time the temperature outside the cabin had equalled that inside. The air was full of bird song and the first cloudberry flowers were out. I left the hut at 5 o'clock the next morning to catch the 6.20 bus, moving my bags in two separate trips. A I took my last look across the landscape, sitting by the roadside a cuckoo flashed past with a male bluethroat in pursuit.

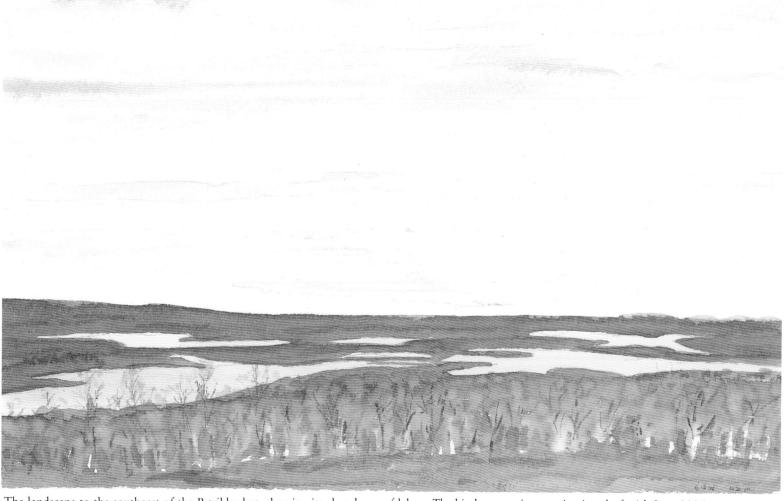

The landscape to the southeast of the Petsikko hut, showing its abundance of lakes. The birches were just coming into leaf. 4th June 2006.

Bramblings

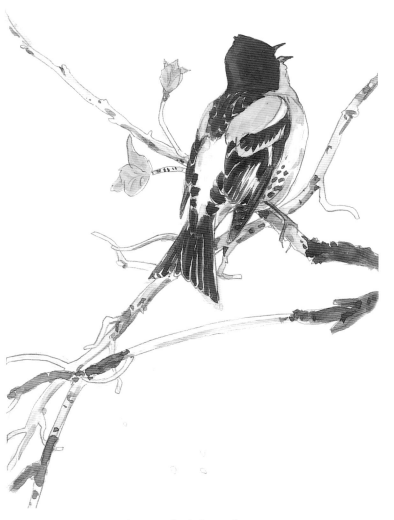

The brambling is the commonest summer visitor to Lapland. Its wheezing song and warning calls can be heard from forests throughout the region. In common with many passerines, males are the first to arrive and are frequently encountered at feeders. As their numbers build, they are found in increasingly large groups, their rich colours forming a stunning patchwork on the snow-covered ground. As the duller females begin to arrive, many males will have already started to set up their nesting territories in nearby forests.

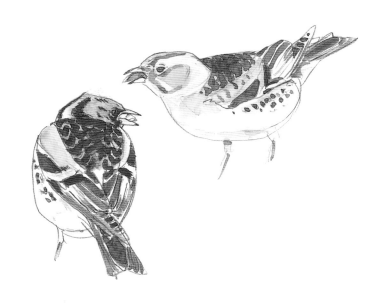

In northern Lapland, I watched the males perform low, fluttering song-flights around their territories. At first he would sit up on a branch, then launch himself into a slight downward glide on gently fluttering wings. Then he would pull out of the glide, rise up and, just as he landed, he would throw back his head and produce his 'wheezing' song. This was repeated continually in a circuit around his territory.

In the same area in early June 2000, I watched hen bramblings gathering material for their nests, as their mates watched over them. I watched one bird repeatedly collecting sheets of a strange, lace-like material, which she wove into her nest together with moss and other vegetation. I collected some. It looked rather like a piece of net curtain and appeared to be some kind of fungus that grew under the snow layer. Whatever it was, it certainly proved an attractive nest-building material for this particular hen.

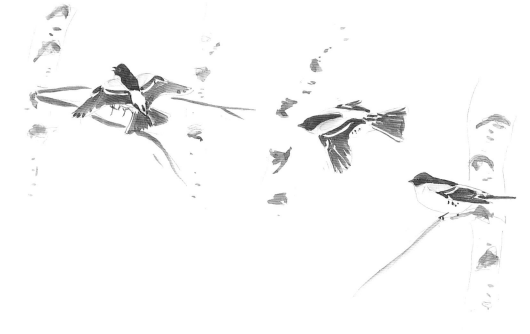

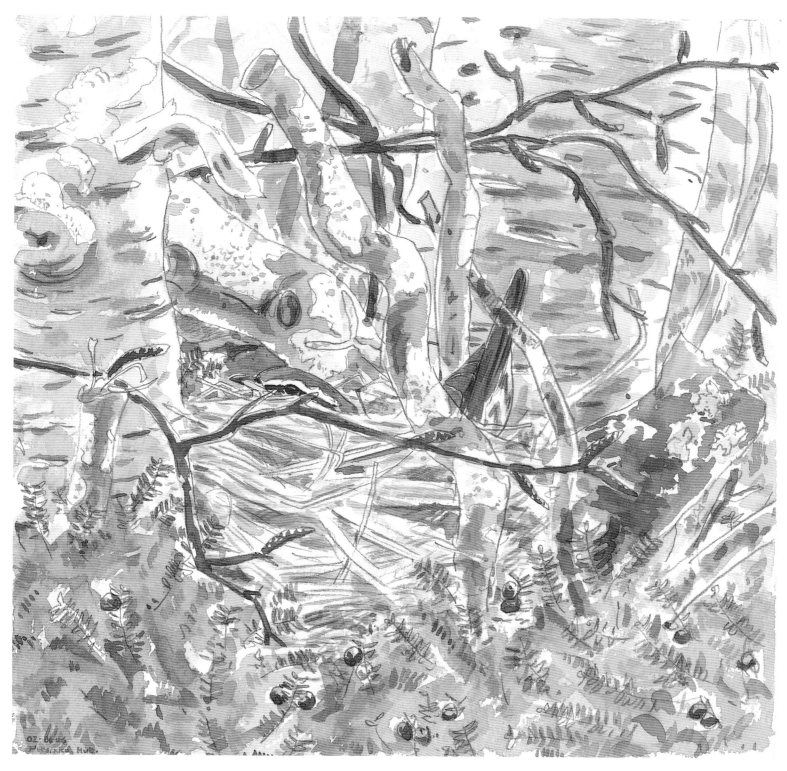

A female redwing incubates her clutch of five eggs, in her
nest constructed between two birch trunks and surrounded
by crowberries. Petsikko, 2nd June 2006.

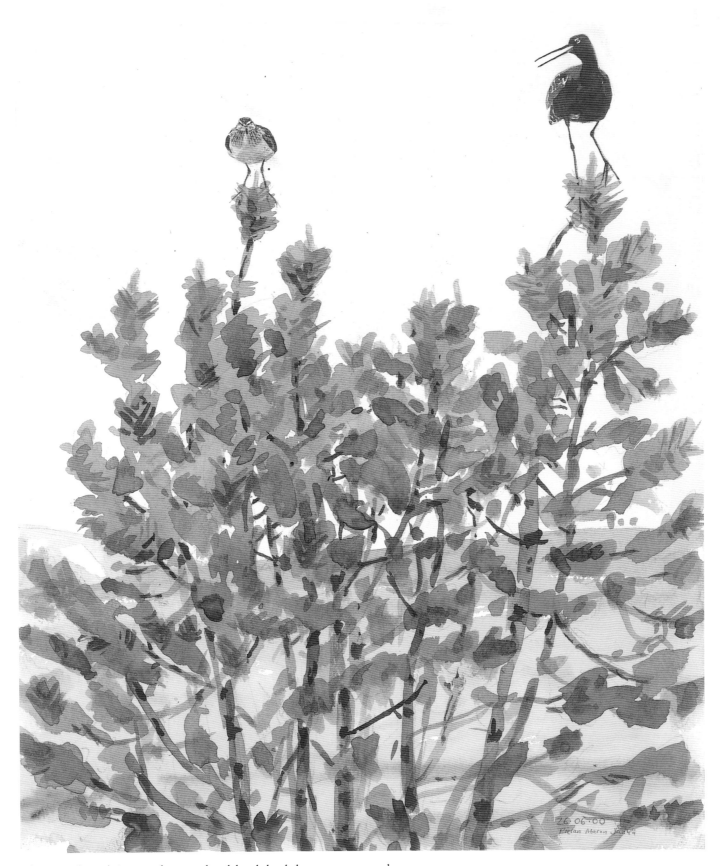

This wood sandpiper and spotted redshank both have young nearby
and sit up on a lone pine to warn them of my approach. When I
went too close to its young, the spotted redshank would try to drive
me away by launching low, horizontal, high-speed attacks at my head.
It only pulled out at the last moment giving piercing 'chu-wick' calls
as it whisked past. 26th June 2000.

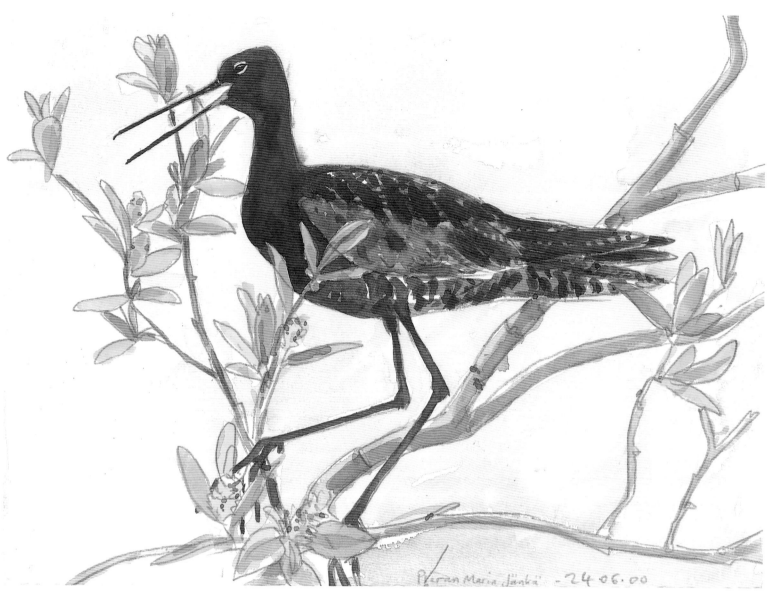

A male spotted redshank perches high up in the
willows and warns his young of my approach.
Having laid a clutch of eggs, the female usually
departs from the nesting grounds after a couple
of weeks, leaving the male to incubate the eggs
and rear the young alone. She will probably
never see her young, and by the end of June,
females are regularly seen on English marshes.
Pieran Marin Jänkä, 24th June 2000.

The Bell-Bird

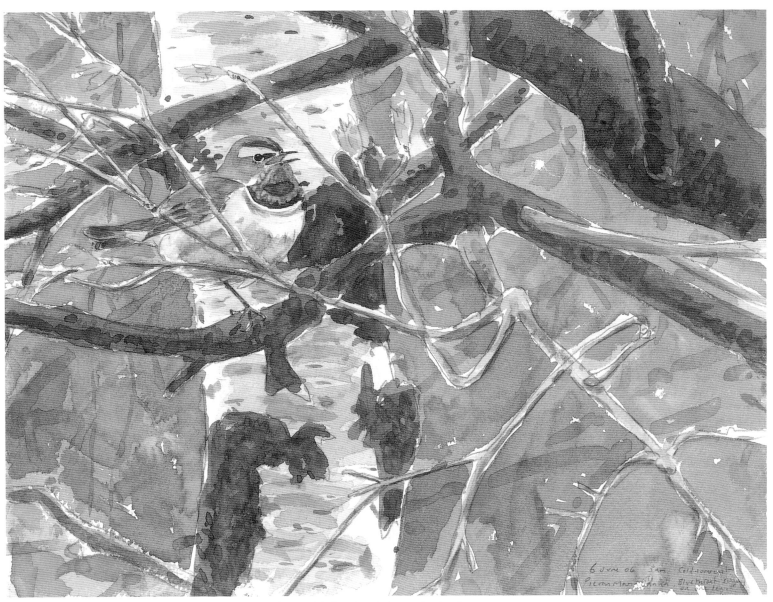

A bluethroat singing at 3am. It was overcast and so cold that it tried to win the favour of a female while sitting all fluffed-up on one leg. Pieran Marin Jänkä, 6th June 2006.

Bell-bird is the name given to the bluethroat in the North due to clear, bell-like phrases of its song. The red-spotted race nests throughout northern Fenno-Scandia eastwards through northern Russia and Siberia, with a small population even nesting in northwestern Alaska.

In northern Lapland, they favour birch forests and patches of willow scrub close to flowing water. The male's song is as outstanding as his plumage is beautiful. It is a rich and complex medley of notes and phrases, which includes excellent mimicry. As well as the bell-like sounds, nightingale-like notes and frequently repeated phrases are characteristic. There is also often a lovely, liquid, trickling sequence that sounds like bubbles bursting and this is often remarkably reminiscent of the small trickling streams close to which they favour nesting.

I kept a list of the species mimicked by one particular male which I sketched in 2000. He incorporated excellent imitations of many of the birds nesting in the immediate area. These included bramblings, redwings, redstarts, wood sandpipers and Lapland buntings, as well as birds recorded on migration through Lapland such as Siberian tits, little gulls, sedge warblers, yellowhammers, great tits and common sandpipers.

The male's exciting song-flight weaves an erratic path.

There were also species found much further south, no doubt encountered on its wintering grounds and migration stop-offs. These included corn bunting and quail together with non-bird sounds such as frogs and crickets. One really remarkable sequence was a perfect rendering of not one, but a pair, of arctic terns performing their courtship-flight. However, the sequence, which really stopped me in my tracks, was that of the noise of an old-fashioned diesel engine starting up. As I was walking along a track, seemingly in the middle of nowhere I suddenly heard an 'engine' start up. The noise really made me jump and I looked around for people before realising that it was in fact the bluethroat.

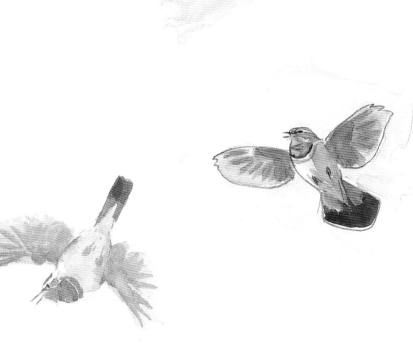

When it sings it often ruffles its throat feathers and the red-throat patch increases in size and appears to shimmer. When displaying the males regularly raise their heads and a larger area of red becomes visible. They also readily fan and flirt their tails revealing bright rusty-red patches at the base of each side. As if this wasn't enough, they also perform a song-flight, which involves flying up into the air, twisting and turning with wings and tail often held fully-spread. They then dance erratically in the air for a few moments before making a weaving glide down.

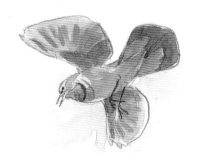

A male raises his wings and fans his tail in display as he sings before his mate who is half-hidden in the streamside thickets. Pieran Marin Jänkä, June 2000.

Ruffs

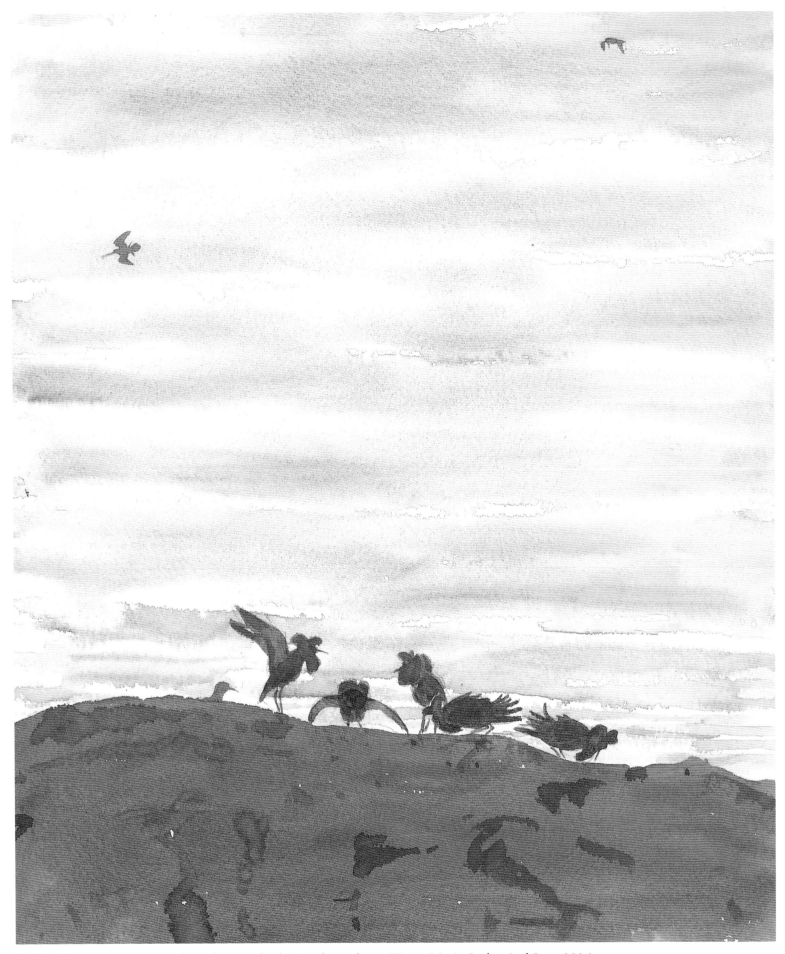

Ruff lekking, with a snipe and a jack snipe displaying above them. Pieran Marin Jänkä, 2nd June 2006

In the world of birds there are few spectacles stranger than the lekking displays of ruffs. These birds use traditional display grounds or leks where the males gather to attract females. The arrival of a female or reeve initiates much strange posturing, sudden jumps and wing-flapping on the part of the males. Each male vigorously defends his own patch. Strangely, however, the males with white ruffs are able to wander freely and unmolested around the lek. The reeves, once mated, are solely responsible for nesting and raising the young. They may either nest in the surrounding area or disperse much further afield.

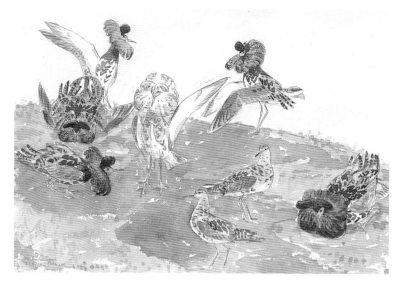

Whilst waiting for new reeves to arrive, the males will either sleep on the lek or feed nearby. As soon as the last of the reeves has arrived, the ruffs, feeling that their summer tasks are complete, rapidly disperse towards their wintering areas and immediately begin to moult their elaborate feathered collars and ear-tufts.

I spent a lot of time sketching them in northern Lapland during mid-May and early June 2006. In July, after my return to England, I visited Cley bird reserve and found many moulting ruffs. I was thrilled to learn that one of the colour-ringed birds there had been seen at a lek in Ekkerøy on the shores of Varanger Fjord, an area I had visited earlier. I felt an affinity with this bird, having visited its brief summer home and witnessed some of the species bizarre behaviour.

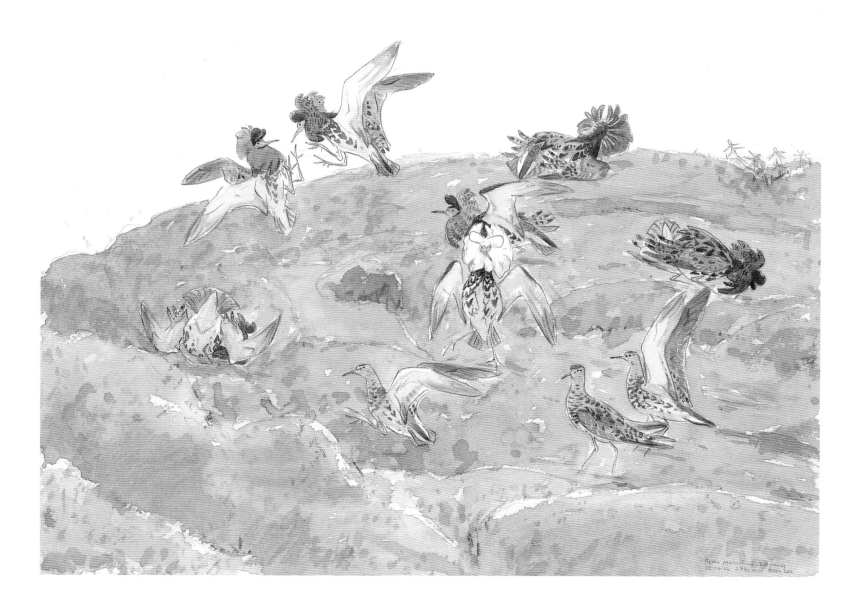

A Red Fox Earth

Some of the cubs dozing in the late evening sunshine. The mosquitoes made drawing hard work for me but they didn't seem to worry the cubs. 11th June 2006.

I wandered home wearily in the low June sun of a Lapland summer 'night'. I was daydreaming, or at least not fully concentrating, and was startled by a loud 'yap' quickly followed by short 'snapping' sounds. The quick movements of a tight group of small animals took me by surprise. As their grey-brown backs and longish tails disappeared into a gap between a cluster of large boulders they reminded me of a pack of mongooses. The wind was blowing my scent directly away from them so I was hopeful that the litter of fox cubs would come back out again.

The cubs being inquisitive were back out within a couple of minutes. They peeped out nervously from the gap between the boulders. The bigger and bolder cubs appeared first, and looked around cautiously before venturing a little further. The rest of the cubs then appeared behind. A nervous bark from one of them would send them all scuttling back in again. Eventually they became much bolder and began to wander around and play. They were young and naïve and not yet fully aware of the potential danger posed by man.

Curled up sleeping.

By sitting still and quietly I could watch them behaving freely. It seemed that what the majority of the seven cubs most wanted to do was to doze in the low rays of the midnight sun in an arch of boulders, which sheltered them from the cold wind. I, however, was grateful for the cold wind, as it kept the mosquitoes at bay. Large numbers had hatched during the previous two days. I stayed with the cubs for an hour or so until a bank of low cloud in the northwestern sky obscured the sun. It suddenly became darker and colder and the cubs disappeared underground.

Cubs watching the same mosquito. Occasionally they would snap at one. 10th June 2006.

I returned to draw them on each of the following two nights. They were great fun and it was interesting to watch them play-fighting and tumbling around, or sleeping out in the open in a tight group. At other times they could be seen making high leaping pounces, very similar to the tactics I'd seen adults using when hunting voles. On other occasions they seemed happy to stretch, scratch and groom. During my later visits the weather became hot and balmy and the wind dropped. It was then more uncomfortable sitting out watching, as I had to have my hood pulled up and my hat pulled down in order to stop mosquitoes from biting. I was, however, able to make quite a few reasonable drawings but was frustrated one evening to find that the sketchbook pages had come loose and, during my walk back all the pencil marks had smudged to a grey mess.

I had only seen one adult fox in the general area; it was a large bushy-tailed individual, probably a dog fox. On my very last visit the vixen either caught sight of, or could smell me as I sat close to the earth. She gave continuous, high, hoarse barks from a nearby forest marsh; the first of these sent the young scuttling underground and I decided that it was now the time to let them get on with their lives.

Varanger Fjord

My introduction to Varanger Fjord came on the 19th May 2000. The day turned out to be exceptional for both birds and weather. The temperature rose to an unseasonable 15°C and there wasn't a breath of wind. Heikki had to attend a meeting in the north and asked if I would like to visit Varanger Fjord in the far north-east of Norway. I was so happy just to be experiencing northern Lapland and had not realised that it might be possible to visit Varanger and I certainly didn't realise just how special a place it is. We travelled up the day before his meeting and stayed overnight in Utsjoki police station but only as guests! In the morning I was dropped off at Nesseby while Heikki headed off to his meeting.

On the way we saw the first swallow of the year. Nesseby is a beautiful place; its church is situated just outside the village on a small peninsular that juts out into the fjord. Here there were large, old, wooden fish-drying structures, which resembled the timber rafters of a tall, steep-roofed house. The scenery was stunning and the place had a lovely atmosphere, particularly in the calm weather and warm sun. The birdlife was fantastic and the following notebook entries help to give an idea of the fantastic birdlife there.

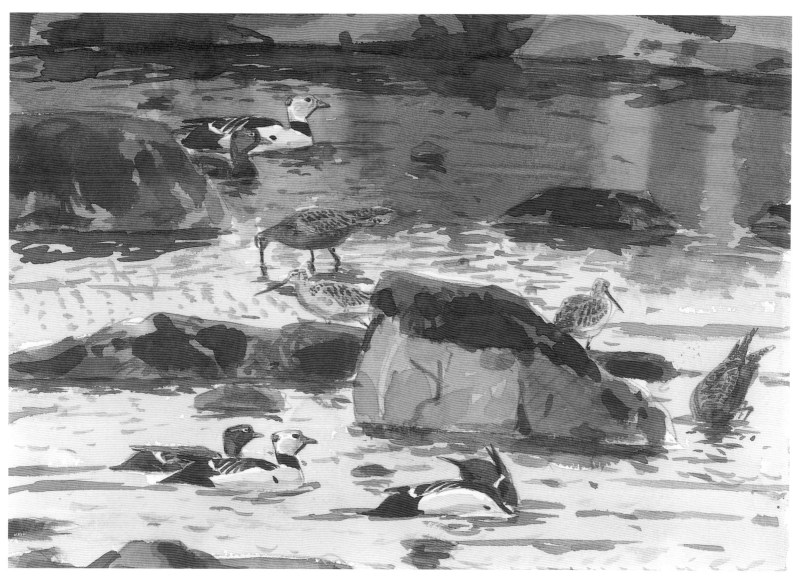

My first ever taste of Varanger Fjord. Here, on a beautiful still warm day, Steller's eiders and bar-tailed godwits gather to feed in the shallows. Nesseby, 19th May 2000.

Steller's Eider	*400, good mixture of drakes and ducks and immatures of various ages.*
Common Eider	*600, twice as big at least as the Steller's and great to hear their 'cooing' calls for the first time.*
King Eider	*3, immature drakes.*
Black-throated Diver	*dozen, beautiful birds some briefly giving far carrying, mournful calls.*
Red-throated Diver	*similar numbers, also flying calling, rather harsh, Canada goose type calls.*
Fulmar	*30, several were very dark 'blue' birds. Very smart-looking, dark lead-coloured with an obvious pale skua-like flash on their primaries.*
Long-tailed duck	*hundreds, often flying around in huge groups. Drakes chasing ducks in groups of up to 30, calling continuously 'ow-orlie….ow-orlie…etc'. The Finnish name 'alli' is onomatopoeic, from the second part of the call.*
Velvet Scoter	*75*
White-tailed Eagle	*fantastic views of an immature overhead, scaring all three eider species.*
Rough-legged Buzzard	*2*
Puffin	*small numbers*
Black Guillemot	*several first summer birds.*
Arctic Tern	*hundreds*
Kittiwake	*250*
Arctic Skua	*8, all dark phase birds.*
Long-tailed Skua	*6, all adults. Fantastic views picking food items off the surface of the water in typical stalling fashion.*
Bar-tailed Godwit	*250, mostly in pairs. Lots of males singing and trying to mate with females by walking up to them with rapidly beating wings, their white underwings contrasting with their deep chestnut bellies. As the tide dropped they began to feed on the shore, often upending in the water. Lots of Steller's Eiders feeding with them in the shallows; this was a very beautiful and unique sight for Europe.*
Common Sandpiper	*1*
Dunlin	*20*
Oystercatchers	*common*
Shelduck	*3 pairs*
Shorelark	*1 landed on the peninsular.*
Lapland Buntings	*regularly migrating northwards.*
Porpoise	*around 20 in groups of up to 7. Often lying motionless in shallow water with the tops of their heads and all of their backs above the water as the tide flowed back into the fjord.*

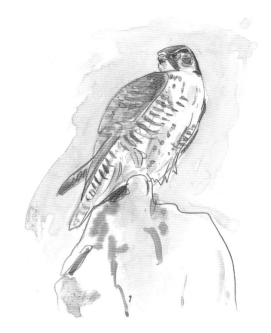

Gyr falcon; Fenno-Scandian birds are slate-grey and reminiscent of peregrines.

On our way back to the border we saw a gyr falcon. I was surprised to see how dark these Scandinavian birds are, being lead-grey above with more obvious head and moustachal markings. Just over the Finnish border, we came across a golden eagle sitting on a roadside telegraph pole, a stunning looking bird, about 4 years old and showing signs of maturity. It flew over the car, then landed on another pole before heading off over the snow and low birches. It landed on top of a small birch, completely bending the top over so that the highest branches now pointed to the ground.

The next time I returned to Varanger was at the end of June 2000. My two-month stay in Lapland looked to be coming to an end. Heikki and his family were due to head for their summer holidays with their family in southern Finland. Although they said that I was welcome to stay in their house, I was finding drawing quite difficult following the midsummer hatch of mosquitoes. Heikki suggested taking a tent and travelling by bus up to Varanger, as there would be little trouble from mosquitoes on the coast.

On the first of July, I hopped off the bus at Nesseby. It was great to be back and to see the coast once more. I set up my tent on the tip of the peninsular, on a secluded rock platform above the high-tide mark. It was sunny and calm, but the wind began to pick up from the north-north-east and blew quite hard until late that evening when it dropped again. The landscape had been transformed since my earlier visit; all the ice and snow had gone. There were still about 250 Steller's eiders present, although almost all of these were year-old birds, with only one or two adult drakes. The majority of adult birds had gone to the Russian and Siberian Arctic coasts to breed. The common eiders were still there and it was

fantastic watching the ducks feeding in groups in sheltered bays with their young gathered together in crèches. The males took no part in this and were to be found further out, in larger rafts, idling and preening, many showing signs of their moult into their all-dark eclipse plumage. From time to time a great black-backed gull would hang in the wind above a crèche of ducklings and attempt to snatch one. The females would gather tightly around the ducklings and by using their webbed feet would launch themselves almost out of the water at the marauders. Small numbers of bar-tailed godwits, dunlin, ringed plover and a single curlew were picking around the shore and half a dozen female red-necked phalaropes were out on the open water.

I had some food outside the tent whilst watching small numbers of long-tailed ducks, goosanders and velvet scoters. There were a few puffins and a single black guillemot diving for fish. A long-tailed skua flew northwards and a dozen of the larger arctic skuas were patrolling over the water close to some large parties of fishing arctic terns. Whilst I watched them diving I noticed several short, backward-curving fins of porpoises cutting through the waves. At one point I noticed a very unusual visitor in the form of a Sabine's gull. Its striking black, white and grey wing markings and dark-slate hood showed up well against the dark water.

I stayed there for another day before catching a bus to Vadsø further along the coast. On arrival, my first task was to find a suitable place to set up my tent. I needed to get out of town, but not too far, as my pack weighed over forty kilograms. I decided to cross the small road-bridge that led to the small island of Vadsøya. This was the original location of the settlement and from there it was possible to see the present-day town of Vadsø. I liked Vadsø very much; a compact town of around six thousand people. Typically many of the houses were painted in a variety of colours and the town was well equipped with shops and a school. It has an active fishing port and processing plant and its own small airport.

I set up my tent out of the way between stunted willows. There was plenty to interest me there. One of the highlights was a group of nearly eighty red-necked phalaropes feeding together

Eiders trying to protect their young from marauding great black-backed gulls. Nesseby, 1st July 2007.

on a small pool. These were all brightly-coloured females who had laid clutches of eggs for their duller-plumaged mates and then left them to hatch and rear the young alone. Temminck's stints were also quite widespread and were surprisingly tame, sitting on their clutches of four eggs. A female ruff flew from beside a tiny willow, where I saw three beautifully patterned youngsters. They had only been hatched a day or so and possessed the longest legs and feet of any wader chick I had ever seen.

On a small pool, a duck wigeon did her best to hide her ducklings in thick sedges. Red-throated pipits often perched up on the lines of fences used to catch the winter's snow and prevent it from drifting over the houses. Here they would sit, often with a bill-full of craneflies, and call to their young, hiding below in a mat of creeping willow, to tell them to sit still and be quiet until I had passed. Occasionally one would launch itself into a typical pipit display-flight, flying up in the air to glide downwards singing, its wings held open in a shallow 'V'.

I spent the following day painting and in the afternoon I decided to telephone a local birdwatcher, Håkon Heggland, whose name Heikki had given me as being a good contact. Håkon was a young schoolteacher with excellent English. He collected all the records of the birds in the area and was keen to gather any notes that I had, he was most interested in the Sabine's gull sighting. We met near to the road-bridge and clearly had much to talk about, so he invited me to supper with his wife Grethe and their baby girl Alma. I had a very nice evening and enjoyed their company. Håkon drove me back to the island and told me to collect my things, as they would like me to stay with them. I was quite happy in the tent but he wouldn't take "No" for an answer. I stayed with them for

First year Steller's eider.

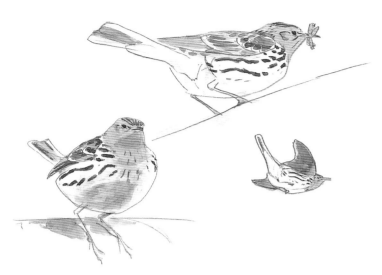

Red-throated pipit

three nights and this gave me the unexpected opportunity of being able to explore more of the coastline. After breakfast Håkon would drop me off somewhere by car and arrange to pick me up again after he had finished school. It was interesting hearing about life there and they both had a very good sense of humour. In addition, Grethe always prepared delicious food.

I was able to visit the huge, fantastic kittiwake colony at Ekkerøy. I also saw my first turnstones with young here and arctic skuas and terns nested in abundance on the shores and coastal fells. Håkon showed me a place where a group of eiders gathered. There, amongst small rafts of ducks and ducklings, or with loafing groups of moulting drakes, small numbers of both Steller's and king eiders were also to be seen. These were non-breeding birds and it was interesting to note all the variations in plumage, bill shapes and colours between the ages and sexes. On the journey, back Håkon stopped the car; his sharp eyes had spotted a large diver out in the fjord. It was a magnificent year-old white-billed diver. On another day, I visited the large glaciated valley and fells near Krampenes which had nesting bar-tailed godwits, long-tailed skuas, dunlin, shorelark, Lapland buntings, phalaropes and wood sandpipers in the valley and ptarmigan, whimbrel, golden plover and golden eagles up on the fells.

The following day I said goodbye to the Heggland family and headed on to Vardø, the next large settlement. Vardø is in fact an island joined to the mainland by an underwater road-tunnel. I got off the bus at the harbour, there were many species of auk from the nearby nesting island of Hornøya. In amongst them was, the Brünnich's guillemot a new species for me. To me these seemed to have a shape and structure distinct from their slightly larger relative the common guillemot. In some ways they seemed almost like black guillemots in shape. They certainly had a 'look' about them that meant I didn't need to strain my eyes in order to pick out the characteristic white marking on their gapes before I knew I was watching one.

There were many gulls around the quay. They were largely immatures with their plumages very worn and many were very pale and bleached due to the twenty-four hour sunlight. A young glaucous gull stood out from the rest, not because it was any paler but because of its large size and heavy, dark-tipped bill.

Vardø proved to be a good place for exploring. One day I took the supply boat to Båtsfjord and back in the hope of seeing belugas, but was unsuccessful. The following day I took a trip across to the island of Hornøya but, as we landed, thick fog engulfed the island. During the four-hour stay, the fog only cleared occasionally, enough to see the nesting cliffs of Brünnich's guillemots. The next day a northerly gale blew up and it rained so hard that I didn't leave the tent. This highly changeable weather is very much part of life at the most north-easterly point of Europe, surrounded by the Barents Sea.

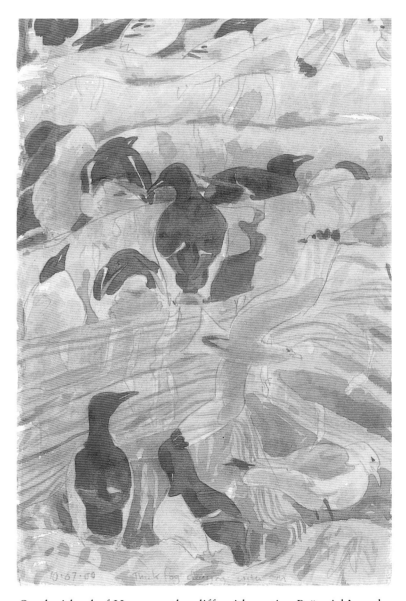

On the island of Hornøya, the cliffs with nesting Brünnich's and common guillemots and kittiwakes, continually appeared and disappeared out of the fog. 10th July 2000.

I awoke the next morning to calm seas and sunshine and began to take down the tent and pack my bags, for this was the last night I'd spend at Varanger that summer. I was going to take the ferry to its final destination, Kirkenes. It was to leave at five in the morning so I had to hurry down to the quay to catch it. Its next stop was Vadsø, which I'd have the chance to see once more but this time from the fjord, before sailing on to Kirkenes. This was also my last hope of seeing belugas. As we left Vardø behind, I scanned purposefully from the bow. All the other passengers were sleeping in their cabins so I had the deck to myself. The wind had picked up a bit and the sea had become a little choppy. Every time I saw a white wave I would check it. I was starting to feel a little tired but was trying hard to maintain my concentration. I wasn't feeling very optimistic but, suddenly, in the distance, several white blobs appeared briefly. They seemed too white and solid to be wave crests, and my heart missed a beat. I didn't want to get too excited but suddenly a beluga surfaced, then two, then three; there were lots, a widely spaced group of over thirty. Many were spouting as they surfaced. They were moving diagonally across the fjord and it looked as if our paths would cross. I had some terrific views of them surfacing, sometimes seven or eight at a time. One surfaced right below me. The water was so clear that, as it dived, I could still see it amazingly well. Even its eye and 'smiling' mouth could clearly be seen before its milky-white form dived out of sight. I looked around for people to call over but everyone else was still asleep in their cabins. I could not imagine a better ending to my first trip to Lapland and Varanger Fjord.

The next time I was in Varanger was in January 2001. My girlfriend, Natasha, and I had gone to Lapland to stay with Heikki and Sinikka and to see the Northern Lights. We had stayed in the Petsikko hut for a couple of nights to be away from artificial light and watch the aurora from the frozen snow-covered lake and then carried on to the fjord. It was fabulous to see all the sea-duck in the midwinter landscape. We walked around the island of Vadsøya. We startled a pure-white arctic hare and it disappeared over the snow. At the eastern end of the island, rising out of the snow, was what I had assumed to be a thick post. Only when we were right on top of it, did I realise what it was. The 'top of the post' moved to reveal a huge hooked bill and the young white-tailed eagle launched itself into the air with powerful down-strokes. Close to, and against the snow, it looked even bigger than its two-metre wingspan as it laboured across to the mainland. We went to examine the place where it had been standing and found some perfectly formed talon prints in the snow. They measured seventeen centimetres at the longest point, not including the sharp claws.

Belugas seen from the ferry between Vardø and Kirkenes.
12th July 2000.

We went on to Vardø. There were over thirty adult glaucous gulls sitting with the herring and black-backed gulls but they disappeared from sight whenever a blizzard came through. We stood out on the beach in fading light looking towards the offshore islands, which include the seabird cliffs of Hornøya. There was a very heavy swell in the Barents Sea and the water was a very dark blue-grey. The wind was blowing hard from the north. The influence of the Gulf Stream kept the temperature up to -5°C but, facing the wind, it felt much colder; it certainly seemed a very wild and beautiful place. We drove back towards Vadsø through many blizzards but the wind kept the ice-covered roads free of snow. I telephoned Håkon to say hello and we had supper with him, Grethe and Alma. It was good to see them again. Håkon said that January wasn't the best time to visit Varanger, as there wasn't much light and he suggested that I should consider returning in March, when there would be more light and the temperatures warmer. He also pointed out that they were planning to move back to southern Norway the following year and, after that, visiting Varanger to paint sea-duck would become a difficult and expensive option. Having now experienced all the sea-duck in the winter landscape, I began to make plans for my return.

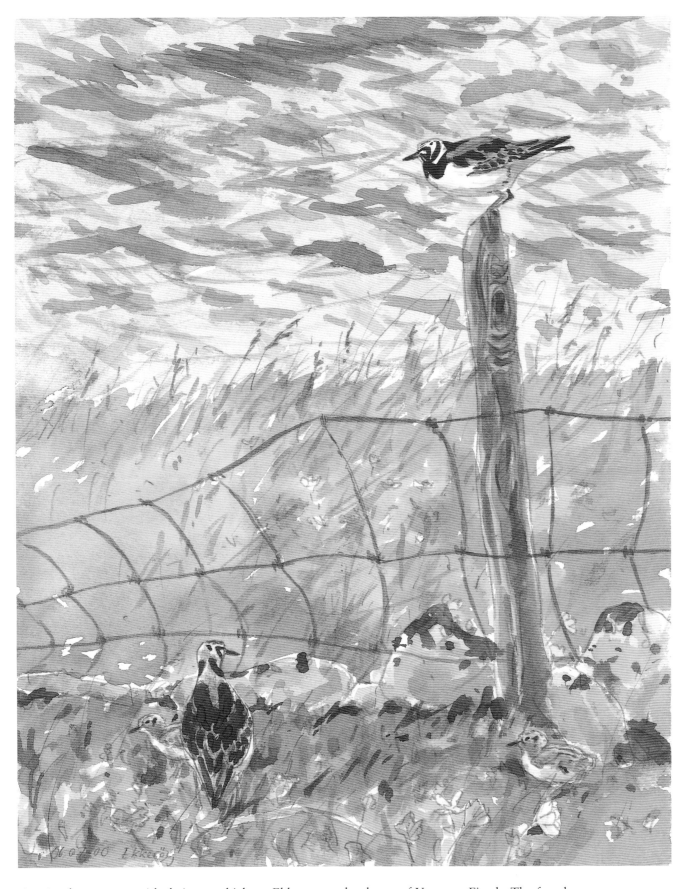

A pair of turnstones with their two chicks at Ekkerøy on the shores of Varanger Fjord. The female looked after them, as the male kept guard from fence posts and nearby rocks.

Many arctic skuas were nesting nearby and the pair readily flew up to drive them away, frequently attacking the skuas from underneath. When I first approached the young I realised what good parents they can be. The male noisily flew at me, landed on my chest and began to peck me. 6th July 2000.

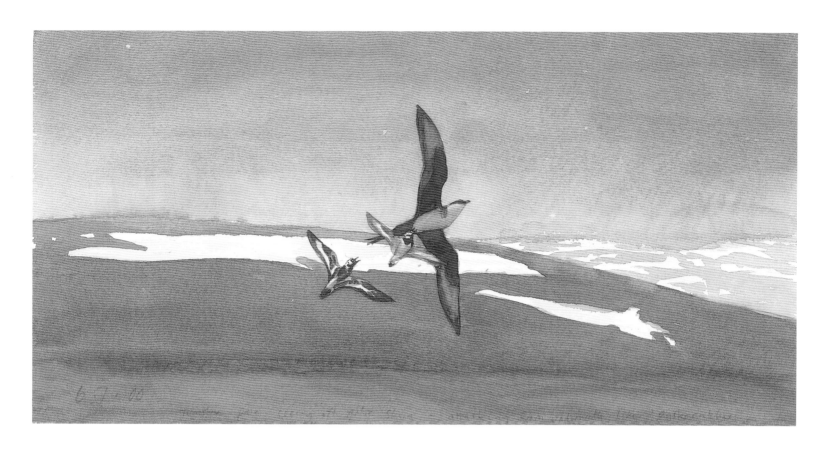

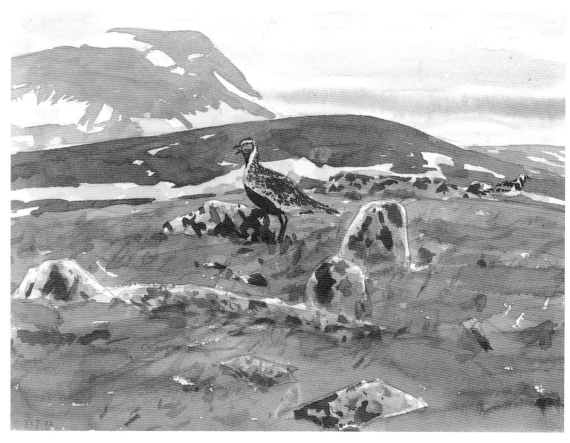

I found them nesting not only on the shores of Varanger but also up on the fell-tops. Here a male turnstone and golden plover begin to warn as I approach. Krampenes, 7th July 2000.

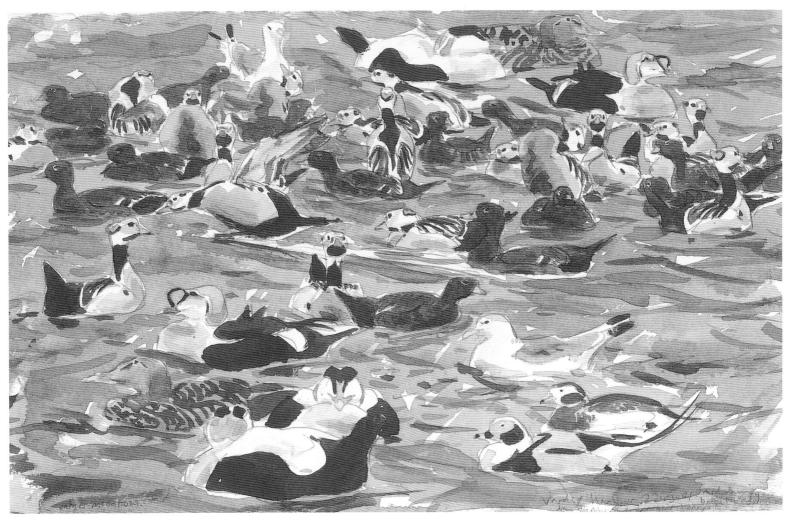

A mixed gathering of common, king and Steller's eiders, kittiwakes and long-tailed ducks. Many of the Steller's eider drakes are displaying by raising their bodies out of the water and flicking their heads back. I even saw them mating on two occasions. Vadsø, 22nd March 2001.

In March 2001 I flew to Ivalo where I stayed with the Karhu family for a few days. On the 17th, I drove to the Petsikko hut, left the car by the roadside and took my belongings to the hut on skis. It was not quite so effortless as the locals made it look but I really enjoyed skiing and it certainly warmed me up. The snow-covered landscape was beautiful, with blue shadows and pink and yellow highlights as the sun began to set. There were lots of willow grouse tracks and places where they had stopped to dig through the snow in order to find berries and shoots. Fox tracks were in evidence too, many of which followed the grouse movements. Interestingly there were several instances where a fox had used either its own earlier footprints or followed the tracks of another.

That night I was treated to a stunning show of the Northern Lights. Just before ten o'clock the display was at it's brightest, with beams of light, flickering moving curtains and huge winding snakes of light. As the aurora illuminated the frozen, snow-covered landscape it was possible to see great detail, even over long distances. The temperature dropped to below -30°C that night, so it was good to have the log burner going and plenty of logs at the ready. I used a whole roll of film but, in the cold, the camera battery stopped functioning after every few shots, so I had to keep it warm by putting it inside my glove until I was ready to use it again.

I headed off at sunrise; it was incredibly cold but beautiful, as I moved slowly on skis through the birches and across their long, ice-blue shadows. On returning to the car I noticed that the two bananas I'd left behind had frozen solid and turned jet-black and a bottle of water had become a plug of ice. After driving only about twelve kilometres, I stopped to watch some Siberian jays moving along the roadside. Some redpolls gave alarm calls as a huge, young female gyr falcon flew low across the road. It was a brief but very close encounter. I crossed the border at Utsjoki and continued on towards the fjord, stopping briefly at Nesseby before reaching Vadsø.

Varanger was beautiful at this time of year, particularly when the sun was shining, creating a sharp contrast between the snow and the dark blue-grey water. The sea-duck were stunning, especially those rafts of eiders of all three species. There appeared to be about two thousand Steller's eiders and up to five hundred king eiders. The Steller's were usually in tight flocks, which were often several hundred strong and scattered around the sheltered bays, with the biggest concentrations frequently in and around Vadsø harbour. King eiders also favoured this area and it was frequently possible to see groups at close range. They seemed to be attracted to the waste products from the fish-processing plant. The main catch appeared to be sild, a small herring. As usual such areas are attractive to gulls and large numbers of kittiwakes and herring gulls gathered in noisy flocks, with smaller numbers of great black-backed, Iceland and the occasional glaucous gulls.

Long-tailed duck were common and often quite vocal, with many courtship chases and 'parachute' display-flights. Small numbers of black guillemots were dotted around the shoreline and a few velvet scoters and mergansers were also seen. Due to the warmer influence of the Gulf Stream, purple sandpipers are able to survive the winters in large numbers and some gatherings were of several hundred birds. All fluffed-up against the cold they looked quite odd and ball-like; often all that was visible of their legs was a single orange foot, with just the toes protruding from the feathers. I watched a domestic cat and a mink hunting them along the rocky tide-line. White-tailed eagles, particularly immature birds, were regularly seen. Ravens and hooded crows were quite common but, with the

exception of the house sparrow, which could be found in any settlement and a sprinkling of mealy redpolls, other birds were, unsurprisingly, scarce.

Arctic hares were regularly encountered on Vadsøya and I spent a couple of afternoons watching and painting them. Up to five were together and I saw a pair 'boxing' briefly. Painting outdoors in watercolours was a very interesting experience. The weather and climate were different from Lapland. The temperatures here were much higher, ranging from -15°C at night to between -5 and 4°C during the day. When the sun was shining, it was possible to paint and there was often a breeze that helped the paint to dry. However, there were frequent blizzards and, as soon as they obscured the sun, the temperature would drop and the paint washes freeze. At such times I would either put the painting in the car or protect it with my coat until the snow stopped. These blizzards didn't usually last long and the sun would come out once more, the frozen washes would thaw and then dry, allowing me to continue painting.

On a couple of occasions to have a change from the harbour, I drove to Ekkerøy and skied to the cliffs to see if the kittiwakes had returned to their colonies. There were thousands either up on their nests or wheeling around the cliff-face. It was an unbelievable sight. Almost every frost-covered nest and overhang had an icicle hanging from it, some of which were over two metres long. Good nesting-sites are at a premium, so the birds must return early each year to claim theirs. A fine pair of adult white-tailed eagles was patrolling the cliff-face, trying to catch unwary kittiwakes. To see these huge birds in amongst the noisy,

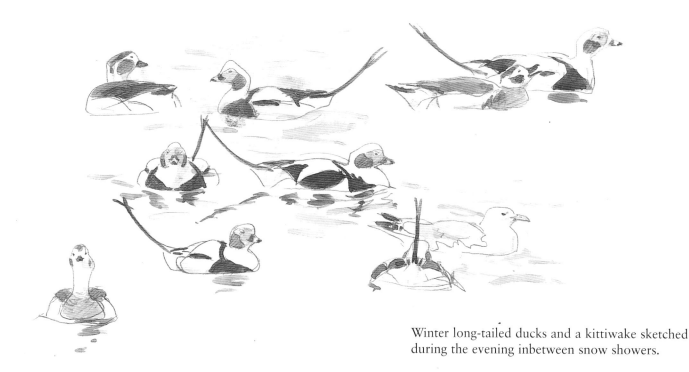

Winter long-tailed ducks and a kittiwake sketched during the evening inbetween snow showers.

clouds of these small gulls was an impressive sight. On one visit, some really heavy blizzards and squalls came through. The winds whipped large quantities of fresh, light snow off the top of the cliff. I couldn't see more than a couple of metres around me and there was often a complete white-out, which sometimes lasted for as long as twenty minutes. I sheltered near a boulder where the snow quickly covered me. During the occasional break, I could see a steady passage of glaucous gulls, mainly adults, moving eastwards along the shore. I was puzzled by a grey patch on the shore that didn't seem to become covered with snow. When the weather cleared, I realised that it was a tight roost of purple sandpipers. Whenever the snow stopped they dispersed to feed. During a bright spell I decided to head back, following a fence-line, before the next blizzard came through. When I got back to the car, I found myself covered in fine, white snow with big patches of ice on my eyebrows and any other exposed hair. My face was quite burnt by the wind, frost and sun.

After a fantastic eight days I said goodbye to my Norwegian hosts and headed back to Ivalo to spend a couple of days with Heikki and Sinikka before leaving for home. As I was having a hot drink and snack with Sinikka, she mentioned that an email, Heikki had been waiting for, had come through and that it was about a possible trip to Siberia. I was more than a little surprised, since I too was expecting to hear news of a possible Siberian trip on my return to England. I asked if the email was from Christoph Zöckler. She read the name and looked surprised that I knew it. I couldn't help laughing. Could it really be possible that it was in Heikki's house, in the middle of Inari Lapland, that I learned that he and I were two of the three Westerners who had been invited to join the trip to Siberia. So began one of the most exciting experiences of my life.

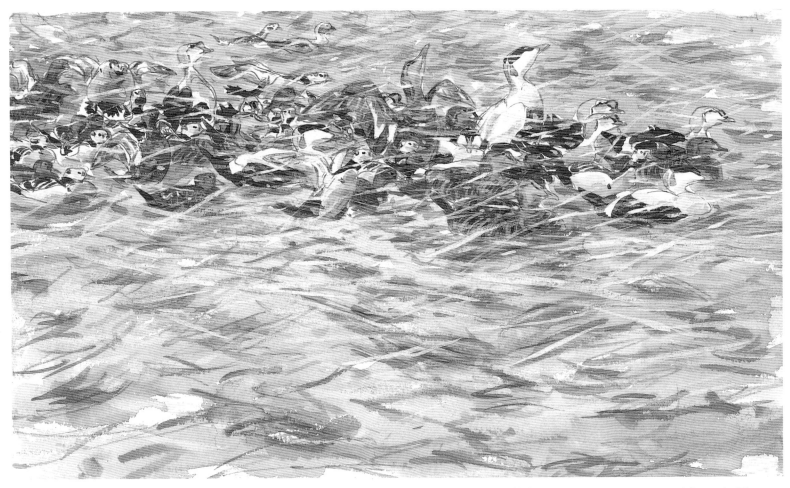

I found the mixed flocks of Steller's, king and common eiders an incredible sight. Here all three species sit out a snow blizzard. They would habitually rise up out of the water, raise their heads and flap their wings before settling down again. Vadsø, 23rd March 2001.

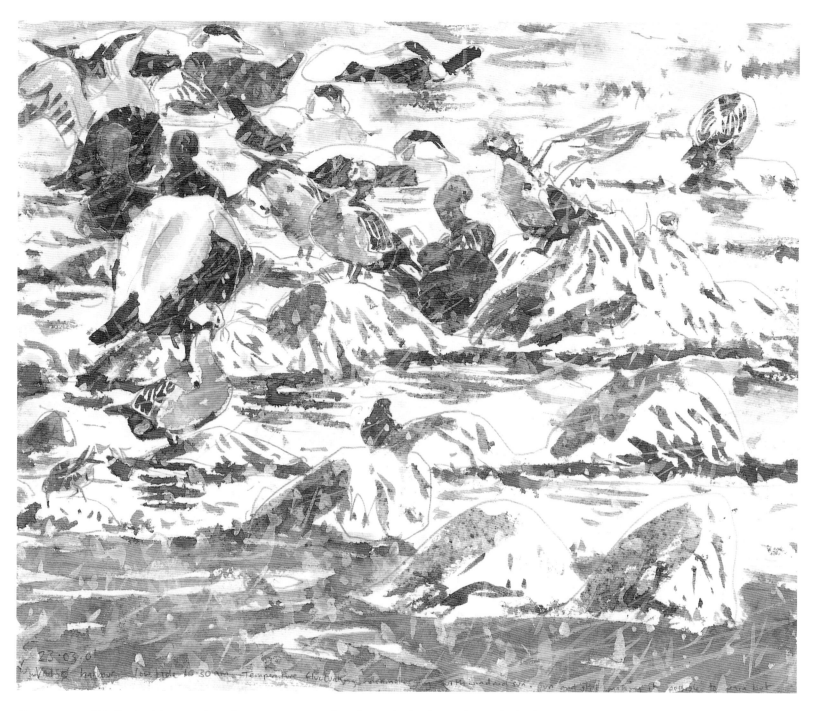

Common and Steller's eiders, gathered on snow-covered rocks in the harbour alongside feeding purple sandpipers. It was interesting trying to paint these birds in changeable weather. In the sunshine, the temperature rose as high as 4°C. However, heavy snow blizzards would come through regularly and, as soon as these obscured the sun, the temperature would drop and the paint freeze. It would thaw again after the blizzards had passed and the sun had re-appeared.

Although snowflakes have obliterated some of the detail, this picture, for me, reflects the weather conditions and sums up my experiences on that morning. 23rd March 2001.

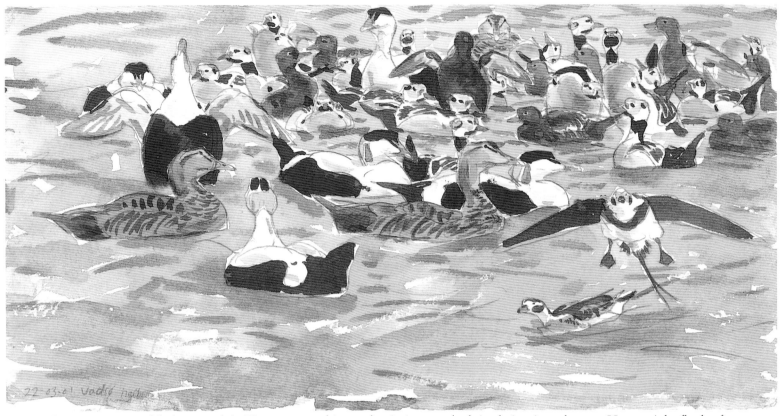

In March 2001 I spent a fabulous week in Varanger watching and painting sea-duck in their winter home. Here a tight flock of common and Steller's eiders gather together. Some of the Steller's are displaying, as is the long-tailed duck, which tries to impress his mate with his parachute display-flight. Vadsø, 22nd March 2001.

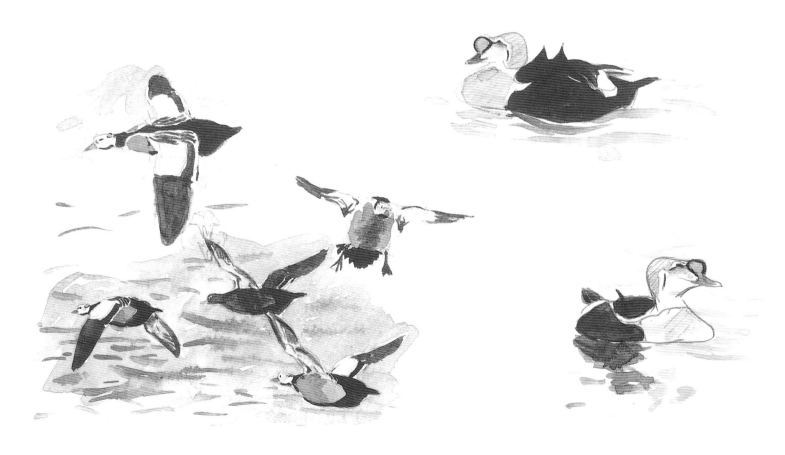

Steller's eiders flying in to land and a beautiful drake king eider.

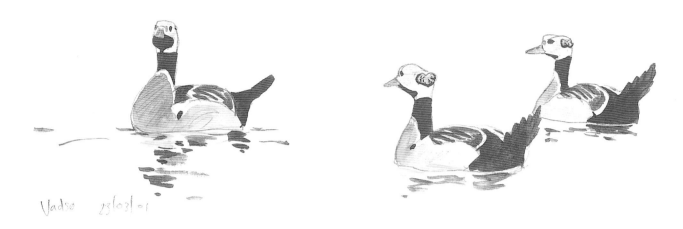

A drake Steller's eider posturing and displaying.

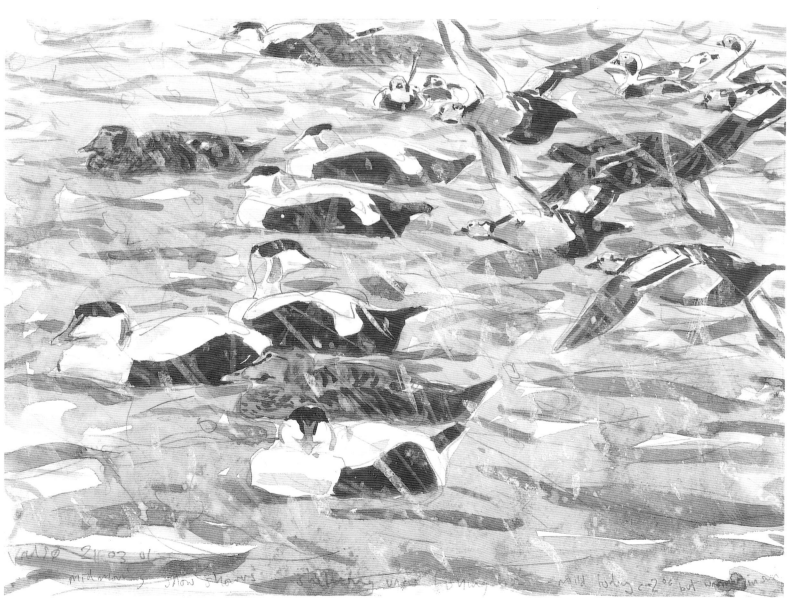

Common eiders, long-tailed ducks and a group of Steller's eiders flying in during heavy
snow. Vadsø, 21st March, 2001.

An introduction by Pavel Tomkovich

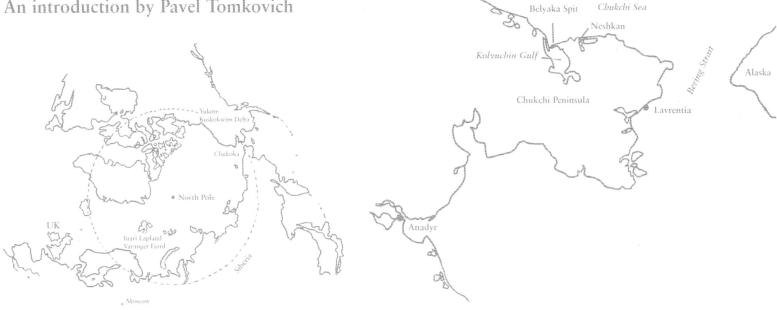

A small watercolour of a wonderful bird, the Spoon-billed Sandpiper *Eurynorhynchus pygmeus*, that has the letters 'J.M.' and another inscription 'Belyaka, 8.06.02' is standing on a bookshelf above my desk and computer at home. It is not only a nice piece of art, but also a reminder of a memorable summer spent in the Siberian Arctic and new friends made there.

Belyaka Spit, a remote site on the arctic coast of Chukotka, lies east of the 180th line of longitude and just to the north of the Arctic Circle in the Russian Far East, and in 2002 was the desired goal of an international crew of ornithologists. Belyaka Spit is a well-known geographic name for ornithologists and birdwatchers seeking the breeding grounds one of the most peculiar and exotic waders, the spoon-billed sandpiper. Yes, for some of our team members it was the desire to see the bird, to imprint its image and some behavioural features on their memories and in their notebooks, but for others it was an urgent scientific need. To explain the latter some introductory words are necessary.

The area was discovered for the ornithological world in 1972-1974 and described by Alexander Y. Kondratyev, a researcher from Magadan, who was collecting data on the ecology of arctic waders for his PhD study. From his publications it became clear that the site was unique for the region in both its high diversity of bird species and the large number of breeding spoon-billed sandpipers. He counted between 50 and 95 displaying males during the years spent on Belyaka Spit and on the neighbouring Yuzhny Island, whilst only a few pairs were known to breed at any other coastal localities in Chukotka. That is why in later years, when I was looking for a place to study the ecology of the spoon-billed sandpiper, Belyaka Spit was chosen as the site for a temporary field station despite its remoteness from any village. In

the period 1986-1988 between 45-51 spoon-billed sandpiper breeding territories were found in the area, and the population seemed to be healthy, despite high predation and low productivity. During the economic depression in Russia in the 1990s almost no ornithological research was undertaken in Chukotka. However, since 2000 the Arctic Expedition of the Institute of Ecology and Evolution, Russian Academy of Sciences has started regular surveys in Chukotka. Even on their earliest expeditions members became alarmed by the lack of spoon-billed sandpipers in many coastal areas of southern Chukotka where they had previously bred. That is why there was an urgent need to visit Belyaka Spit, the core area of the species' breeding range, and to see what was going on there.

Early in the northern spring of 2002 the Arctic Expedition, consisting of seven people under the leadership of Eugeny Syroechkovski, Jr. travelled by air, in gradual stages, from Moscow to Anadyr, then on to Lavrentia and finally to the village of Neshkan on the coast of the Chukchi Sea. From there small teams of people began surveys or more focused field studies in different places in the area. As the only person with prior knowledge of Belyaka Spit I was to lead the team heading there. Vanya Taldenkov, a student from Moscow University had to accompany me together with one of our three new foreign friends. It was no surprise that each of the latter wanted to go to Belyaka, the paradise of spoon-billed sandpipers, but that was impossible at the beginning of the season. They had to vote and finally James McCallum went with us. Each of those three westerners was a personality, and I would have liked any of them as a companion. But James was special in that he was an artist, and I consider it was destiny that brought us together.

A heavy 'vezdekhod' (which in Russian means 'going anywhere'), an almost tank-like vehicle on caterpillars, took us the 70 kilometres along the sea shore, across still-frozen rivers and channels to the old hut near the tip of the Belyaka Spit, which would be our home for the next month.

Belyaka Spit separates the Kolyuchin Gulf from the Chukchi Sea and is a 20 kilometre long tongue of sandy and gravelly land, narrow at the base, but up to 4 kilometre wide near its tip. The surface of the wide part of the spit is like a washboard consisting of long, low flat ridges of tundra with shallow, marshy depressions containing mosses and sedges in between. Numerous ponds and lakes of various sizes are scattered across the spit. Yuzhny Island is another similar piece of land, 2.5 kilometre from Belyaka Spit at the mouth of the Kolyuchin Gulf. We could easily hike to the island before the sea ice broke. Some man-made constructions are characteristic of this flat landscape. There are two huts, one on the spit and another on the island, and close to each one are wooden towers used for sea navigation. At the end of the spit a tall cross stands above the grave of a sailor called Vladimir Belyak and in several prominent places the jaw bones of large whales stand vertically, erected by Eskimo people in earlier times. The horizon is partly rimmed by low mountains.

Several species of Beringian birds such as emperor and snow geese, tundra swan, Pacific common eider, sandhill crane and Vega gull were already present in very late May, hanging around on snow-free patches. Others such as white-billed and Pacific divers, Steller's eider, grey phalarope, pectoral, rock and western sandpipers, long-billed dowitcher, pomarine skua were just arriving or passing through. The diversity of species and the abundance of birds increased daily. We all enjoyed the birds, life and each other's company and every day filled the 'log-book' with new observations. By the year 2002 the local bird list consisted of 112 species with 41 species breeding, at least, occasionally. In that year we managed to record 80 species with two new ones, white-winged scoter and white-tailed eagle added to the list.

But real work for us started several days after the first spoon-billed sandpipers arrived on the 2nd June. We began to map territorial birds in the vicinity of our 'home', to catch birds in order to colour ring them and later, to count all the 'spoonies' along the spit and on Yuzhny Island and to find their nests. However, when we had a little bit of free time we could see James standing or sitting like a statue somewhere in the distance on the flat tundra where he was undoubtedly sketching birds. We were surprised by his ability to spend sometimes hours almost motionless in the cold, windy environment. And we were always waiting impatiently for his return to hear about his findings and to see new paintings of bird behaviour and birds within the landscape. He has very special way of portraying his subjects – they are not only realistic-looking on paper but they are rendered with very few touches; but they all have a special mood, which I've only ever seen in James's work.

Once a special dinner was cooked and we were waiting for James, who was back in camp but stuck in his tent (he preferred to sleep in his tent near the hut 'in fresh air'). Our impatience was growing, together with our hunger, but the reason for the delay became clear when he brought in a drawing of a spoon-billed sandpiper, signed and dated, the one that I currently have in Moscow. Well, apart from the inscriptions just mentioned, it has another one: Happy birthday Pavel! Yes, it is one of the most memorable birthday souvenirs that I have ever received, and this special gift was for my 50th birthday! Another memorable event also occurred that day, the finding of the very first nest and egg of the spoon-billed sandpiper of the season and the earliest on record.

The bird in the drawing has an additional detail, a ring on one of its legs. The presence of the ring was not only highly symbolic for me personally but also scientifically significant. When the bird was later trapped on its nest it emerged that it had been originally ringed as an adult during my previous study in 1987, 15 years earlier and only 460 metres away. This meant that it was at least 16 years of age, which is very old for a wader of such a small size. We later caught two further ringed birds on their nests, which were both females. These had been ringed as downy chicks, one in the same year as the male and the other the following year. These were 15 and 14 years old respectively. Surprisingly the latter bird was a daughter of the ringed male and she was nesting 1.5 kilometres from where she had hatched and saw the world for the first time.

Many other exciting things were learnt and many beautiful exotic birds were seen during the month that we spent in complete isolation on Belyaka before we left to participate in another project in a different area. But that June of 2002 remains a brilliant link in the chain of events in our lives. However, one result of our study has greatly saddened us. There has been a sharp decline in the local spoon-billed sandpiper population. We counted only 18 pairs and territorial males in the area where about 50 pairs were breeding 15 years earlier. Hence, the decline has taken place not only in southern Chukotka, but all over the species' breeding range. It means that it is not only low productivity locally that is responsible for the species decline; something else is happening on their migration routes and wintering areas. Recent estimates of the world population are of only 300-500 breeding pairs! The species is becoming dangerously close to the brink of extinction. If this happens it will be a loss that can't be replaced. I hope very much that the charming art of James McCallum will help to draw attention to the catastrophe facing this amazing bird species. We have to find a way of saving the spoon-billed sandpiper, a wonder of our world.

I am extremely grateful to James for his irreplaceable role both on the expedition and in my life.

Pavel Tomkovich, Moscow, February 2007

A Summer in Chukotka

The first morning in Moscow was spent sightseeing, with a walk to see Red Square and the Kremlin, before spending the afternoon birdwatching in the Botanical Gardens. I had flown in with Chris Kelly, another member of the expedition and we had met Heikki who had arrived by train from Finland.

The Botanical Gardens were quite overgrown in places and were superb for birds. Thrush nightingales were common and we had excellent views of them singing and displaying. There were plenty of pied flycatchers and wood warblers. A golden oriole was singing high in the trees and we had good views of a lesser-spotted woodpecker. The highlight for me, however, was a very pale nuthatch, ash-grey above and white below with red-buff restricted to its undertail. The following day we met Evgeny Syroechkovski, Jr. the expedition leader, whom we were to know as 'Zhenya', and the rest of the expedition members and boarded a plane to Anadyr; the expedition had begun!

After an eight and a half hour flight, we arrived in Anadyr and quickly experienced how life in Russia works. The airport was based around a large block of concrete buildings, which were crumbling and run down. As the plane taxied in, we passed a collection of skeletons of planes and helicopters, which had been stripped down for spares. We were due to leave for our next stop, Lavrentia, the next morning but it appeared that the plane had been double-booked. All our baggage was put together and we had to stand and guard this considerable pile for many hours. There seemed to be no rooms available at the airport for us to stay in. It also appeared that the next available flight might not be for two weeks. Zhenya spent many hours in and out of meetings with various officials. Suddenly we had rooms to stay in and after a meal we

were able to get some much needed sleep. This episode was an early example of his impressive negotiating skills. On the next day there was lots of waiting around and no sign of any progress with the plane. Outside, a few sandhill cranes were migrating and a pine grosbeak was perched on the top of some low willows. The pied wagtail subspecies looked very different here; there were several eye-striped white wagtails and a lovely male black-backed wagtail feeding on the open gravel roads. The following day, the 15th May, again began with much waiting around; things weren't looking too hopeful. Suddenly Zhenya appeared and announced that we would be leaving on the next plane and we needed to check in at double-speed. Included in the expedition equipment were two five-litre bottles of ethanol but these had been confiscated, as they were deemed a fire hazard. We boarded a well-used, twin-propeller plane and soon began the ninety- minute flight to Lavrentia. A queue of people, many with openly visible cigarettes and lighters, quickly formed outside the toilets and a cloud of cigarette smoke wafted through the plane every time the door was opened. I later learned that, following a conversation about the importance of the ethanol to the expedition, Zhenya had been able to acquire two five-litre bottles during the flight "that just happened to be under one of the seats".

Lavrentia was a small town of wooden houses and buildings with a couple of stores. It was, in common with most towns here, heated by a large, insulated pipe, which passed through each building from a coal-powered station on the edge of the town. Large patches of snow still remained but they were beginning to melt and everywhere was starting to get muddy. Much of the access between the houses was along ramshackle wooden walkways. There seemed to be an equal mix of Russian and native

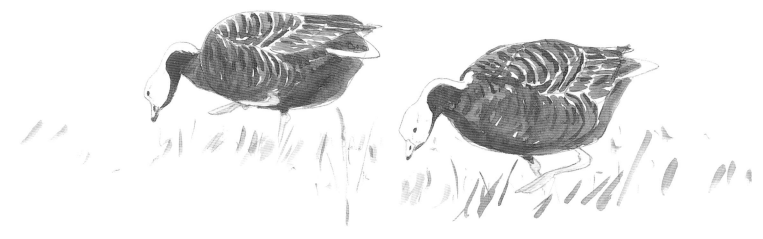

Emperor geese

Long-billed Dowitcher

people, mainly Chukchi. Just outside town was a series of lagoons and these were to become the focus of my spare time during the next six days.

On our first day there, there was a big movement of sandhill cranes, with over two thousand migrating in groups of up to 140 during a three-hour period. The passage of waders and waterfowl was also underway and was to increase in both number and variety. There were species here, which were new to me, including western and rock sandpipers and semi-palmated plovers. I also saw some more familiar species in different plumages and there was no better example than the grey phalarope. These birds, particularly the brighter-plumaged females, were a deep red-chestnut and the alternative name of red phalarope seemed far more appropriate. Whistling swans and snow geese passed through in small numbers; the latter were exclusively white-phase birds. All their heads had become stained rusty-yellow by minerals found on their wintering grounds and migration routes in America. Another memorable sight was of a line of thirty-six birds migrating high over some snow-covered mountains. At first I thought they were geese but then realised they were pomarine skuas.

We had originally planned to head north by 'vezdekhod', full-track people-carriers, a typical means of long distance travel here. The Russian name means "go-anywhere". In the end it was decided we would travel by helicopter. So we left for Neshkan on the 21st May, having bought large quantities of supplies from local stores: half a dozen sacks of bread, sacks of potatoes, smaller hessian sacks of rice, much butter and cheese, tinned meat, sugar, sweets, condensed milk and a few other luxuries such as a small jar of instant coffee for me.

Neshkan, a settlement right on the edge of the Chukchi Sea, which was still frozen, was flanked by a series of long, narrow lagoons, running parallel to the shore. It was

essentially a scaled-down version of Lavrentia but with a big radio-dish set on the eastern edge. Beyond this was a massive area covered with thousands of old, rusty oil drums. Nearby some had been put to good use. The tops and bottoms had been cut off and the sides flattened to form sheets, which, in turn, had been nailed over a wooden frame to make a large barn.

The village was almost exclusively populated by Chukchi people and a large crowd gathered around the helicopter as we landed. It was a strange situation, as they were largely silent and just stared at us. Several were dressed in impressive coats made from various skins. One of the first things I noticed was a distinct smell coming from some of the people, which I was later to recognise as seal oil. It also transpired that the helicopter brought either vodka or government cheques or both, for a significant proportion of the population of 700 people quickly became drunk and were out of action for several days. We were given a couple of rooms to share. These were very basic, with everything seemingly covered in an oily film, probably of seal blubber. We laid out an old canvas tent and slept on top of that. One of the big heating pipes entered the room directly from the outside, through an oversized hole, which always seemed to have a different dog poking its head through in the mornings. Scattered all around the village were the bones and skulls of walrus, whales and seals. It was certainly a colourful place with something always going on and it served as a good base from which to begin our surveys.

To the east of the village, I noticed several stints that confused me initially. They were singing and displaying,

Long-billed dowitchers were regularly encountered, frequently in pairs. Wet sedge beds seemed to be their favoured breeding habitat.

Pacific golden plover song-flighting.

often using oil-drums as song-posts. I realised that they could only be semi-palmated sandpipers. This was an American species I'd not expected to find nesting here. Later Chris went on to survey the whole area and found it contained a loose colony of over fifty territories. Our arrival coincided with some exceptionally hot, sunny weather and the area was alive with migrating birds. In addition to the snow geese, the first emperor geese and black brant were seen. There were migrants arriving from both the Old and New World: dowitchers, pectoral sandpipers, another semi-palmated plover, American wigeon and green-winged teals from America. Heikki saw a savannah sparrow and I bumped into an American tree sparrow. Then, from the Old World, came ruffs, sanderling, grey plover, Eurasian wigeon and teal, bluethroats and yellow and white wagtails. The pectoral sandpipers were moving through in good numbers, often in small parties. Some males had set up territories or display grounds where they would try to court migrating females by inflating their airsacks and making loud booming calls.

After six days in Neshkan, a group of us set off for Belyaka Spit, a twelve-mile long shingle spit stretching out westwards into the frozen Chukchi Sea and the vast Kolyuchin Gulf. We left in two 'vezdekhods', which belonged to the commune, and were frequently used by local reindeer herders, some of whom were our drivers. We set off at 3 am, as the temperature was below freezing and the ground harder. The journey was to take just over nine hours; including two breakdowns, once when a track came off and again when one of the guide-wheel bearings shattered and there were also several tea stops. We dropped off Heikki and Valery Buzun, a Russian, at Cape Dzhenretlen, between Neshkan and Belyaka Spit. There was a rather ramshackle hut there, which the thawing snow had left standing in a large pool of muddy water. As we approached, a group of four brown bears, two large

and two small, walked across the ice. The driver said there was a whale carcass nearby which had attracted them so we had to be cautious. Inside the hut was a polar bear skull. Despite all this, Heikki was thrilled to be based there. This was where, in 1878-79, the Finnish-Swede, Adolf Erik Nordenskiöld, on his epic voyage through the North-east Passage in the Vega, had got stuck in autumn drift ice and had had to spend the winter. Heikki had read an account of this journey as a youngster and it had long fuelled his imagination.

Our next stop was Alyarki, near to the base of the spit, where we visited an old Chukchi man and his family who still lived in the traditional way in a large 'iaranaga', a wigwam type tent constructed from long wooden poles with canvas stretched over them. Traditionally these would have been covered in skins. In the centre of the tent was a large, stone-ringed fire with a kettle hanging above it and there was a rectangular wooden area covered with skins where people slept. Outside there were other smaller structures and several dog sledges.

When we finally arrived at the end of the spit we found the cabin we were to stay in a pretty run-down state. We had learned from some hunters that the windows had been

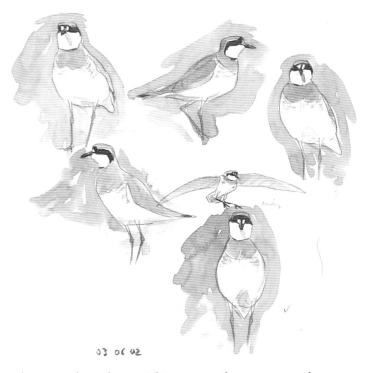

03 06 02

A male Mongolian plover. This was another unexpected migrant; a very handsome and elegant plover, which looked incredibly long-winged in flight. This bird favoured one of the dry gravel ridges, where it fed in the company of a male Pacific golden plover and a spoon-billed sandpiper.
Belyaka, 3rd June 2002.

broken so we had brought along some new glass. The porch door was missing, the main door had been blown in and the whole hut was full of snow. It took some time to dig out, during which we found two dead dogs in the porch and the main hut largely covered in rotting seal fat. The cast-iron cooking range was in bits but enough pieces were found to put it together and get it working again. Now that we were largely organised, we unloaded our gear and food and said our goodbyes to Zhenya and the Chukchi drivers. They would come back to collect the three of us, Pavel Tomkovich, Vanja Taldenkov, a young biology student, and myself in a month's time.

We scraped up as much of the seal fat as possible from the floors, rebuilt the chairs and tables and fixed the windows. I found the Russians to be extremely practical as well as being academics. They seemed to be of the opinion that Westerners were lacking in basic practical skills, but I began to gain a little respect from them when we all went out to

the shoreline to collect planks of wood washed up during the autumn storms. Having been born on the coast in England, I'd been brought up to collect or earmark washed-up timber and had already located several suitable pieces here on an earlier walk. One wide plank fitted perfectly in the porch and served as a shelf for storing food whilst others were suitable for repairing the porch door. With the repairs mainly done, Vanja and I began to cut and chop driftwood. Seemingly impressed, or perhaps relieved, by my basic practical abilities, everyone began to relax. Pavel had brought a roll of white paper, which he pinned to the walls and tabletops. Everywhere now looked much better and the hut became an excellent, snug base.

There were only two benches/beds, so I set up my tent outside. I was surprised to see Vanja walking around the camp with a Geiger counter. There was a disused navigation light on top of a tall, heavy wooden structure, which held an old raven's or rough-legged buzzard's nest.

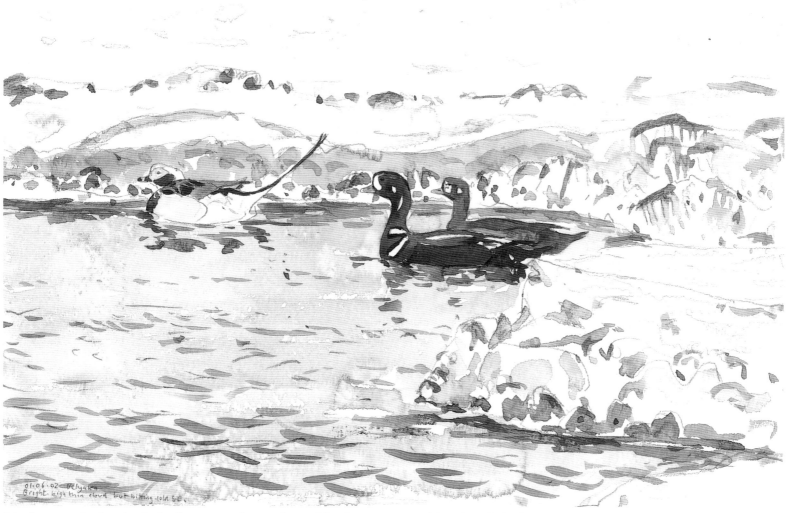

My first-ever harlequin ducks fly in over the tundra and land on an icy pool beside a drake long-tailed duck. The harlequin was a species I had long wished to see and these birds were even more beautiful than I had imagined. It was a bitterly cold day and by the time I had finished painting, the cold had got into me and it took a while before I could get my legs working again and return to the warmth of the hut. Belyaka, 1st June 2002.

Below there was a nuclear battery lying on the tundra and Vanja was working out safe distances around it. The radiation levels around camp were deemed safe. However, the battery itself recorded extremely high levels of radiation and I was taken aback by the thought that I had earlier been sitting quite close to it, scanning for birds with my telescope.

For the first three days the weather there was really cold, with low cloud, snow and rain showers. The wind from the north-east was bitterly cold and the rain froze on our coats and binoculars. In the cold weather, migration was at first quite slow, but as the weather improved so did the migration. On a small lake that had begun to thaw there was a white-billed diver in full summer plumage. It was the first of many and was one of the most magnificent birds I had ever seen.

By the 7th June the surface snow had totally disappeared. It had melted quickly during the previous couple of days as the temperature fluctuated between 2 and 10°C. Many of the lakes rapidly became ice-free but the sea remained frozen. We used one lake outside the hut for water for cooking and a smaller one for washing in. Breakfasts were rice or pasta with condensed milk and black, sugared tea or, for me, instant coffee, followed by bread, butter and jam. The rice had to be sorted prior to cooking to remove any stones and husks; even then, stones slipped through and an element of caution was always needed when eating. When the first mould was spotted on the loaves of bread, Pavel had us all sitting down, cutting out the mouldy patches before he stacked them neatly on the range and heated them through to kill off the fungus. From then on the bread was like wood but it was fine with butter and jam and plenty of tea to wash it down.

I tried to cram in as much as possible during the day so I often skipped lunch and returned for tea, which was a stew of potatoes, pasta or rice with tinned beef or pork. Very occasionally we would supplement the tinned meat with a wild duck such as a pintail, long-tailed duck or eider. Pavel was expert at preparing the ducks, cutting up the bodies and separating the liver. The sea-duck had to be skinned before being cooked, otherwise they apparently tasted fishy.

Looking back through my diaries I see that my notes are full of totals of migrant birds and new displays and behaviour. Some of the highlights were big movements or gatherings of birds such as pomarine skuas and grey phalaropes. Species new to me were turning up regularly.

These included: Baikal teals, harlequins, grey-cheeked thrushes, Pacific divers, Mongolian plover, marbled murrelets, horned and tufted puffins and, of course, the reason for our visit, the strange and wonderful spoon-billed sandpiper.

Some selected diary extracts help to give a flavour of life on Belyaka Spit.

8th June 2002 *Strong south-west wind and overcast. Wind dropping and cloud clearing by 9pm. Then totally calm and a beautiful sunny night.*

A grey-cheeked thrush was feeding just outside the tent when I returned in the late afternoon. There was a beautiful 'sunset' with the midnight sun never actually setting but hovering low above the frozen sea, its colour reflected in the recently formed pools of melt-water. The sea-ice had changed colour in the places where it had begun to melt, appearing a neutral grey rather than a crisp blue-white. Rock and spoon-billed sandpipers were singing overhead and grey phalaropes were calling from nearby pools. Snow buntings sang from the hut roof and from driftwood perches and there was a chorus of wails from Pacific and black-throated divers, accompanied by the howls and warbles from the white-billed divers.

9th-10th June 2002 *Sunny with a light cool north-east wind.*

On these two days we surveyed the entire spit for spoon-billed sandpiper territories. We saw several arctic foxes in various stages of moult ranging from their thick, white, winter coat to their grey-brown summer one. When we combined all our observations we ware able to deduce that there were at least five different individuals hunting the Spit.

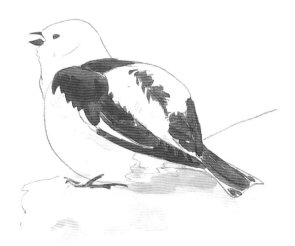

Male snow bunting, fluffed up in the cold, singing from the cabin roof.

11th June 2002 *Sunny with a light east wind then thick fog moving in from the sea to engulf the land.*

This morning we headed off to survey the offshore island of Yuzhny for spoon-billed sandpipers and other nesting birds. Pavel had prepared a meal containing split peas, since these had a steady energy release, and we took some sweets, chocolate and some salted pig fat to keep up our energy levels. We walked for an hour or so across the frozen sea before we came ashore close to a small hut, standing on the beach. There was another visitor here, for there was a dog team and sledge outside, so we knocked on the door. The dogs began barking and eventually the door opened; a pump-action shotgun appeared, followed by a Chukchi man from a reindeer camp. He was heading towards Neshkan to get his radio repaired. It was of the type that could be hand-powered by winding a handle but his children had been playing with it and broken it. He had stopped off to hunt some seals. We chatted for a while then let him get back to sleep. There were two sets of fresh bear tracks outside the hut and he had seen one on the island earlier that morning. We failed to find any spoon-billed sandpipers on the island but we did find four pairs of red knot that looked as if they might nest on the shore there.

On the way back, we called in at the hut again. This time the occupant was a bit more awake and he made us some tea. On the porch roof there was a walrus skull, complete with tusks, from an earlier hunting trip. Our host wore an expertly made coat, fashioned from a mixture of animal and sealskins. Apparently wolverine fur is the preferred skin to be used around the hood, since it is said to be the best insulator and doesn't gather moisture. We were then treated to a demonstration of how to catch seals with a net and told a story of a whale that was trapped in the ice all winter. Apparently it kept itself from becoming frozen in by bashing the ice with its back. Its back had become covered with snow and it looked as if there was a dome shaped hill on the ice. It apparently succumbed in April when so much snow had drifted over it that its blowhole became blocked and it suffocated. After we finished our tea we headed back across the ice. A thick band of mist was moving in. A strange, but beautiful, white rainbow-like arc of light or 'fogbow' appeared briefly before the sun was blocked out and the temperature crashed. My companions had GPSs and I had my compass which we had checked before we set off. It was strange and eerie walking on the ice through the fog and around melt-water pools. Occasionally pomarine skuas and Pacific and king eiders appeared briefly then disappeared out of the gloom before us. Eventually we got back to base and found our beds.

A migrant arctic warbler feeding amongst dwarf willows on a low coastal ridge. Small numbers were seen passing through on Belyaka Spit and later in the expedition we found them nesting and feeding young. 8th June 2002.

15th June 2002
During the previous few days, loud bangs like rifle shots had been heard coming from the ice. Today the ice had broken at the entrance of the Kolyuchin Gulf and ice sheets were clearly moving in tidal currents. Pavel said that much of the south of the gulf was now ice-free. On my return to the tent that evening, I was shocked to see that a big tidal channel had formed between the spit and the island.

16th June 2002
Bright, sunny and quite hot. The 'event' of the day was a mass-hatch of mosquitoes, which occurred from midday onwards. In addition thousands of midges had hatched the day before and their larval cases lay in thick bands around the edges of the lakes. The mosquitoes spelt an end to carefree sketching, at least when it was hot and still.

21st June 2002
A still and sunny morning but a fog bank hung over the sea to the north-east and cold, but light, gusts of wind blew from that quarter by late morning.

It was strange to hear the sea once again now that the ice had gone. The previous night and early that morning the sea had been ice-free for miles to the north. Then, in the late morning, the tide began to flow and huge areas of floating ice appeared at the mouth of the Kolyuchin Gulf, covering the open water once more. Within minutes, the scene was seemingly transformed to winter once again. Scraping and rumbling sounds, like those of a distant jet plane, could be heard as the ice was pushed together and compressed. Kittiwakes followed the ice-floes and distant seals, appearing as dark dots, drifted in on the larger sheets.

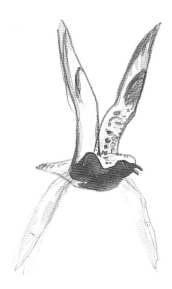

Grey plover singing.

23rd June 2002

Much colder and overcast today with light, cold north winds. The temperature dropped and ranged between 0 and 4°C. In the afternoon the wind increased, raindrops began to freeze as they landed and there were also showers of fine snow.

There were spectacular movements of ice driven by the tide and onshore winds. A mass of broken ice was piled up on the shore and strange-shaped formations drifted by. Later vast sheets of ice drifted in. Many of these had seals loafing on them and I counted about 145 on one sheet. Through the telescope I could make out common and ringed seals, with the occasional larger bearded seal amongst them. These were more than twice the size and could be picked out by eye. Out in the water I could see quite a lot of heads of common or ringed seals; swimming amongst them were some seals with a really strange head-profile. It took me ages to work out that these were in fact the same species; they were just sleeping on their backs with their heads upside down.

The wind and tide continued to move the ice but it was melting quickly. Seabirds and movements of Pacific, king and Steller's eiders were soon to become an added feature, particularly during onshore winds.

On the 2nd of July Valery arrived by boat with a hunting and fishing group from Neshkan. On landing, the children immediately ran into the camp and began hunting for birds eggs and shooting at nesting waders with catapults. They had to be asked tactfully to stop by the Russians, via their elders who could see little wrong in their activities. We had several pairs of spoon-billed sandpipers nesting around the camp and the children's activities put them and their nests at immediate risk. I quickly realised that there was a huge variety of threats affecting the future of these birds.

The weather had begun to deteriorate rapidly when Zhenya and the rest of the expedition arrived in heavy snow. They had a dead reindeer, acquired from one of the reindeer camps in a sack tied to the roof of the caterpillar; this was to be our food for the next week. Over a twelve-hour period the weather changed from calm, to drizzle, to rain, to hail, to snow then blizzards, sleet then rain again and ended with mist. It was not the ideal welcome for our friends. Sadly Pavel and I had now to leave the spit that had been our home for the past month. Along with three new members, Christoph Zöckler, Gill Bunting and Zhenja's wife Lena, we were to re-join the expedition to survey possible new breeding areas of spoon-billed sandpipers. Vanya remained at Belyaka and was joined by new members from Japan and Korea.

We left Belyaka Spit on July 4th. During the following six days we were constantly on the move. With the aid of satellite maps we tried to identify potential new nesting areas for spoon-billed sandpipers and we also re-visited previously known ones. During this excursion we found no new areas and noted only serious declines at the previously known sites. The trip was, however, very enjoyable and we saw some excellent wildlife and landscapes. Two of the highlights were a raft of ten summer-plumaged white-billed divers swimming in a line and some big groups of long-tailed skuas. At Cape Rekokavrer we found a spoon-billed sandpiper nest where the eggs were chipping and a 3mm hole could be seen in one egg. By morning we were treated to the sight of a newly-hatched chick with mini 'spoon-bill' complete with egg-tooth. We saw snowy owls over the tundra, pikkas in the upland boulders and a magnificent male brown bear.

On July 12th we arrived back in Neshkan where we had a very welcome sauna and then said our goodbyes to the village before heading off in a different caterpillar with new drivers. We didn't get far as the drivers turned out to be completely drunk and following a nail-biting full-speed ride, weaving a path across a low raised cliff of tundra bordering the sea we came to a standstill and both drivers fell asleep. In the morning they were fine and turned out to be good people. They introduced me to a new piece of equipment, the 'tundra microwave', which consisted of a petrol blowtorch on which there was a stand to hold a large kettle. A large kettle of water could be boiled in a couple of minutes.

The next five days were spent surveying new areas on our way back to Lavrentia. It was exciting to birdwatch in areas that Westerners had never visited. One of the highlights of this leg of the trip was a wolverine, spotted by Christoph, as it wandered through a valley of dwarf willows. Lots of passerines and ground squirrels gave alarm calls as it passed through their territories.

Another encounter, with a bear, was memorable for other

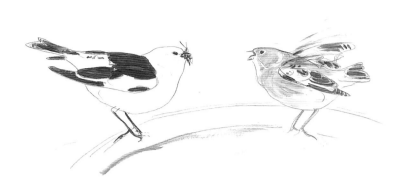

Male snow bunting feeding newly-fledged young.

reasons. A female with two cubs came running down a mountainside away from the other members of the group directly towards me. It then stood upright on a ridge, glaring at me as it waited for its cubs to catch up. It then disappeared below the ridge before coming up onto the next one where it again stood facing me whilst its cubs caught up. This happened once more but there was now nothing but a few yards of open ground between her and me. Somehow I managed to remain calm and continued walking slowly and diagonally up and away from her. She was standing fully upright looking at me. Her cubs caught up and she looked at them, then back at me, then down the slope, which she then decided was the best route to take. As they sped off, my legs went a bit wobbly and it took me a few minutes to compose myself before I headed back to camp.

We also found wolf tracks in some soft mud and I was surprised how large they were. There were some great birds too; Pechora and buff-bellied pipits, Baird's sandpipers with young, a male Mongolian plover with his three young and, in the mountains, a male red knot with four tiny chicks. Red-necked stints were quite common by mountain streams and we ringed several young. Whilst one of a brood of chicks was being ringed, the rest were often kept warm beneath somebody's hat. On one occasion, a male, on hearing his young calling from beneath Pavel's hat, hovered in front of him calling back to them. Memorably Zhenya slowly put out his hand and gently caught the parent in mid-air, and it too was ringed before the family was released.

On July 18th we flew back to Anadyr. We had to take a boat from the airport to the main town. It was a superb crossing with large numbers of belugas, many cows each having a small, grey calf. Three orcas surfaced briefly and several Aleutian terns could be seen among the mass of arctic terns. We spent a couple of days in Anadyr, which,

being further south, had additional breeding species. A few pairs of long-toed stints were breeding in the nearby marshes and, amongst the cliff-top scrub, exciting passerines were busily feeding young. Dusky and arctic warblers, little buntings and, most exciting of all, Siberian ruby-throats, all had broods. A dusky thrush had its nest in the framework of a crane and there were independent fledged young around too.

A group of Swiss ornithologists had recently returned from studying the white form of the goshawk. They had some horror stories to tell of plagues of mosquitoes and black-flies in the forest swamps. On our last day we all went out for a meal together and were joined by an American pilot, Bill Eldridge, who worked for the Fish and Wildlife Department in Alaska. He was over to help with aerial surveys of waterfowl. We got on well immediately and, after the meal, everyone gathered back at the place where we were staying to have a few drinks before we parted company the following morning. I was asked to show some of my sketches and paintings and it was a good evening with which to end the trip. Before we left, Bill suggested that I visit the other side of the Bering Straits sometime to see what happens there. We stayed in touch and were eventually to meet again in Anchorage.

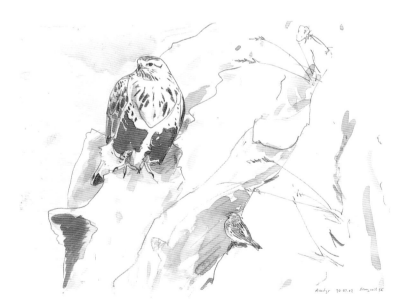

An arctic redpoll bravely mobs a rough-legged buzzard, which doesn't even appear to notice it. Anadyr, 20th July 2002.

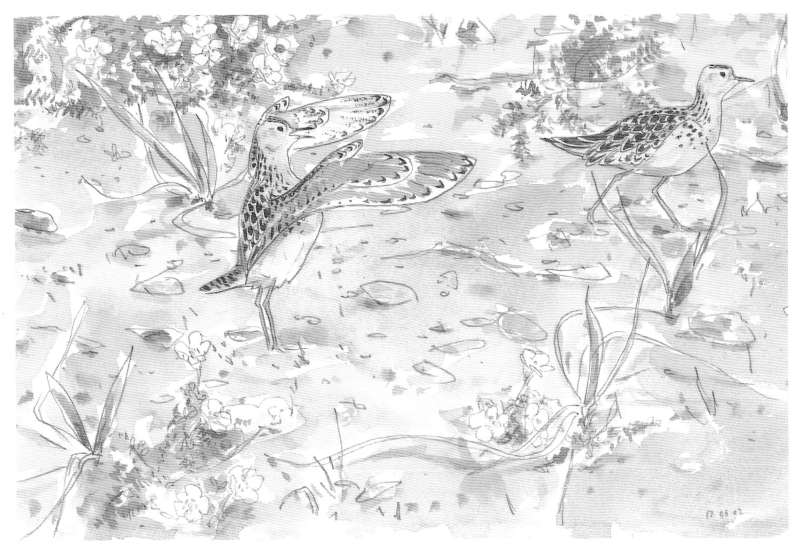

A pair of buff-breasted sandpipers. Seeing these birds was one of the unexpected treats of my stay on Belyaka Spit. Although predominantly a North American species, birds have regularly been seen in Chukotka, suggesting that small numbers may breed in the Old World. Very soon after I had discovered this pair, the male began his bizarre display. He would stand bolt upright with his wings held rigidly outstretched, the small alula feathers erected, and his tail slightly cocked. He would then begin to make strange clicking and hiccupping sounds, rapidly flicking his head upwards until, at the end of the sequence, it was thrown right back with its bill held vertically.

The female would frequently run away and then the male would chase after her with his wings either held out or closed. In the latter case, he would often quickly spread a single wing above his head and then close it rapidly. During the chases, he would make sudden erratic changes in direction and the display would become very crazed and frenzied.

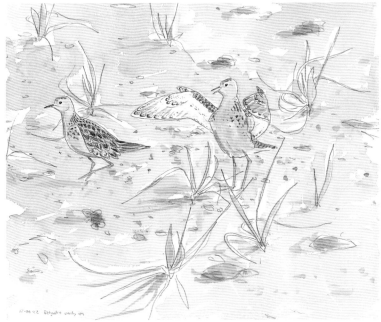

When the male was displaying it was possible to see some exquisite markings on the underside of its wings. Towards the tip of each primary and greater covert feather, there was a dark crescent-shaped mark. Behind this was delicate peppering which gradually faded out along the length of each feather. Belyaka, 17th June 2002.

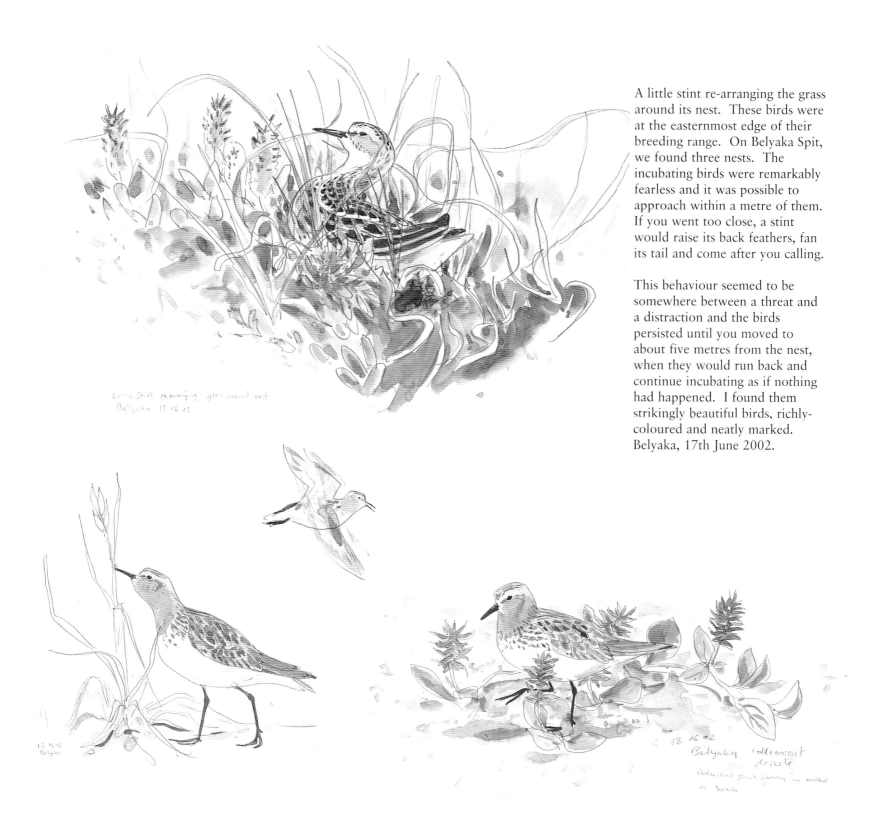

A little stint re-arranging the grass around its nest. These birds were at the easternmost edge of their breeding range. On Belyaka Spit, we found three nests. The incubating birds were remarkably fearless and it was possible to approach within a metre of them. If you went too close, a stint would raise its back feathers, fan its tail and come after you calling.

This behaviour seemed to be somewhere between a threat and a distraction and the birds persisted until you moved to about five metres from the nest, when they would run back and continue incubating as if nothing had happened. I found them strikingly beautiful birds, richly-coloured and neatly marked. Belyaka, 17th June 2002.

The red-necked stint is another attractive small wader. On Belyaka they were a regular migrant but only a few pairs stayed on to breed. When singing, they could be seen fluttering upwards, then gliding down before fluttering up once again. This continuous display scribed an undulating path across the sky whilst the birds constantly called a rhythmic, almost croaking, 'waarp-waarp-waarp....etc'. Here one bird pecks insects from dry grasses on the beach, whilst the other picks its way through the flowers of a willow 'forest' which formed a creeping mat across the sand. During the second half of the expedition, we were able to find good numbers nesting beside small alpine streams and springs in uplands and on mountainsides. Belyaka, June 2002.

Spoon-billed Sandpiper

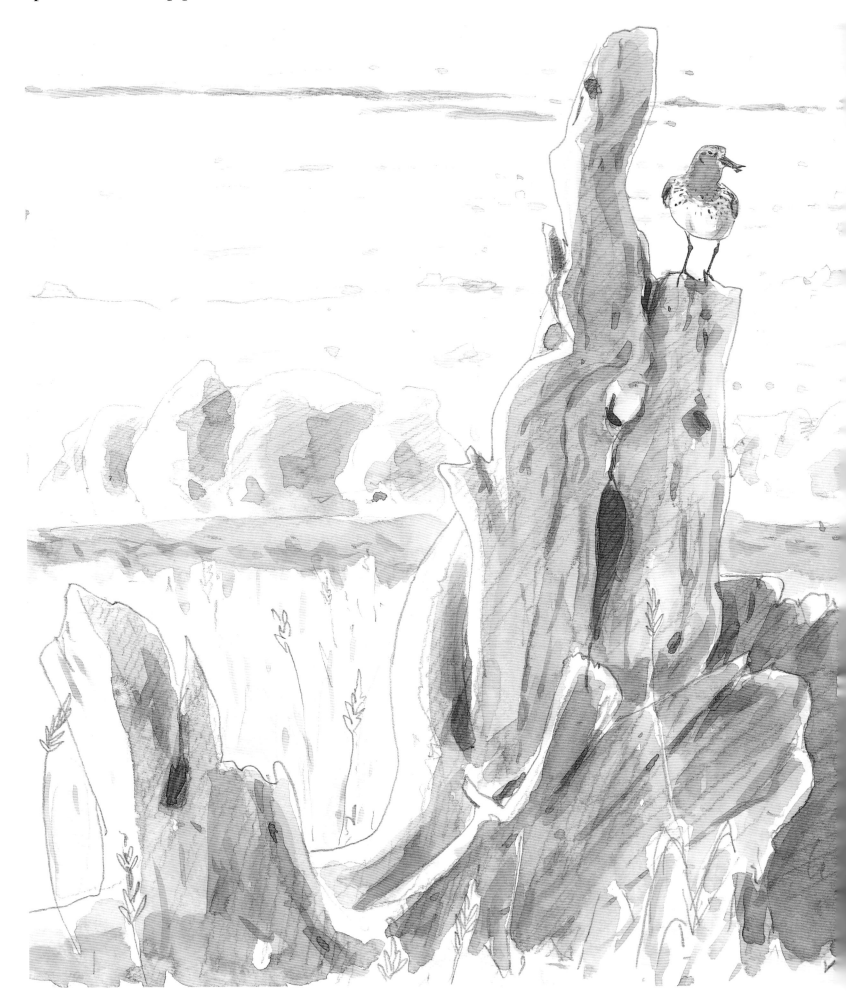

A male spoon-billed sandpiper sings from one of his favourite driftwood perches. In the background, the frozen Chukchi Sea. Belyaka Spit, 14th June 2002.

14·06·02 ♂ Spoonbill sandpiper sings from late evening Drift wood on Belyaka Spit. Behind is the frozen sea, the beginning of Kolyuchin Bay.

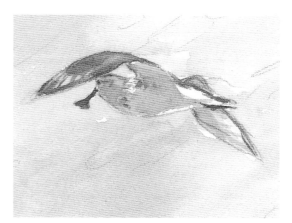

Male song-flighting.

The first bird arrived on Belyaka Spit on the morning of the 2nd of June when it was heard singing over the cabin. By evening three or four males had arrived and I was able to get my first views of one perched on a piece of driftwood. It sat there, fluffed up, preening, scratching, stretching and occasionally singing, its rich terracotta-red throat and breast glowing in the low evening sunshine.

The following morning it became apparent that this male had already made several nest-scrapes in the dark soil of the ridges, amongst mosses and low dwarf willow clumps. He then began to advertise his readiness to mate by singing and displaying from the ground or in flight. He would also sing his buzzing, cricket-like song when sitting in one of the nest cups, with his tail cocked vertically, showing off his gleaming white undertail coverts. I was very fortunate to be watching him when the first female appeared; she had probably just arrived.

I was surprised how quickly she joined the male and I watched as the pair set off together to inspect the nest-scrapes he had made. Perhaps this shouldn't have been such a surprise, as past studies of this species have shown that the birds often return to the same partner and the same area to breed. In any case, these northern summers are very short and time is of the essence. The male would show his mate each scrape in turn by sitting inside each one, calling with his tail cocked. The female would approach him silently, her tail cocked in a similar manner. As she approached he would rise from the scrape and stand on the edge, his tail still cocked but his hunched body held high so that the white-feathered thighs were clearly visible and his head was bent forward so that his bill was nearly touching the ground. In this posture, he would make a series of continuous buzzing calls and the female would slip into the scrape, the shadow of her mate's tail and wing-tips falling across her back. She would sit in one of these nest

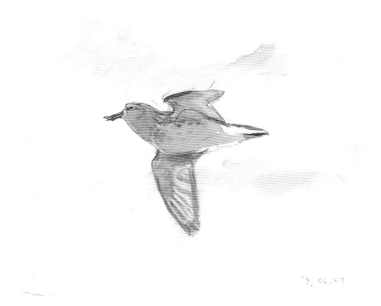

A male singing above camp. 7th June 2002.

cups for a short while, presumably assessing its suitability for nesting. When she rose from the scrape, the male would become very excited and adopt a more upright posture. He would rapidly flutter his wings and call loudly to announce his readiness to mate. Frequently the female appeared uninterested and would move away.

Following such unsuccessful mating attempts, the male would often commence his display-flight, preen rapidly or carry out other activities to release his pent-up sexual energy. On the few occasions when mating was observed, the male was seen to hover above his mate, calling excitedly, then land on her back and the pair would quickly mate.

By the end of the next day, June 4th, there were already eleven males and at least two females in the general area. With the increase in numbers, the frequency of singing and display-flighting intensified as territories were established. As more females began to arrive, pairing often seemed to take place as rapidly as observed previously. The presence of at least one unpaired male in the area led to frequent disputes and noisy chases as his search for a mate took him through several territories.

By the end of the first week on Belyaka, the songs and display-flights had reached a peak and between the 9th and 11th of June a survey of the entire spit and an offshore island had been carried out. The three of us worked as a group, spread out in a line, and were able to efficiently cover all suitable breeding habitat. The spoon-billed sandpipers on the spit were quite specific in their choice of breeding habitat, preferring areas with dry, flat ridges interspersed with lower, damper depressions. The drier areas were usually a mixture of bare, open sand and fine gravel, sparsely vegetated with dry *Elymus* grasses, low mat-forming dwarf willows, crowberry, lichens and mosses.

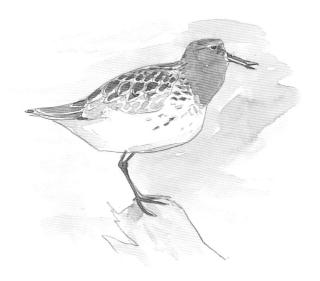

Male singing from the ground.

The first egg was noted on 8th June and full clutches of four eggs were found from the 14th onwards. Now that the pairs had begun to incubate they naturally became silent and less obvious. Both sexes share the incubation; the males usually incubate during the day and the females at night, with the change-over taking place between 5 and 8pm. The males then recommence their singing and display-flights as they are free from incubation duties until the morning.

When I was on Belyaka, many first clutches were lost to arctic foxes who had turned to foraging for birds' eggs as, that season, there were very few voles or lemmings to be found in Chukotka. Up to five individual foxes, recognisable by their moult patterns, which ranged from thick, white, winter coats to shorter, grey-brown summer ones, were noted on the spit. They preyed heavily on all the waterfowl, waders and passerines. The only birds, which seemed able to defend their nests were the large white-billed divers and sandhill cranes. Many spoon-billed sandpipers laid a replacement clutch, some of which were again depredated. Fortunately some of these survived and several young eventually fledged.

On Belyaka the first eggs began to hatch on 4th July, the very day I left the spit, so, unfortunately, I did not see any young there. I was, however, lucky enough to see newly-hatched young with their wonderful miniature spoon-ended bills at other sites later on.

During my stay on Belyaka I was fortunate to be working with Pavel Tomkovich who had stayed on the spit and studied spoon-billed sandpipers during the 1980s. I was able to draw, paint and interpret their behaviour and compare my findings with those of the experts close at hand. These informal discussions, which frequently took place over the evening meal at the cabin, were both memorable and rewarding.

The result of our surveys showed a decline of about 60% on Belyaka, a figure sadly mirrored all over the species' known range. More than three-quarters of all suitable nesting habitat in Chukotka has been surveyed recently and it is currently thought that there are fewer than three hundred and fifty pairs of these charismatic waders left in the world. Some of our observations from Belyaka have highlighted further worrying trends in their populations.

On 4th June I noticed that three of the newly-arrived birds were carrying rings. I well remember that Pavel looked very surprised when I told him about the rings. When he trapped them later, his suspicions that these might be some of the same birds, which he had ringed during his previous study there during the 1980s, were confirmed. This discovery showed, not only that the species can be very site-faithful, but also can be extremely long-lived. One of the birds was at least sixteen

years old, a remarkable age for such a small wader. Subsequent ringing studies have revealed that very few young are returning to the breeding grounds and this lack of recruitment of young to the dwindling population is cause for considerable concern.

It is currently impossible to protect their wintering grounds, since, with the exception of a dozen birds found in Thailand and a handful elsewhere, these are largely unknown. It is generally believed that the majority spend the winter in Bangladesh. Huge areas of coastal marshes and mudflats have already been reclaimed and developed in Japan and similar destruction is occurring in Korea. This spells disaster for a huge number of migrant waders, which stop off there to refuel. The spoon-billed sandpiper looks to be in grave danger of extinction in the near future unless its requirements are better understood and catered for.

There are many mysteries surrounding this bird, the most intriguing of which is the evolution of its bizarre bill. Observations on the breeding, wintering and migration areas have yet to reveal any specialised feeding methods.

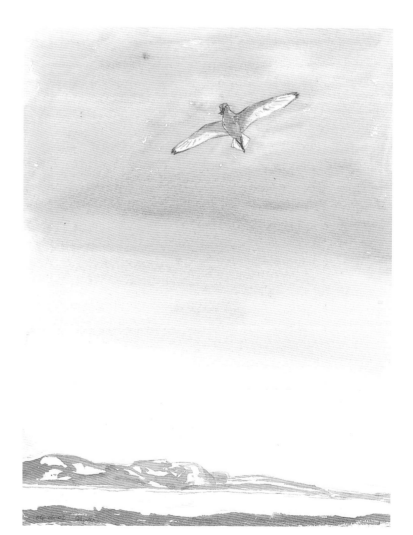

This male hangs in the air above his territory on stiffly outstretched wings, singing his buzzing cricket-like song.

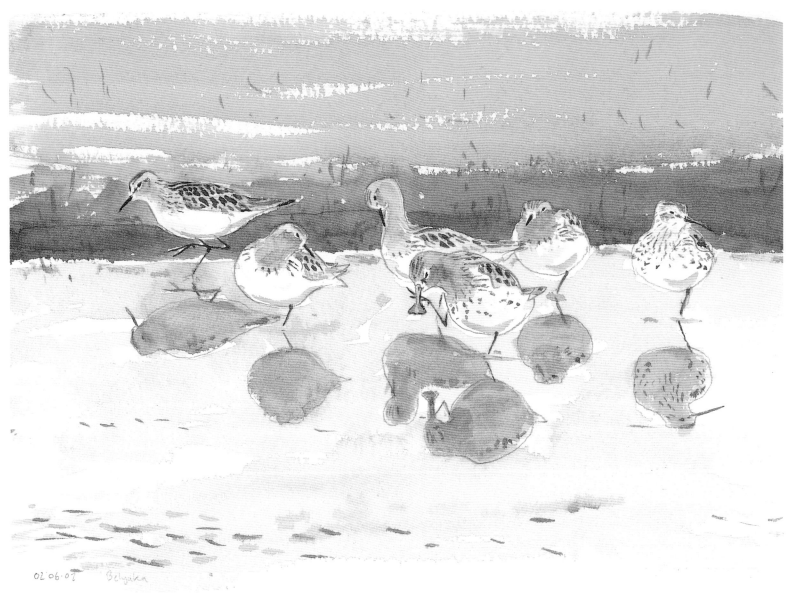

02 06 02 Belyaka

A wonderful small flock of mixed stints and 'peeps'. I watched these single spoon-billed and western sandpipers, three red-necked stints and a little stint from the middle of an ice-free pool. They looked stunning in the late evening sun and I stayed with them until my feet became numb with cold. Belyaka, 2nd June 2002.

Having only arrived on the previous day, this male quickly set about constructing a series of nest-scrapes, kicking out unwanted material with his feet. This activity was interspersed with bouts of singing, displaying and feeding. There was no time to be wasted; a female arrived later in the day and, by the afternoon, she was already inspecting his newly-excavated scrapes! 3rd June 2002.

A pair of spoon-billed sandpipers on territory amongst new flowers of lousewort, with the blooms of creeping, mat-forming willows appearing just above the sand and gravel. 6th June 2002.

Female

A rapid run forward, then a peck, was a typical feeding action. At other times they would feed in shallow water very much in the manner of other stints. There was no clue from its feeding habits to account for the evolution of such a bizarre bill. Indeed observations made both on their wintering grounds and on their migration route have provided no evidence of specialist feeding methods and the reason for their unusual bill structure remains one of the species' many mysteries.
1st July 2002.

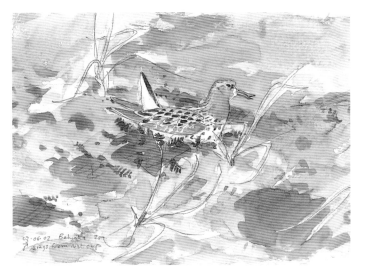

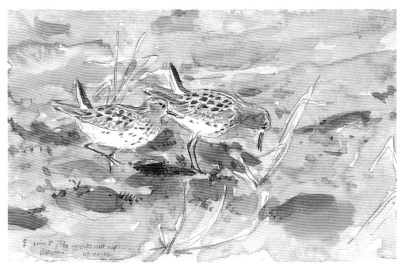

Having constructed the scrapes, the males, their tails cocked, would sing from one of them inviting the females to inspect their work.

The females would approach with their tails cocked and as they drew close the males would rise out of a scrape, stand on its edge and face away. The males continued to call but bowed their heads so that their bill tips almost touched the ground.

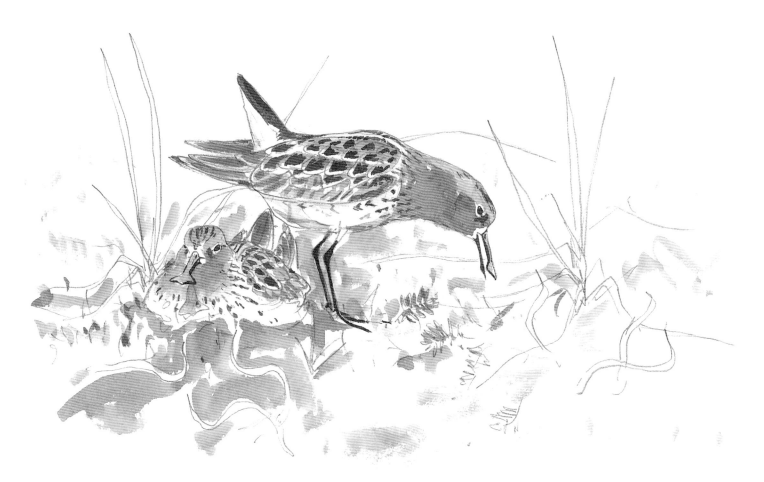

Whilst the males remained posturing above them, the females would slip into the nest-scrapes for a few short moments. When the females rose from the scrape the males would become very excited, standing bolt upright, fluttering their wings. This latter posture is common to many waders just prior to mating. Often the females would run away but occasionally successful mating was observed when the male would hover above the female then land on her back and mate. 3rd June 2002.

Eventually a scrape in which to lay the eggs will be chosen. Often these are lined with vegetation such as old, small willow leaves. Here a male is incubating in a patch of dry grasses. Studies have shown that the males normally incubate during the day and the females at night, with the pair changing over duties between 5 and 8pm. When the males were incubating their songs were no longer to be heard. 14th June 2002.

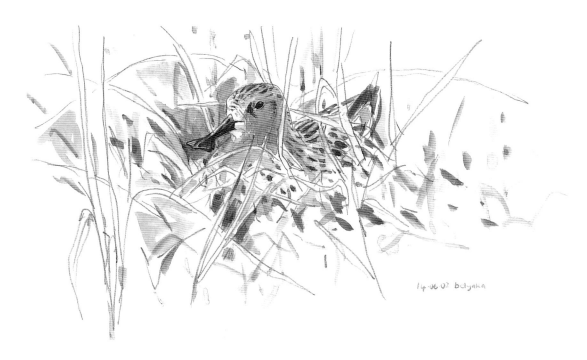

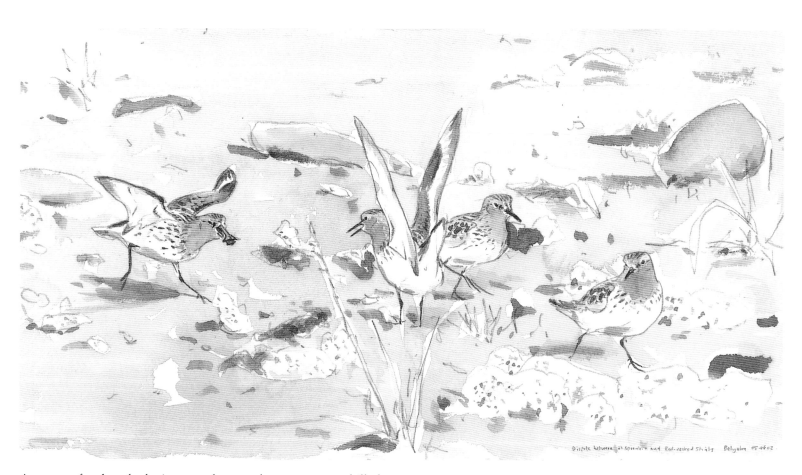

A group of red-necked stints wander too close to a spoon-billed sandpiper's territory. The male runs out calling loudly and with his wings spread, attempts to drive them away. 5th June 2002.

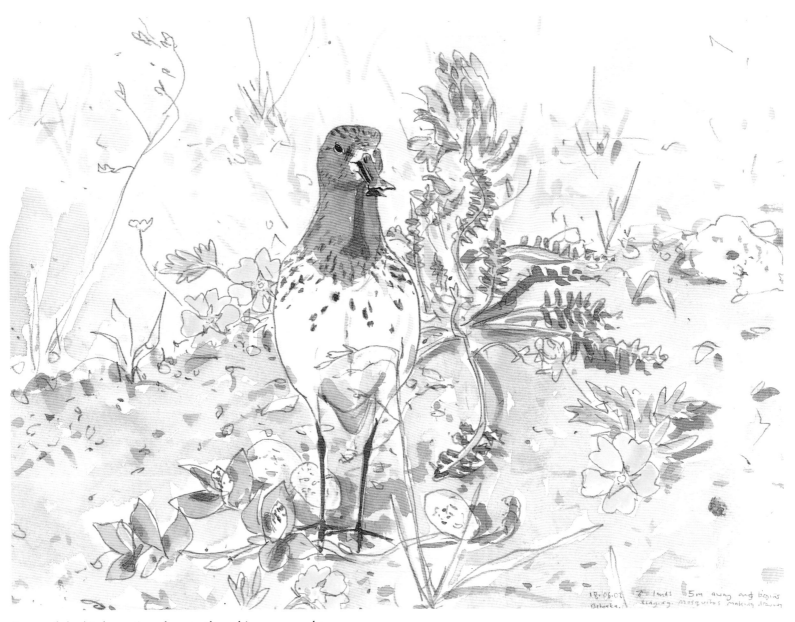

Some of the birds nesting close to the cabin grew used to our movements and could be quite fearless. This male stood singing a few metres away as I sat sketching him.

On bright days when the sun was overhead, the shadow cast by their bills fell over their breasts and often appeared as a 'kipper' necktie.

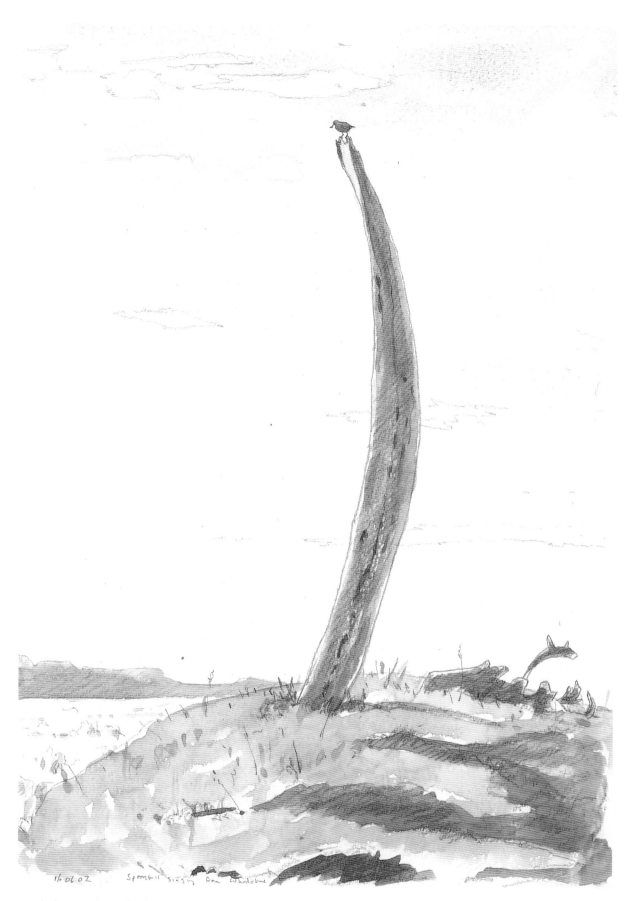

A whale's jawbone had been erected on top of a small mound and a collection of reindeer antlers placed beneath it. This was an ancient native site and the highest point in the area. One male spoon-billed sandpiper, with a territory nearby, would regularly use it as a song post.

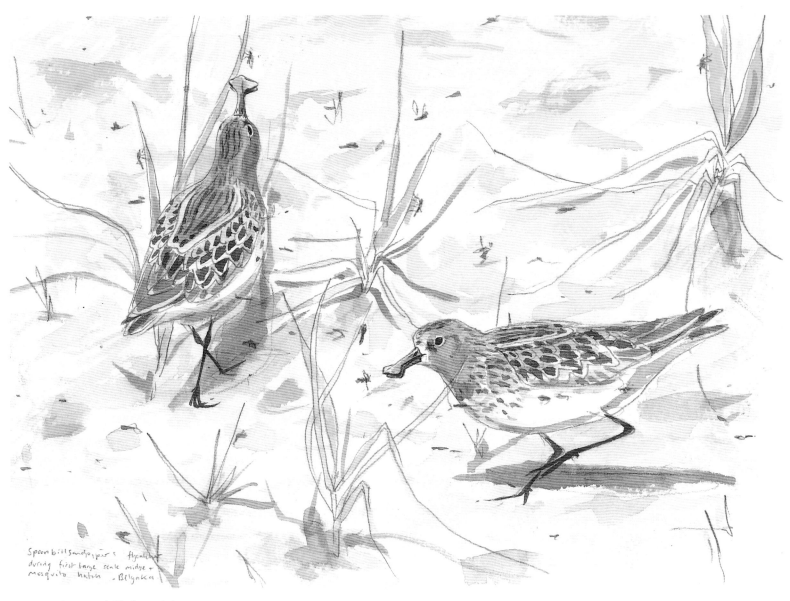

Spoon bill sandpiper x flycatching
during first large scale midge +
mosquito hatch — Belyaka

A pair of spoon-billed sandpipers
'fly-catching' during the first big
hatch of midges and mosquitoes.
22nd June 2002.

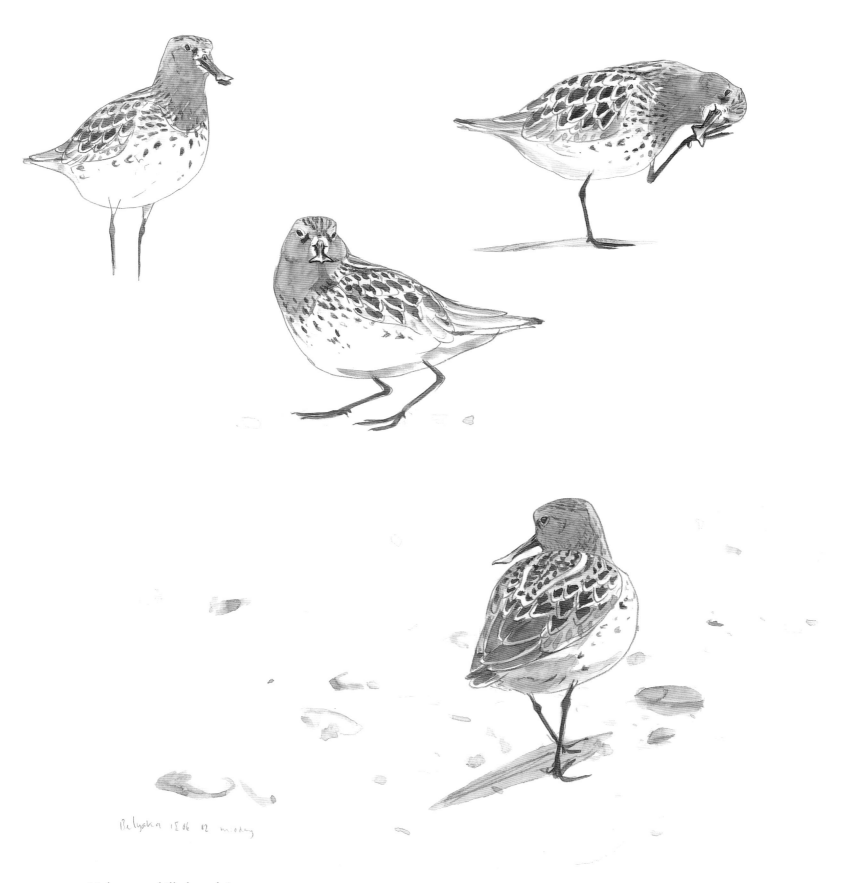

Belyaka 15 06 02 morning

Male spoon-billed sandpipers.

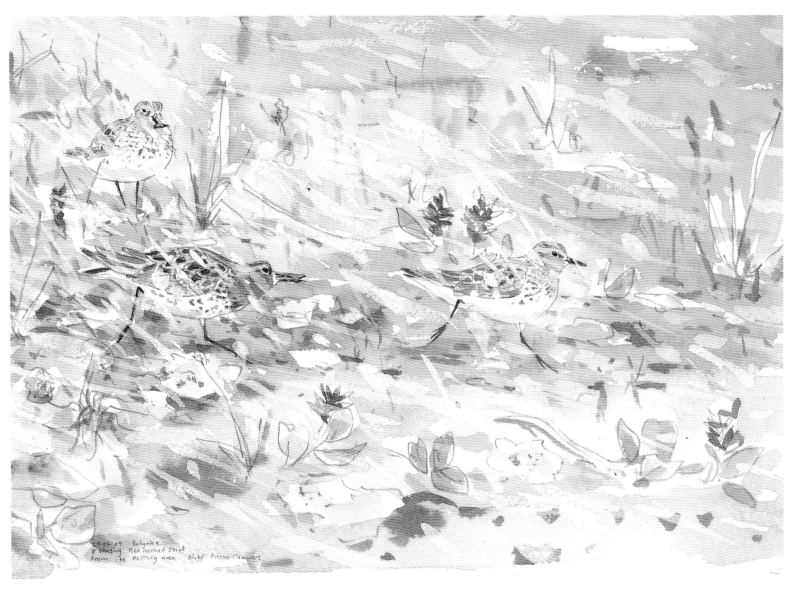

During a snow flurry a male, watched by his mate, chases a red-necked stint from the nest-site. 29th June 2002.

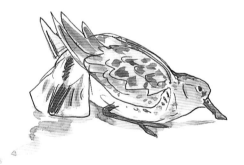

A male tries to distract me away from his nest by feigning injury.

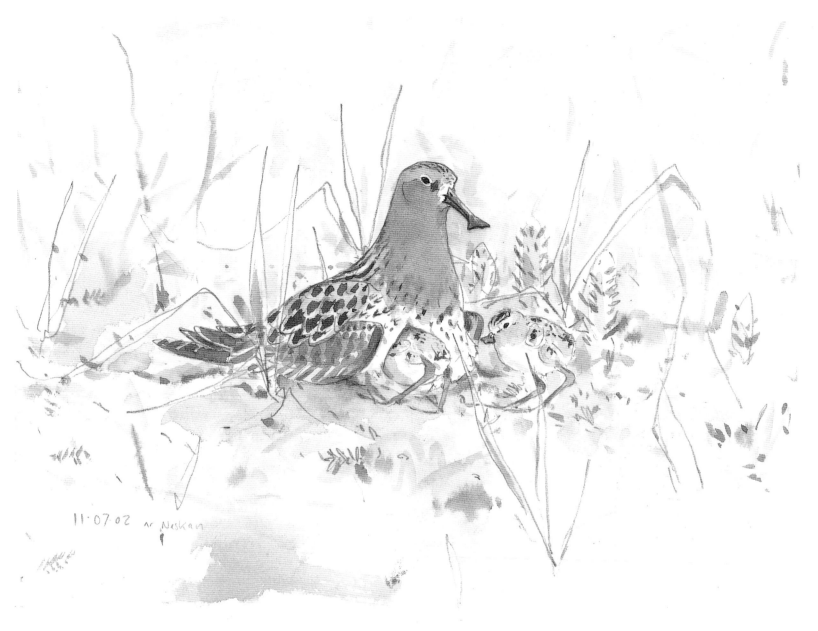

11·07·02 nr Neshkan

I was due to leave Belyaka Spit just as the
first spoon-billed sandpiper eggs began to
hatch. We were to see chicks at a later stage
of the expedition, including this male
brooding young. West of Neshkan,
11th July 2002.

Newly-hatched chicks. Rekokavrer
Cape, 9th July 2002.

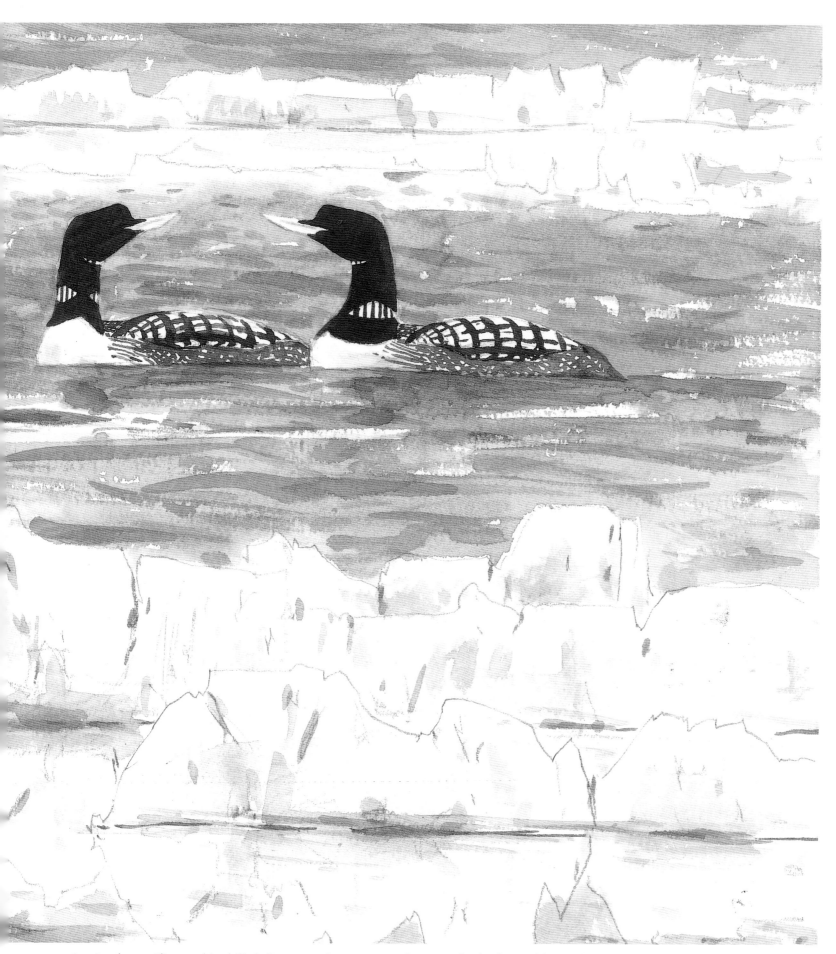

A pair of magnificent white-billed divers together on an ice-free stretch of a frozen lake. Belyaka Spit, Chukotka, 2nd June 2002.

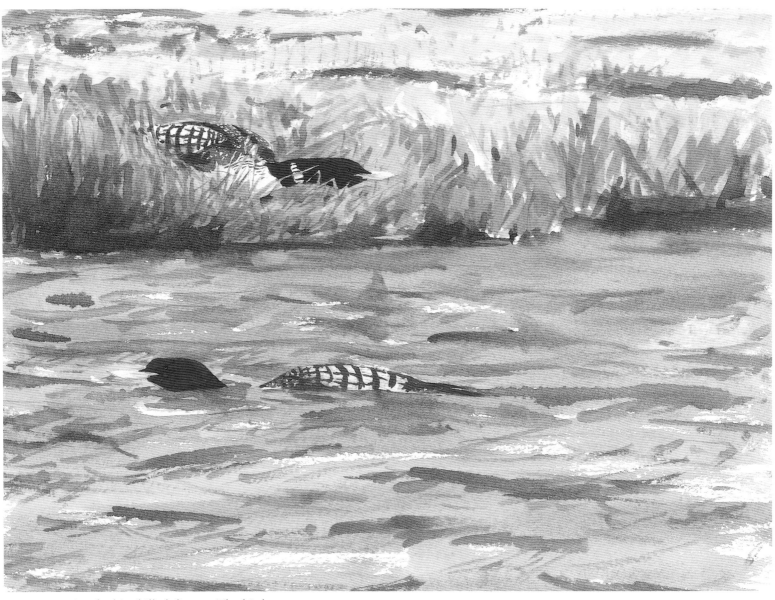

A nesting pair of white-billed divers. The bird on the bank lies flat on its nest while is partner sinks low in the water.

Sometimes the head and bill is all that can be seen of these huge birds. If the water is choppy even these can be difficult to see and it is surprising how easily such a massive bird can seemingly disappear. Belyaka 25th June 2002.

My past experience of divers was of seeing them in their grey and white winter plumage on the open sea. In their summer dress they are absolutely beautiful, with many intricate markings and large, attractive eyes, features that don't carry well over long distances.

I had seen black-throated divers in breeding plumage in Lapland, where they gather in spring in small openings in the ice on the mighty Lake Inari. Later, as the ice melts they move onto smaller lakes to nest. However my month spent on Belyaka Spit, proved to be an amazing and unforgettable encounter with divers.

Pairs of red-throated and Pacific divers were regularly found all over the spit, nesting on lakes. On the larger lakes there were several pairs of magnificent white-billed divers. I can still picture vividly the first one I saw as it swam on a small patch of ice-free water. I stopped dead in my tracks. I could barely comprehend what I was seeing; it was both exhilarating and awe-inspiring. The diver was unnerved by my approach and, after a few minutes, it launched itself into flight using powerful wingbeats aided by its huge webbed feet, with which it ran along the surface of the open water. I was left in a state of disbelief and never really got used to the fact that I shared my summer with these birds nesting nearby.

On the southern part of the spit there was a single pair of black-throated divers. They were very similar to the Pacific divers but differed in subtle ways. Their heads were a slightly darker lead-grey, lacking the peculiar 'blonde' cast that the Pacific divers often appeared to show. They have a patch of white on their flanks but this was not always visible and depended on their posture. Often the easiest way to tell them apart was by comparing the black-throated divers' slightly larger size, longer snake-like neck and its fractionally heavier bill.

It was wonderful to fall asleep around midnight listening to the cries and wails of the divers. It was not until I went to Alaska, however, that I saw the great-northern diver in its spectacular summer plumage.

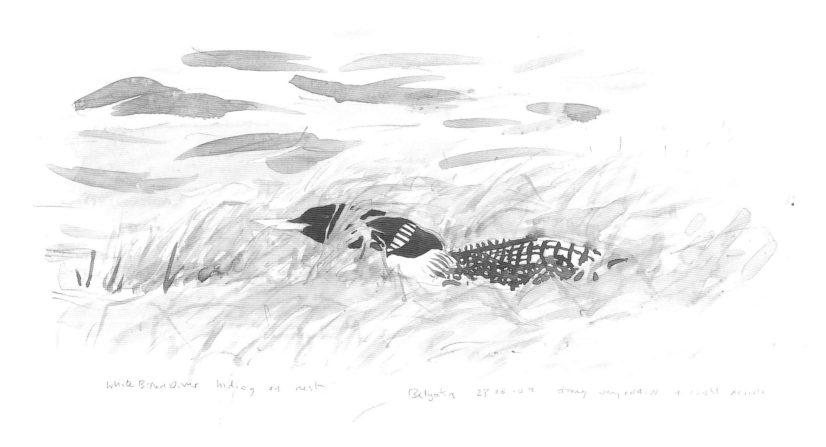

White-billed diver hiding on its nest.

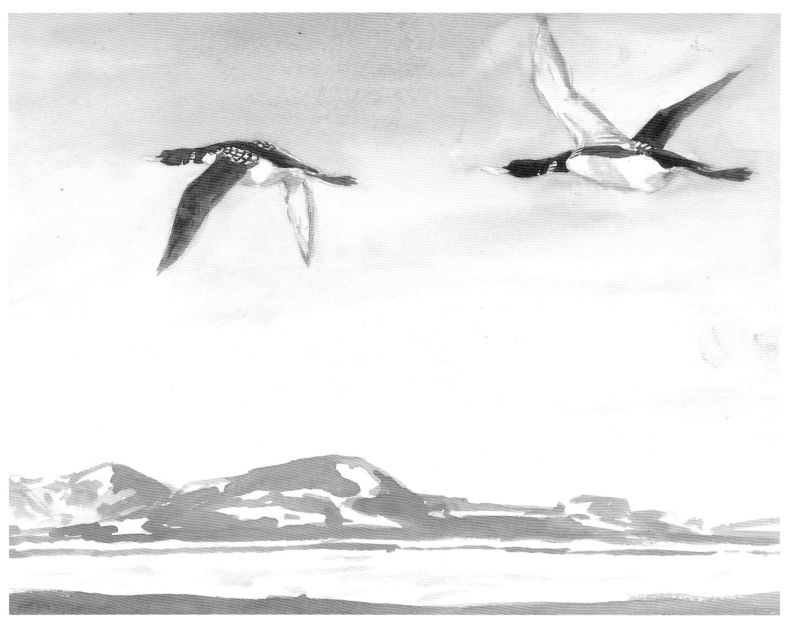

A pair of white-billed divers flying over the
springtime landscape of Belyaka Spit.

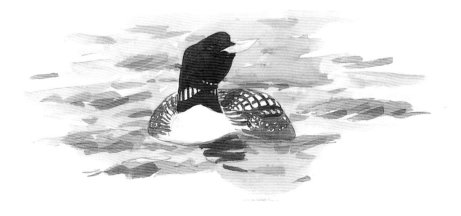

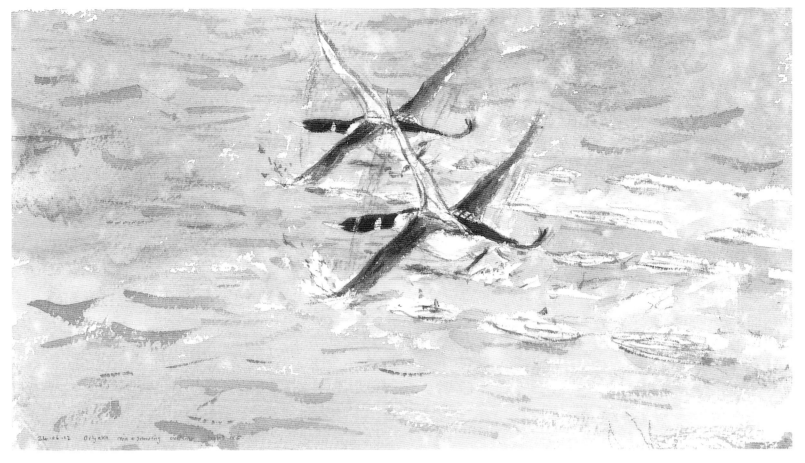

Using fast, powerful wing-beats and with the help of their huge webbed feet the pair get airborne. Each time their feet come out of the water they are held closed and the backwards thrust causes them to curl upwards. 23rd June 2002.

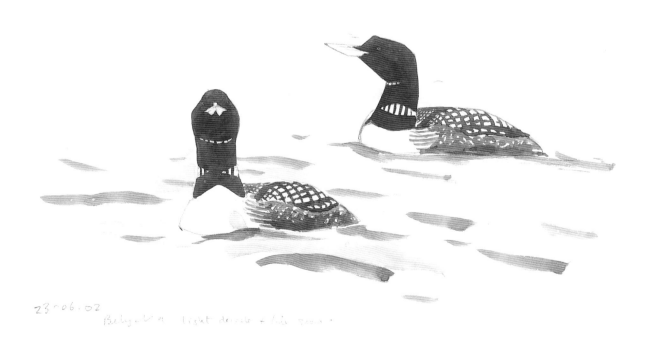

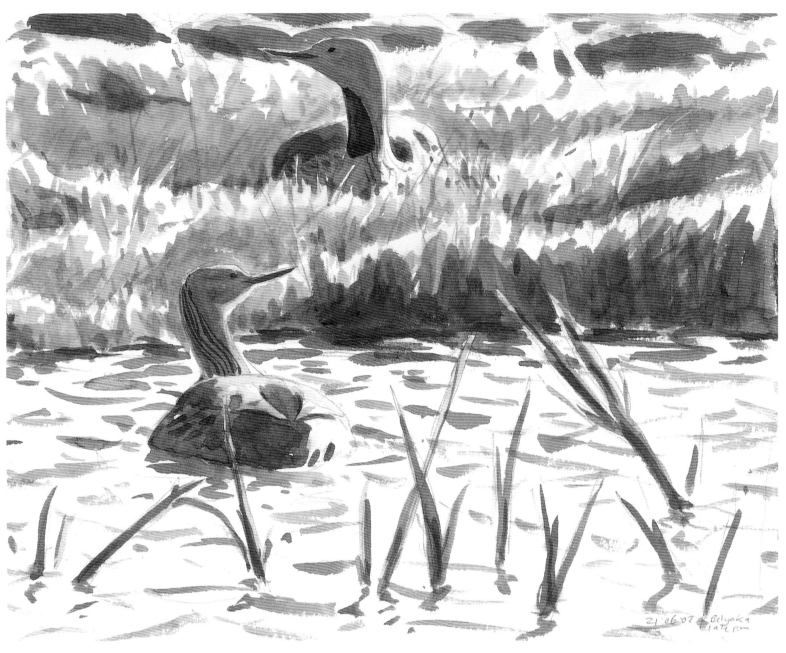

Red-throated divers in the late evening
sun at their nest-site on the edge of a
small lake. Belyaka, 21st June 2002.

Sounding their loud 'goose-like' calls a pair of red-throated divers
arrive in from over the frozen sea. Belyaka, 25th June 2002.

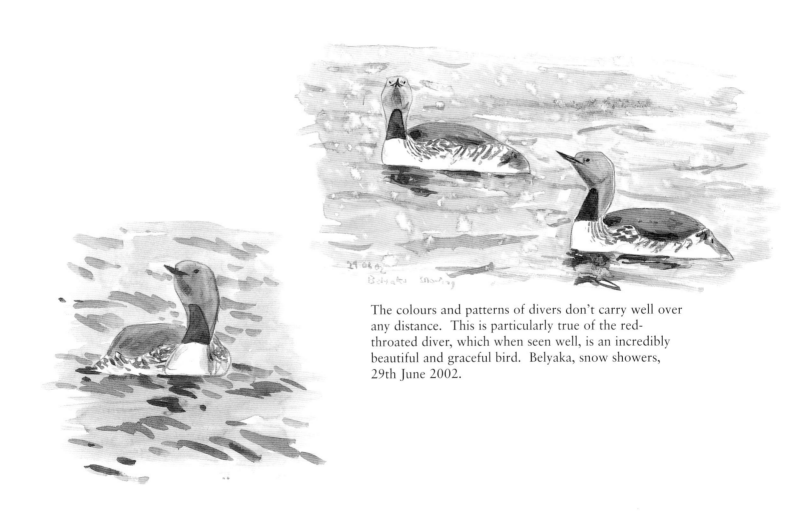

The colours and patterns of divers don't carry well over
any distance. This is particularly true of the red-
throated diver, which when seen well, is an incredibly
beautiful and graceful bird. Belyaka, snow showers,
29th June 2002.

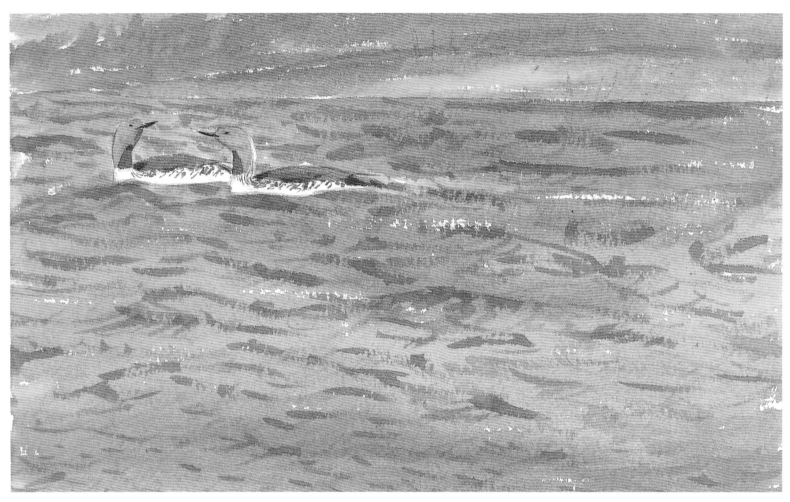

A pair of red-throated divers. Belyaka, June 2002.

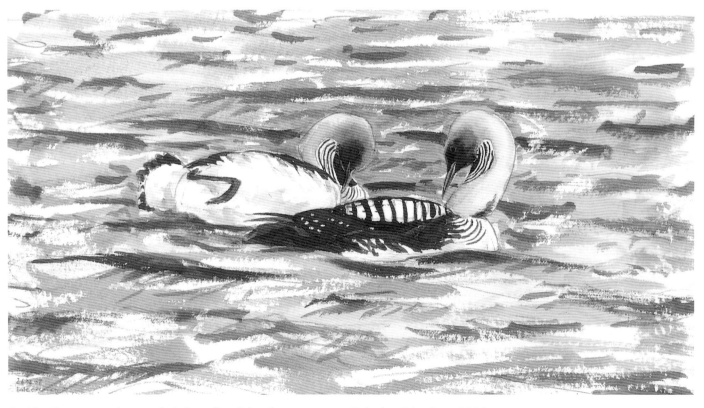

Pacific divers preening on their breeding lake close to camp. Belyaka, 21st June 2002.

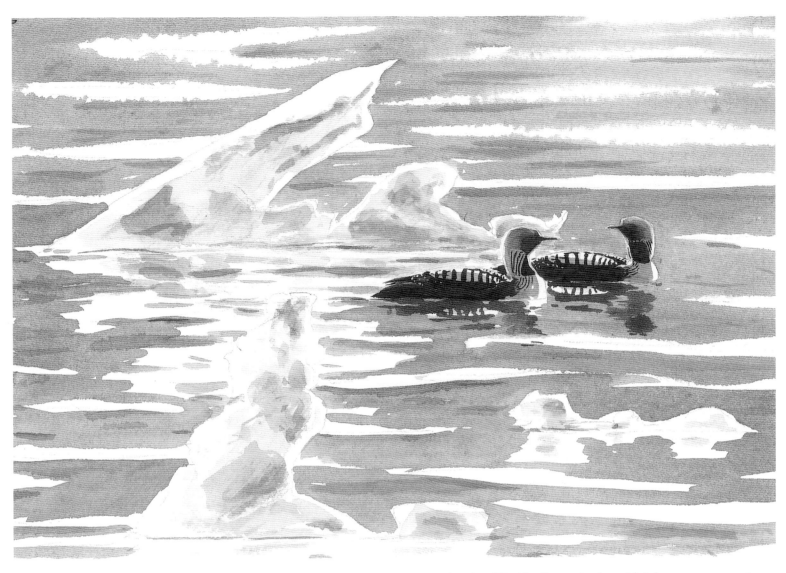

A pair of Pacific divers, in the midnight sun, amongst ice formations close to the mouth of the Kolyuchin Gulf.

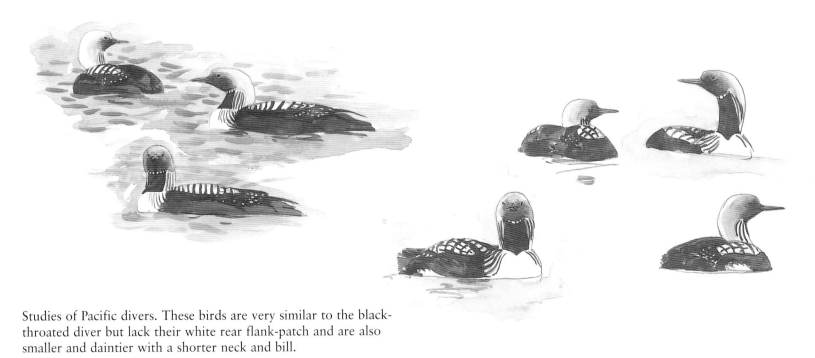

Studies of Pacific divers. These birds are very similar to the black-throated diver but lack their white rear flank-patch and are also smaller and daintier with a shorter neck and bill.

Phalaropes

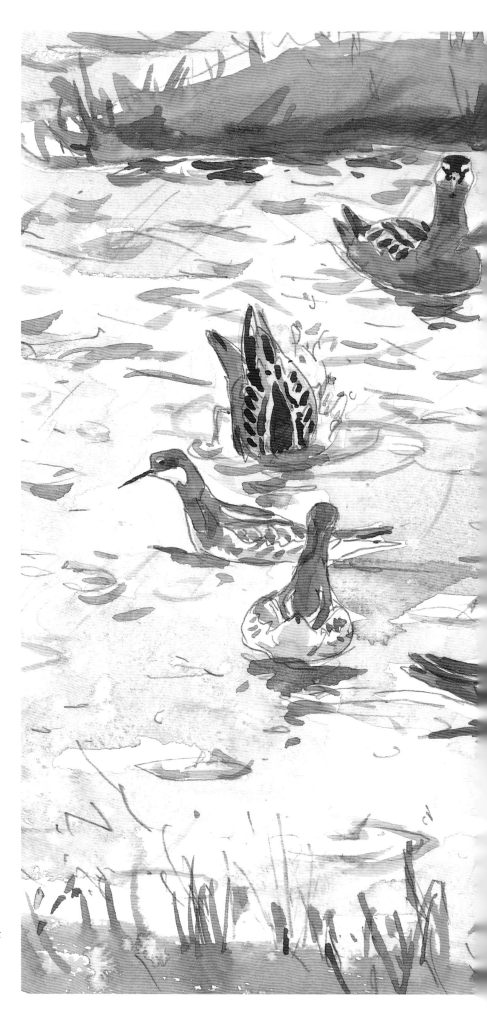

Large groups of both grey and red-necked phalaropes gather to feed in small coastal pools. Belyaka, overcast with light rain, 15th June 2002.

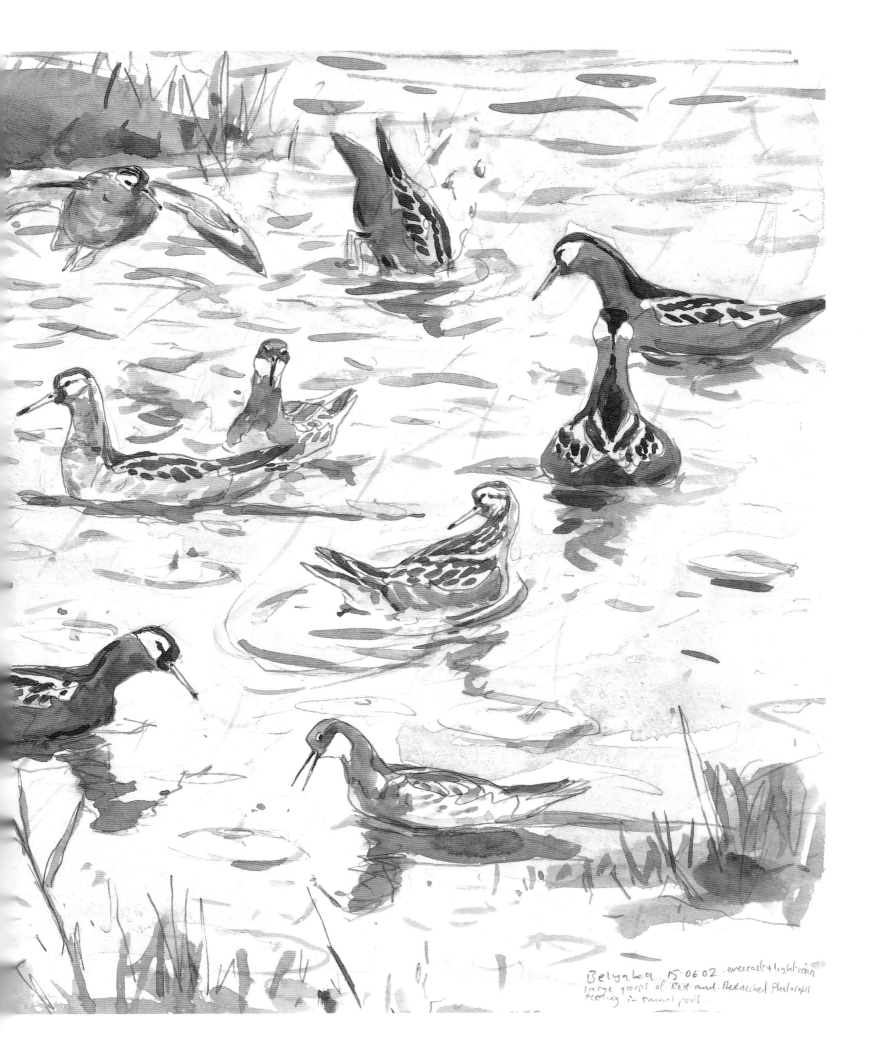

Belyaka 15.06.02 overcast + light rain
large groups of Red and Red-necked Phalaropes
feeding in small pools.

113

Phalaropes are unusual amongst wading birds in that it is the female of the species that has the brighter plumage and courts the male. I have seen females displaying to duller-plumaged males by making strange, twisting flights. At other times, when paired, females beat their wings suddenly and rapidly producing a loud whirring noise. Sometimes the females lead the males around pool edges to show them a series of potential nest-sites. All this display and courtship behaviour by the brighter member of the pair makes it easy to forget their genders. I am always initially surprised when the duller male mounts his richly-coloured partner and mates with her.

Early in the season it is common to see pairs dotted on small pools all over the tundra and it is the females, which see off any intruders. It is not unusual to witness chases where several females pursue a single male and this behaviour reminds me of drakes chasing a duck; I have seen as many as five grey and up to seven red-necked phalaropes in pursuit of single males.

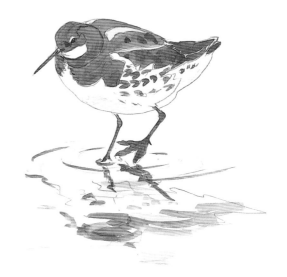

This pelagic existence is unique amongst waders. Their feet have evolved to suit this sea-faring life by developing coot-like, lobed feet, with half-webs between their toes. Phalaropes can be remarkably confiding. The following diary account tells of my first close encounter with a red-necked phalarope.

Pieran Marin Jänkä, 10th June 2000
There were a couple of small, round pools in the palsa bog. I painted a female red-necked phalarope feeding on one, only a metre away, seemingly unconcerned by my presence. From time to time she would suddenly become very alert and begin calling. It would often take a while before I could see or hear another phalarope migrating over the bog. Here I also saw the famous 'spinning' for the first time. This began with an obvious backward kick from one leg, which was then continued; the inside leg was presumably held motionless to maintain stability as the bird swirled around in a tight circle. By performing this manoeuvre, many food items must have been brought to the surface since the phalarope repeatedly pecked in all directions.

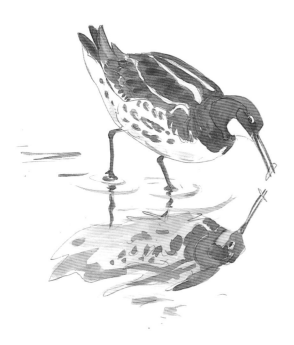

Once mated the female lays a clutch of eggs for her mate and it is he who incubates them and rears the young. She may stay on for a week or so and may even lay another clutch of eggs for a male who has lost his own. However she will soon disappear. By July, females can often be seen gathered in large groups on pools or the open sea, where they swim around like miniature gulls. On a short boat trip along the Arctic Coast of Siberia I counted over one hundred and sixty female grey phalaropes on the open sea. They were in small flocks of between fifteen and forty and looked stunning as they swam and flew around in tight groups.

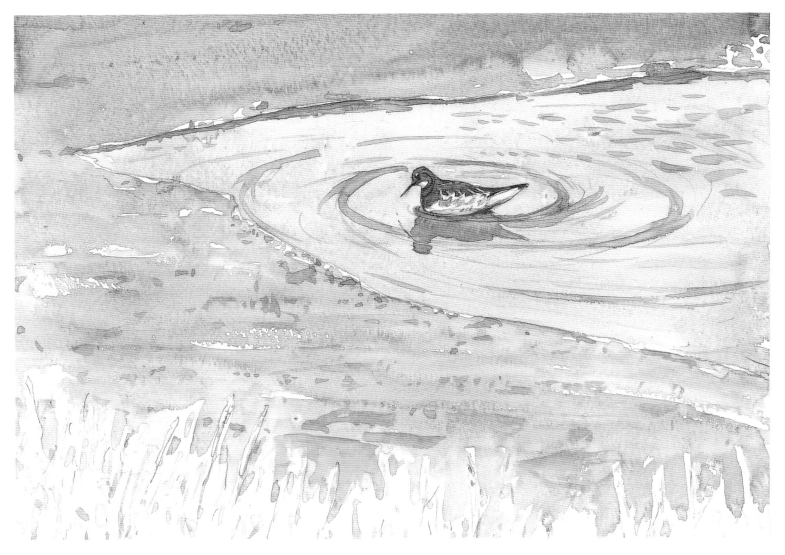

Female red-necked phalarope. This bird was feeding by 'spinning' on an open patch of water on a frozen lake. Belyaka, early morning, -4°C but feeling colder, 31st May 2002.

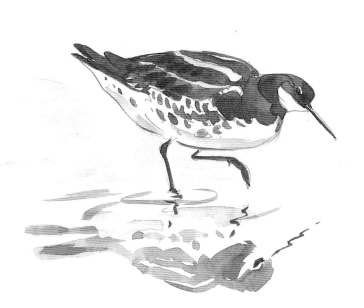

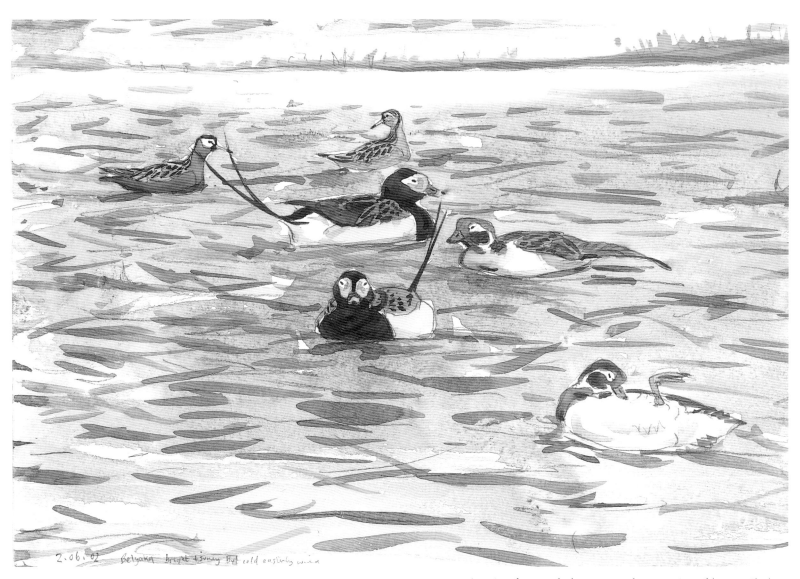

2.06.02 Belyaka bright + sunny but cold easterly wind

A pair of grey phalaropes and two pairs of long-tailed ducks gathered on a small open pool. In the evening light, the warm areas of their plumage seemed to glow. Belyaka, 2nd June 2002.

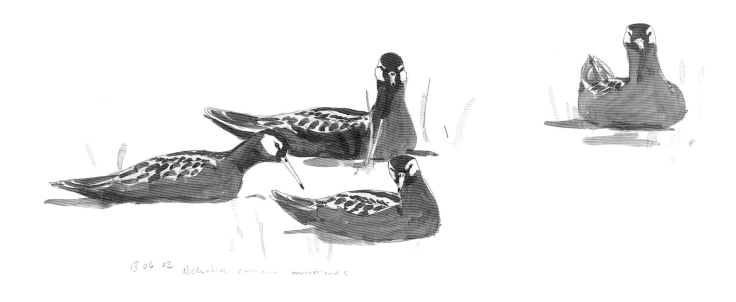

13.06.02 Belyaka enclosure overcast cold S

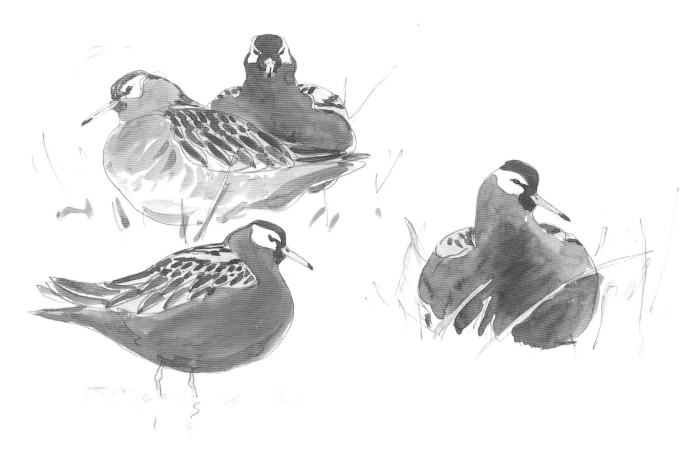

11·06·02 Belyaka
only very light NE today overcast but about
pm 3 Gulm cold to draw

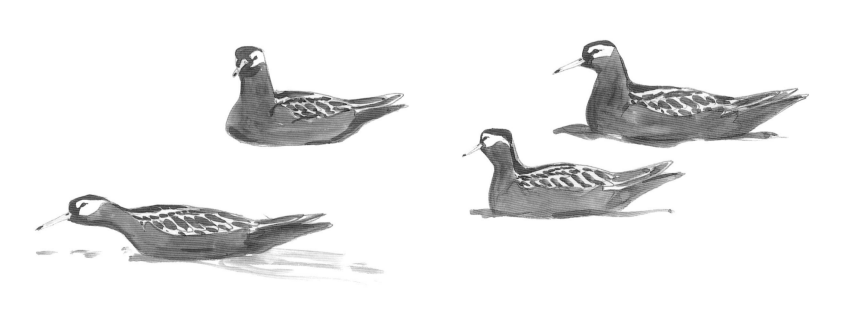

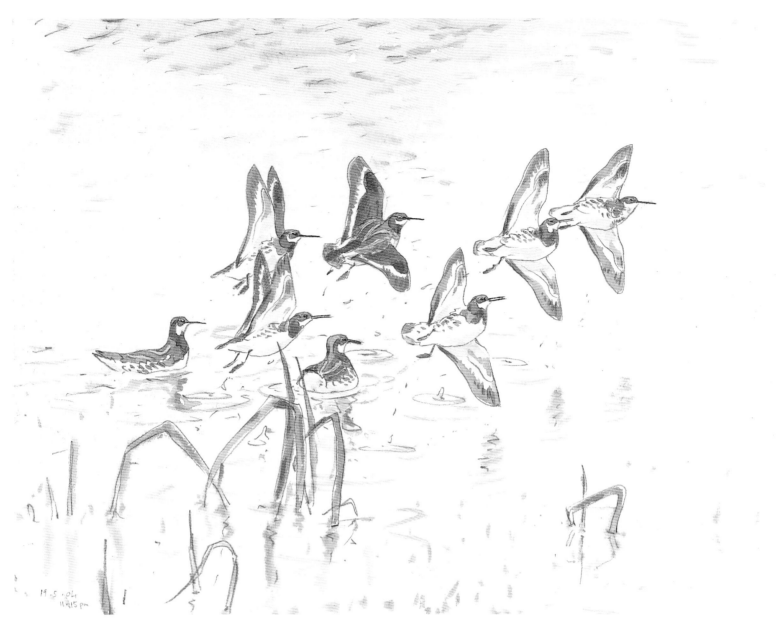

A flock of seven female red-necked
phalaropes in pursuit of a single male.
Old Chevak, 11.15pm, 19th May 2004.

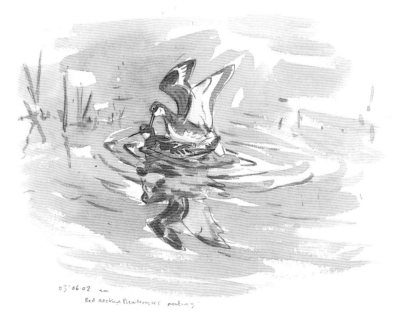

As it was the female who performed all the
courtship displays, it was easy to forget its true
gender. So when they came to mate, it was the
duller-plumaged male, of course, who mounted
the female. Belyaka, 3rd June 2002.

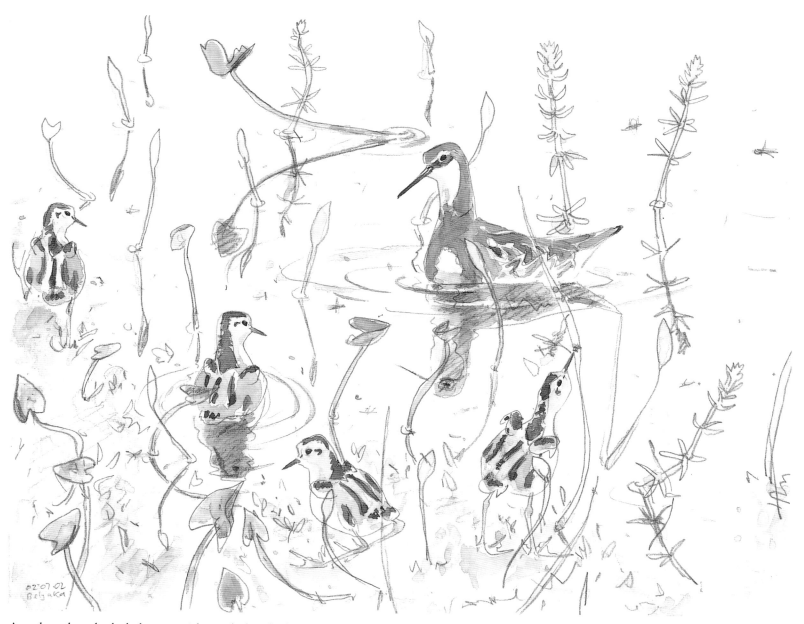

A male red-necked phalarope with newly-hatched young. These tiny atoms of life favoured the edge of the mud pool where there was an abundance of freshly-hatched insects on which to feed. Belyaka, 2nd July 2002.

At Old Chevak, this male had built his nest right next to the boardwalk leading from the tents to the old church. At first it was nervous and would leave the nest whenever people walked by but, after a few days, it grew used to our daily movements. 28th May 2004.

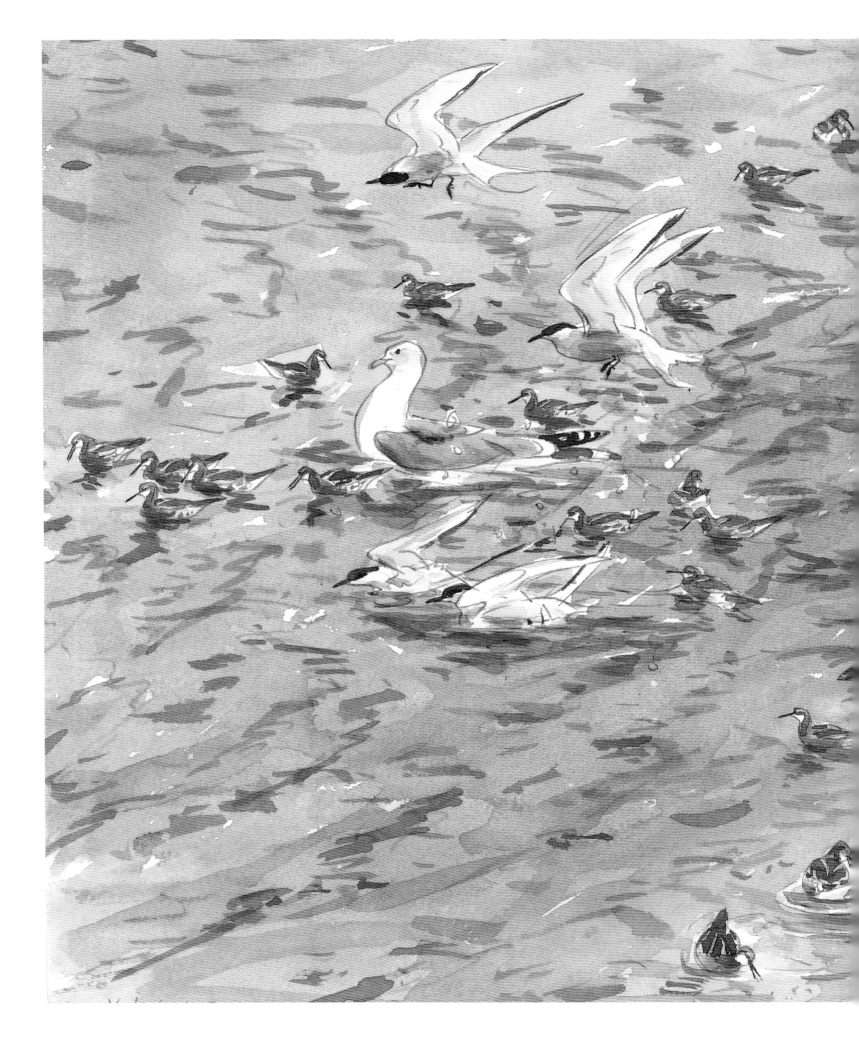

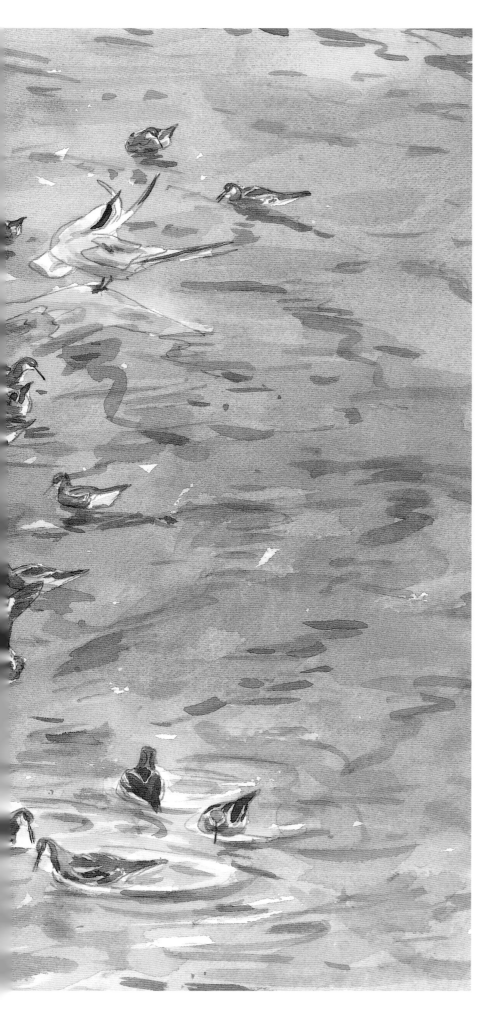

Shortly after laying their eggs, the females leave it to their mates to incubate them and bring up the young. Having left the nesting area, they frequently gather together in groups. Up to eighty female red-necked phalaropes were found on this pool in Vadsøya, Varanger. They often shared it with common gulls and arctic terns which used it for bathing, 4th July 2000.

In Lapland, it is possible to experience a snow flurry or hail storm even in June. A red-necked phalarope shelters from a shower of large hailstones amid mosses and horsetails, and the flowers of sedges and bog rosemary. Mielikköjänkä, 16th June 2000.

Dotterel

A male dotterel incubating its full clutch of three eggs on a fell-side at Kiilopää.

I observed him, using my telescope, sitting amongst lichen-covered stones, dwarf birch and crowberry leaves. He seemed remarkably timid for this species and I later discovered a freshly-plucked dotterel close by, which helped to explain his nervousness. The day began with rain and drizzle and by the time I had finished painting, thick fog had engulfed the fells. I was completely disorientated and it was some time before I was able to pick up one of the trails that led back to the car.
27th June 2000.

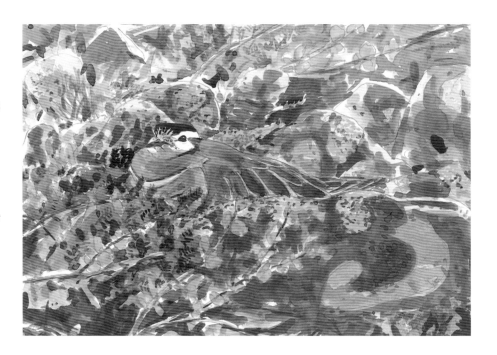

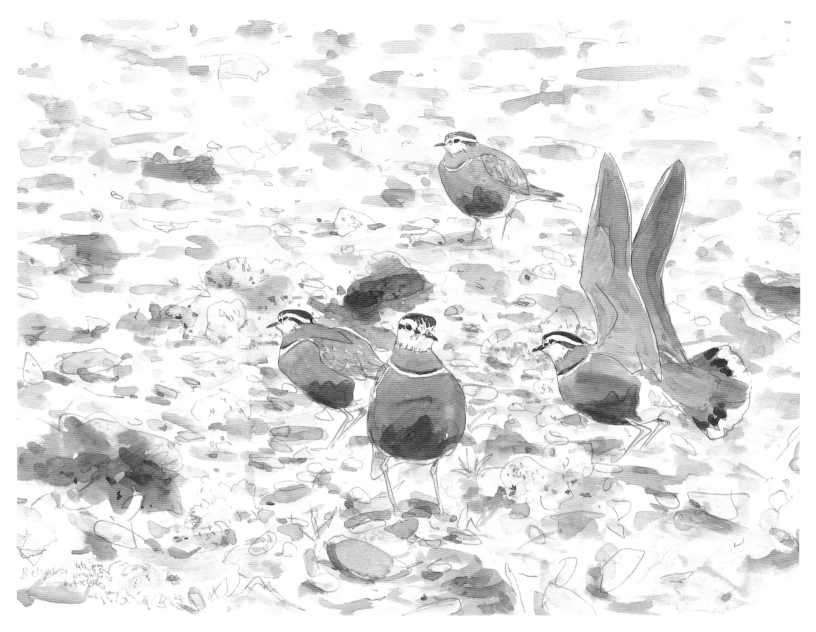

The dotterel is like the phalaropes in that it is the female, which has the brighter plumage. It is also the female, which sings and displays and it is the male who is left to incubate the eggs and rear the young alone.

A party of four dotterel arrived on Belyaka Spit in the late afternoon and favoured one of the dry-moss and lichen-covered gravel ridges. The females engaged in much posturing, aggressive-looking displays and brief nest-scraping.
7th June 2002.

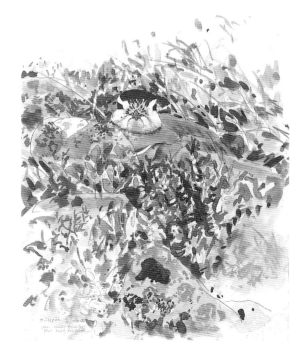

Arctic Foxes

This small fox is another species, which exhibits adaptive colouration. Throughout the winter, the foxes' coats are thick and pure white. During the spring, they begin to lose them and they can look a bit 'moth-eaten' as they start to moult into a darker lead-grey or brown coat. This shorter, summer coat reveals their true diminutive size. Despite their small size they are often the main predator of birds' eggs and young.

Successful breeding years are often closely linked to the abundance of lemmings and voles, whose numbers fluctuate over a three or four year cycle. However, over large areas of the Arctic these rodent-peaks can be more erratic in occurrence. The foxes only breed when rodents are abundant and form their staple diet and, for that matter, that of other arctic predators such as skuas and snowy owls. As a consequence ground-nesting birds are left largely unmolested and can experience bumper-breeding years. When rodent numbers are low, the foxes, although not breeding, have to turn their attention to other food sources and, during the nesting season birds' eggs and young will form the main part of their diet. Any surplus food maybe cached underground.

Although arctic foxes are beautiful animals and very much a part of the natural food cycle, it can be very frustrating to see a large percentage of eggs and young depredated by them before your eyes.

In Siberia I remember asking my Russian companions about the chances of seeing an arctic fox. They, being experienced visitors to the North, had already deduced that it was a poor rodent year and so replied "Don't worry, you'll see them soon enough and then you'll wish you hadn't". Later on I was thrilled to see my first foxes but soon understood what my companions had implied.

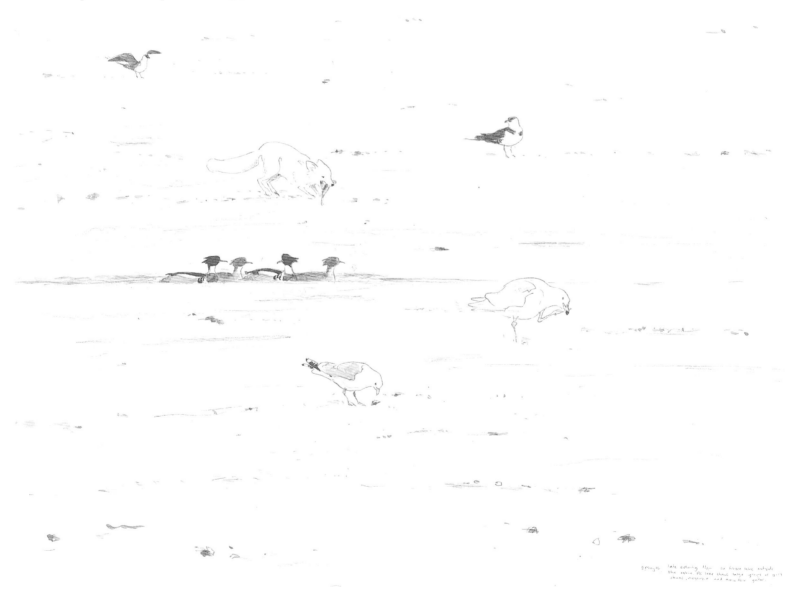

As the lake ice began to thaw and thin, many food items became available to wildlife. Long-tailed and arctic skuas join mew and glaucous gulls to pick at morsels in the ice. An arctic fox, still in its full winter pelt, finds a dead fish and startles a group of mergansers, which had just surfaced. Kanaryarmuit, late evening 8th May 2004.

An arctic fox approaches the nesting area of a pair of Vega gulls, which dive-bomb continually in an attempt to drive it away. The fox is used to such attacks; it has already raided the nests of other Vega and even those of the large glaucous gulls but, from time to time, it would turn and face them. The gull's nest was out on a small island, several metres from the lakeshore, but the fox simply slid into the water and swam out to the island, returning to the shore with an egg. Once the nest was discovered and the first egg plundered, the gulls gave up their attacks and just sat on the water and watched the fox return to take the remaining egg. A pair of long-tailed ducks watched from the lake edge; they too had already endured the same ordeal. Belyaka, 22nd June 2002.

Temminck's Stints

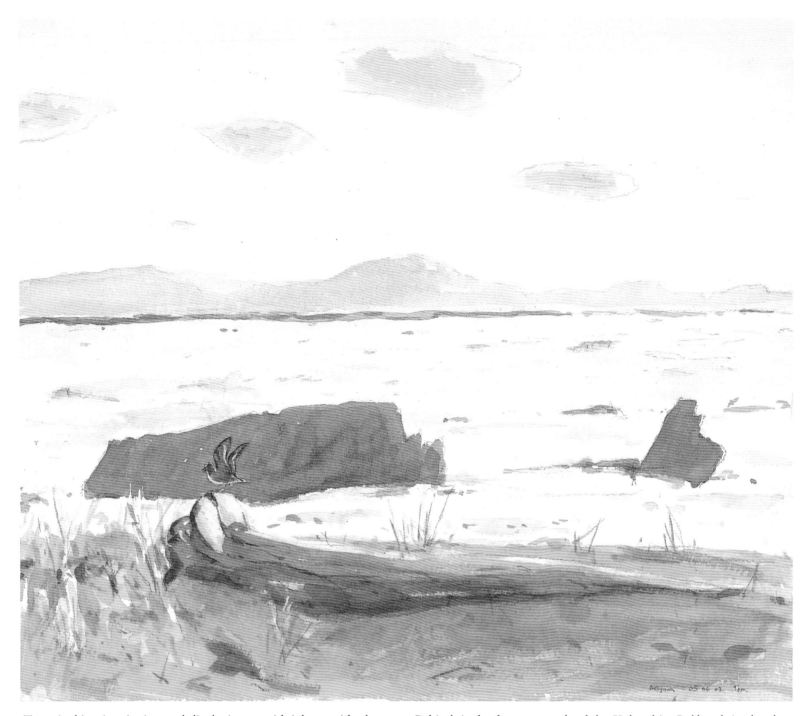

Temminck's stint singing and displaying at midnight outside the tent. Behind, is the frozen mouth of the Kolyuchin Gulf and, in the sky above, are the nacreous or 'mother of pearl' cloud formations characteristic of northern climates. These clouds are formed between twenty to thirty kilometres above the earth's surface and at temperatures below -80°C. Belyaka 5th June 2002.

Seeing my first Temminck's stint performing its hovering display-flight in northern Lapland was a magical experience. My attention was first attracted by its loud, bright, trilling song and I looked up to see a tiny bird hovering in the sky. Its fluttering wings, held high above its back, were angel-like as the low sun shone through them. In this vast open landscape, it seemed to me to be a tiny sprite, rising up from the bog and I instantly developed a soft spot for them. I had seen the first ones, towards the end of May, gathered on the thawing edges of the frozen lakes. They were so small

that they were difficult to see in the dead vegetation until they flew. On one occasion I saw a group of sixteen in a tight, noisy flock; as they whizzed around calling, they reminded me of a group of tiny common sandpipers getting ready to migrate.

The breeding behaviour of Temminck's stints is very interesting. In the North they are often found nesting in loose colonies. Once a male has attracted a female, the pair mate. The female lays a clutch of eggs for the male to rear;

Song-flight.

she then she finds a new male to mate with and lays a further clutch, which she incubates herself. The male delays incubating his clutch until he has mated with a second female. Overall, males will generally fertilise two clutches of eggs and females will mate with two separate males; this means that every bird has a clutch of eggs to rear themselves.

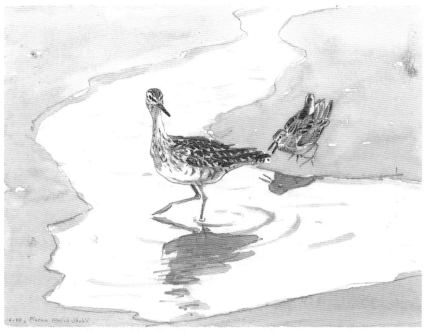

Despite its small size, this stint threatens a wood sandpiper, which passes too close to its nest. Pieran Marin Jänkä, 4th June 2000.

Temminck's stint with four newly-hatched chicks. Belyaka 2nd July 2002.

Lapland Buntings

During the spring Lapland buntings often gather to feed in fields and meadows where the snow has melted and exposed the vegetation. They will feed there before setting out on the next leg of their journey northwards to the bogs and tundra. The males are the first to arrive; this flock, which peaked at 120 birds, was made up almost exclusively of males. Ivalo 18th May 2000.

Lapland buntings are widely distributed across the northern bogs and tundra regions of Scandinavia, Russia and North America. They prefer open landscape, avoiding forests or dense scrub, but often favouring areas of dwarf birch and mat-forming willows.

The males are especially handsome, with their bold black and white markings and rich rufous-red neck-patch. Their song is a lovely, loose but rich, jangle, which is delivered from the ground, a low perch or in flight. During his song-flight the male rises diagonally up 15 to 20 metres above the ground. He then glides downwards on slightly raised wings, with his tail loosely spread and delivers his jangly song. His descent following a wide arc or spiral.

Once paired, the female sets about building the nest, often with the male close by keeping a look out for potential danger. The nests are made of grasses and, in Lapland, are frequently built on the sides of hummocks, concealed by dwarf birches. The nests are lined with feathers, often those of the willow grouse who, at this time of year, are moulting into their summer plumage.

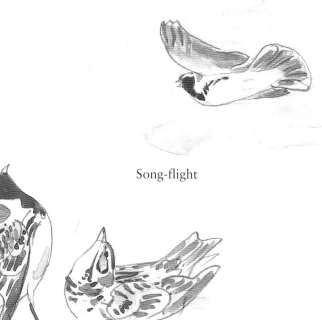

Song-flight

During courtship the male dances backwards and forwards in a semi-circle around his submissive mate.

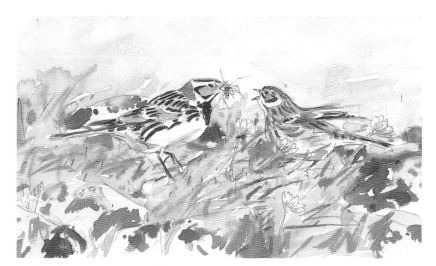

A female collects willow grouse feathers with which to line her nest, as her mate watches over her.

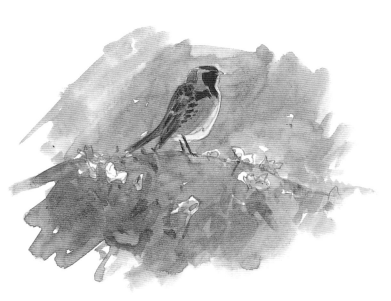

A male in low midnight-light amongst cloudberry leaves and flowers. Pieran Marin Jänkä.

A female presents one of her fledglings with a bill-full of crane-flies. Vardø, 10th July 2000.

Pectoral Sandpiper

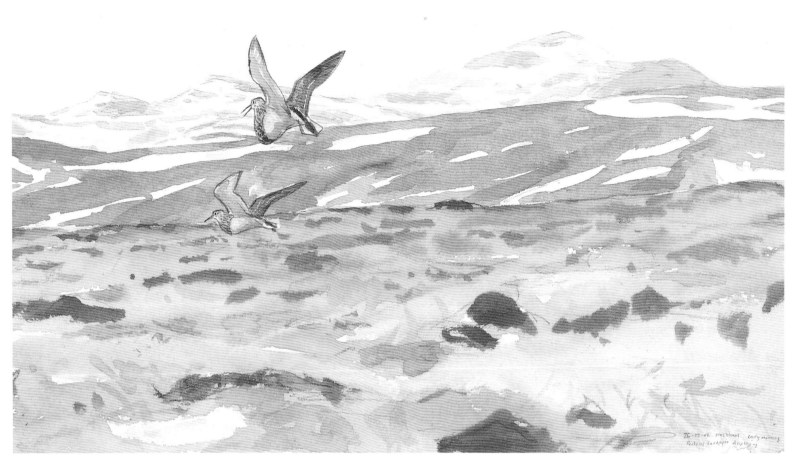

Males display to females both in the air and on the ground.
Neskan, Chukotka, 26th May 2002.

During my visit to Siberia, then again in Alaska, I quickly realised that my experience of these birds in Britain was very basic. I had read that the males possessed air sacs in their breasts, which they inflate during display but this in no way prepared me for what I was to witness.

The first pectoral sandpipers I encountered were around the village of Neshkan, on the arctic coast of Chukotka. They favoured wet sedge-filled pools on the tundra. The males often sat on hummocks and they could be seen to have a fully-feathered, loose fold of skin hanging from their breasts. Some were solitary whilst others were in small groups. They waited for migrating females to pass by, at which point, they suddenly launched themselves into flight, their loose folds of skin fully-inflated like a balloon. It was at once fascinating and grotesque to see the swollen, bladder-like breasts that seemed to vibrate, as the males produced their deep, booming song and pursued the females over the tundra. Having finished calling, they

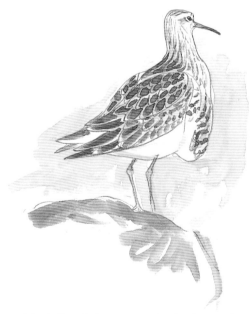

Males with deflated throats on the look-out for any migrating females to court.

glided on angled-wings, with their heads stretched forwards and their breasts deflated. They then suddenly flapped vigorously before they continued to glide and eventually landed.

The males sometimes courted the females on the ground, with their throats fully-extended and tails cocked. In some ways they were like ruffs, in that the males appeared to have established display grounds, to which they would return. As with reeves, the females, once mated, dispersed, built their nests and reared their young alone.

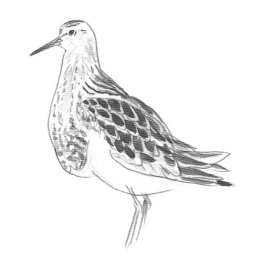

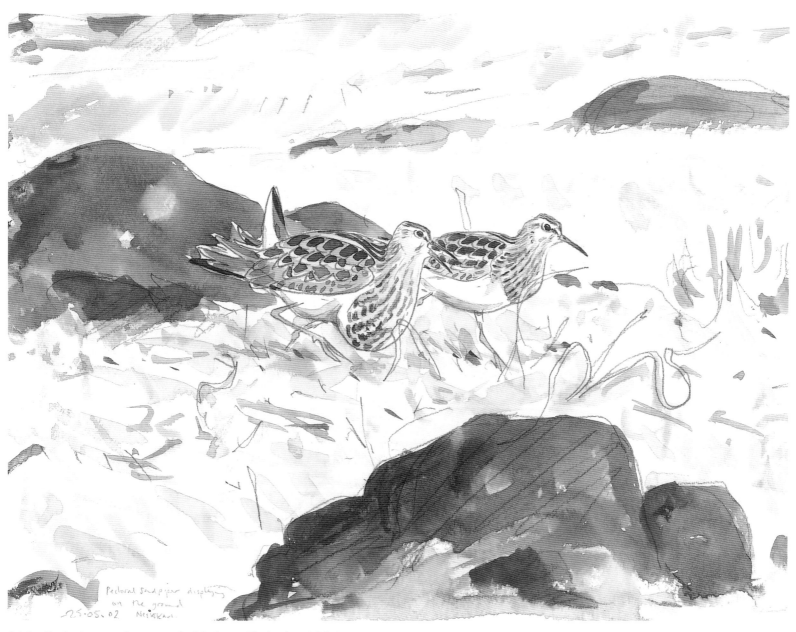

Male displaying on the ground. Neskan, Chukotka, 25th May 2002.

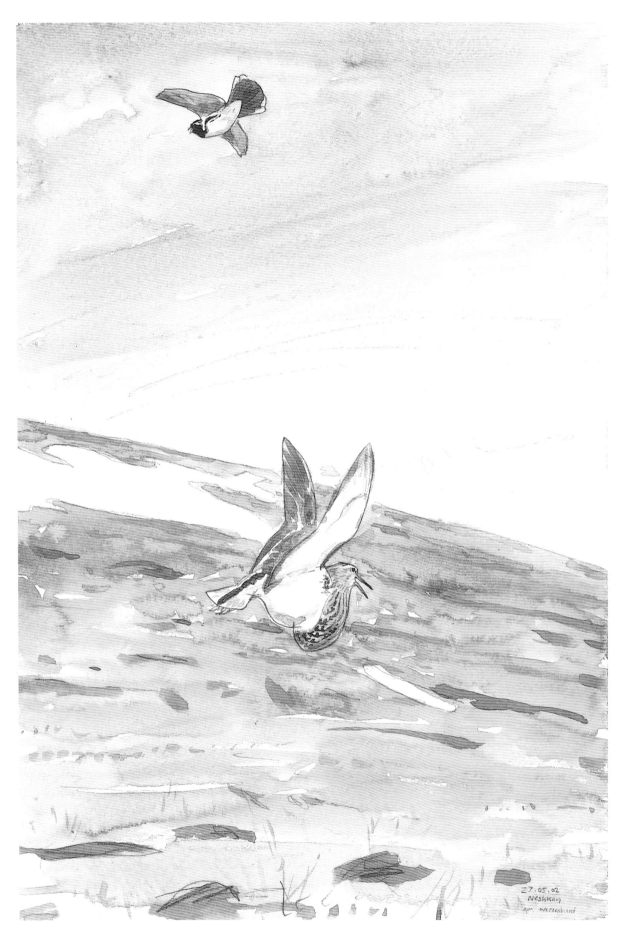

A male pectoral sandpiper, with fully-expanded throat, sings his booming song over the tundra, as a Lapland bunting song-flights overhead. Neskan, Chukotka, 27th May 2002.

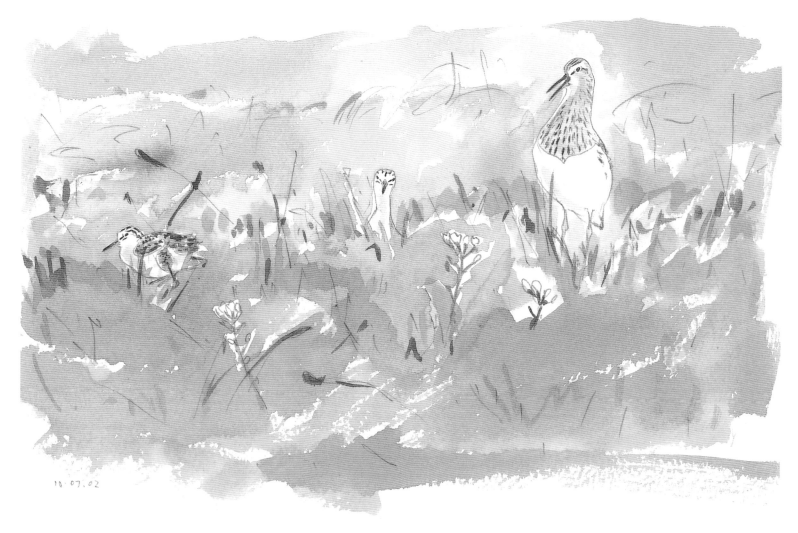

A female with half-grown, downy
young. Rekokavrer, 8th July2002

Skuas

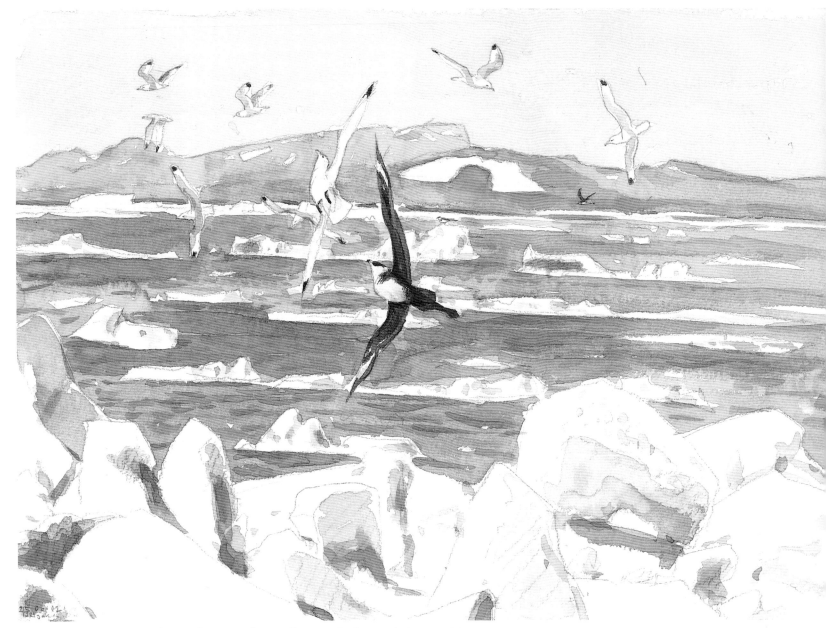

Pomarine skua harassing kittiwakes over the ice-floes. Belyaka, 25th June 2002.

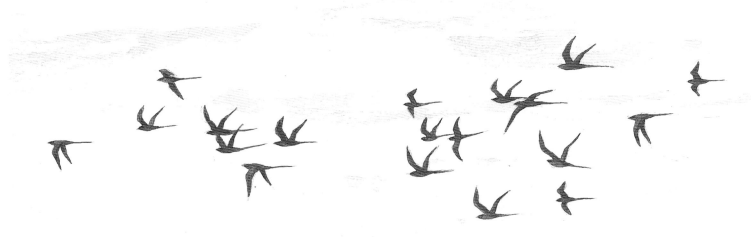

A party of long-tailed skuas migrating high in the sky. The low levels of rodents in Chukotka in 2002 meant that many did not breed and, by July, we encountered flocks of up to 120 birds, almost all of which were adults.

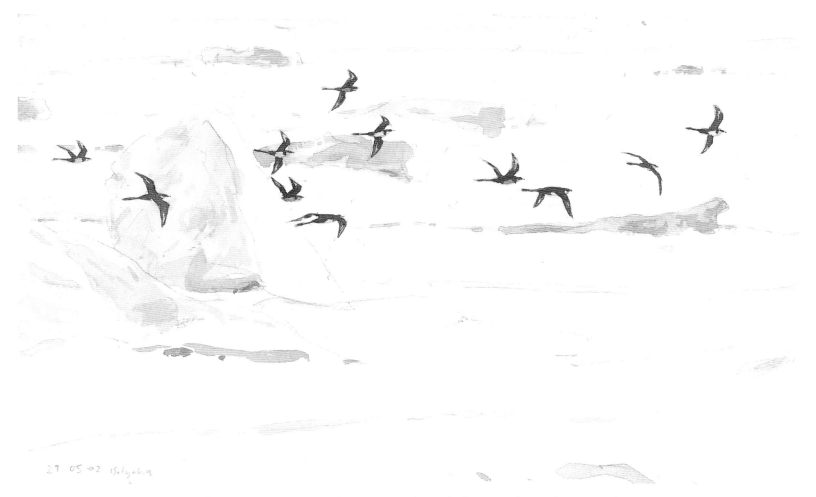

27 05 02 Belyaka

We experienced good numbers of pomarine skuas on Belyaka Spit at the end of May and in early June. They were migrating over the frozen sea or southwest over the spit. They had arrived on their breeding grounds to find low levels of rodents and, having decided not to nest, were already leaving. 29th May 2002.

Skuas are striking birds with a flight silhouette somewhere between a gull and a large falcon. In the summer, the adults are readily distinguishable by their central tail feathers. The pomarine skua's are long and thick, twisted at the end and forming a distinctive 'spoon' shape. The long-tailed skua's are really impressively long and thin, whilst those of the arctic skua are only half this length.

Pomarine and, to a slightly lesser degree, long-tailed skuas depend for successful breeding on there being good numbers of rodents available. Arctic skuas seem less dependent on rodents and will turn their attention to birds when rodent numbers are low.

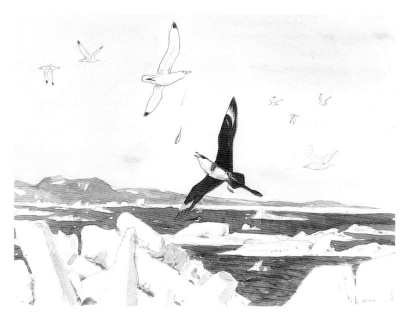

A kittiwake gives up its catch. Belyaka, 25th June 2002.

Grey Plover

Grey plovers breed in northernmost Russia, Siberia, Canada and Alaska. Ever since I first got to know them in their lead-grey winter plumage in creeks and on mudflats around my home in Norfolk, they have been one of my favourite birds. In late spring, prior to their northward migration and again on their return in early summer, it is possible to see them in their striking black, white and silver summer dress. The males are especially handsome, being solid-black below. This was one of the species I had dreamed of seeing on their breeding grounds and my dream came true, firstly in Siberia, then again in Alaska.

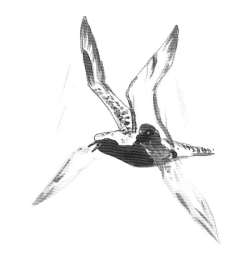

A grey plover flies with slow, elastic wing-beats, high over its territory, singing its mournful song.

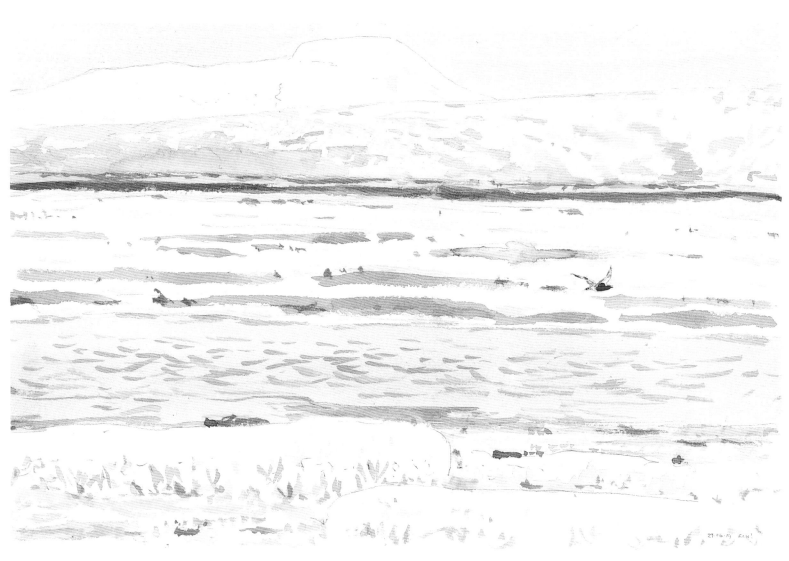

The first grey plover of the season passes over the largely-frozen landscape.
Aphrewn River, Kanaryarmuit, 29th April 2004.

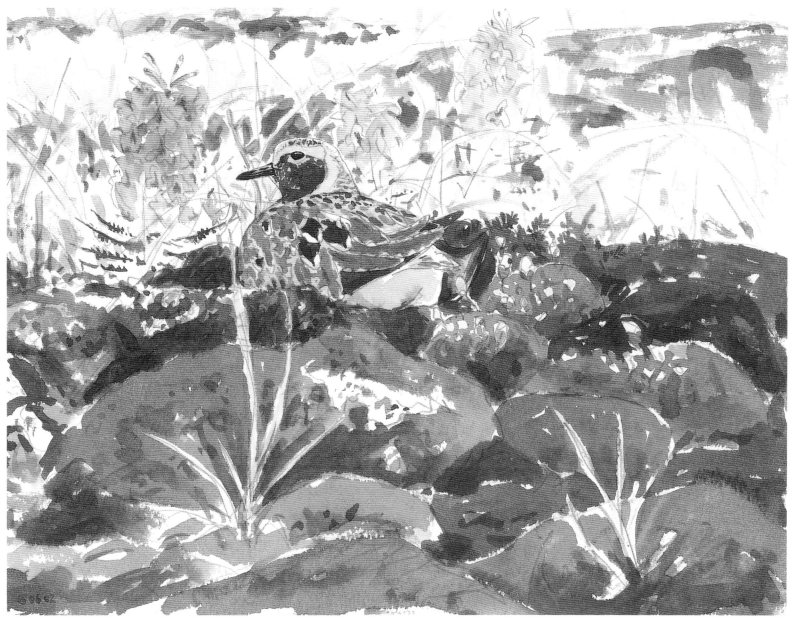

One of my lifetime ambitions realised. A female grey plover incubates her clutch of four eggs on an area of moss and lichen covered tundra, bordered by sedges and the flowers of lousewort. Belyaka Spit, 16th June 2002.

A male arranges lichen around his nest-scrape. Kanaryarmuit, 9th May 2004.

Having chased off a rival, this male briefly holds up his wings on landing.

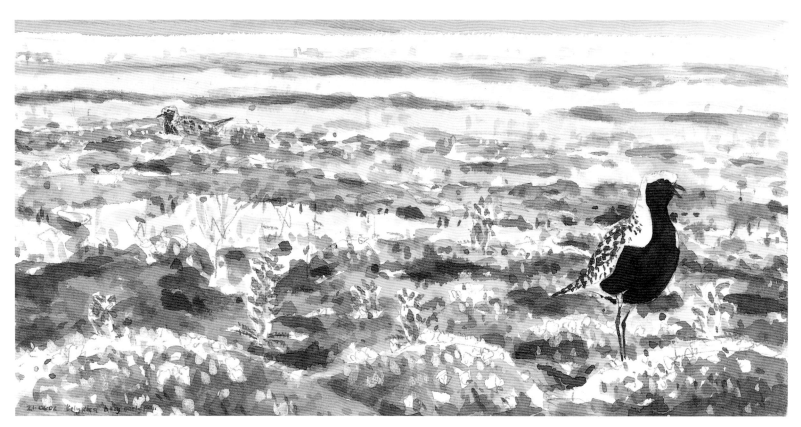

As I approach the nest area, the male warns the female of my arrival. Belyaka, 21st June 2000.

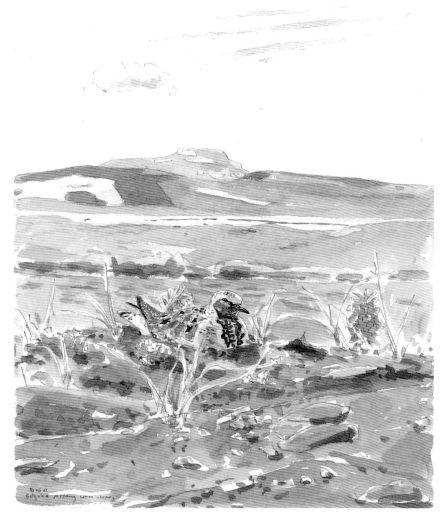

The grey plover on its nest.
Belyaka Spit, Chukotka, 16th June 2002.

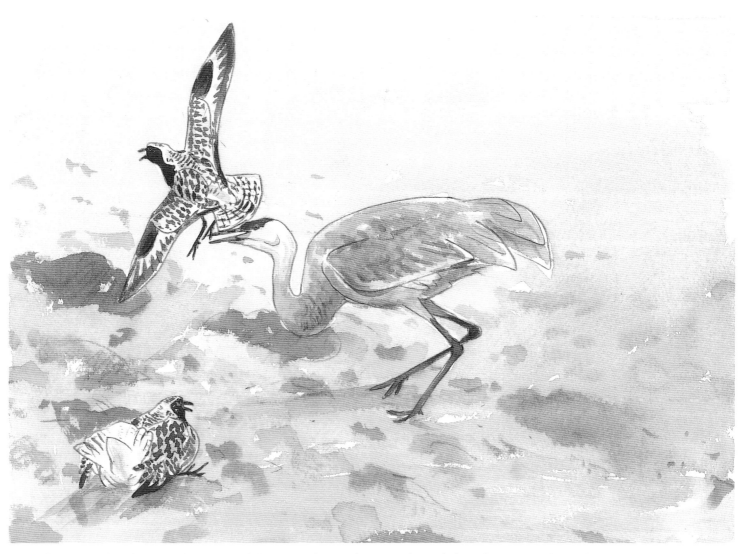

A sandhill crane has discovered the nest of this pair of grey plovers. The male launches an aerial attack, whilst the female feigns injury in an attempt to lure it away. These actions were in vain and the crane proceeded to stab the eggs with its heavy bill and drink the contents. Old Chevak, 26th May 2004.

Despite their heavy losses around Old Chevak in 2004, I did at least manage to see a pair with one small young. 24th June 2004.

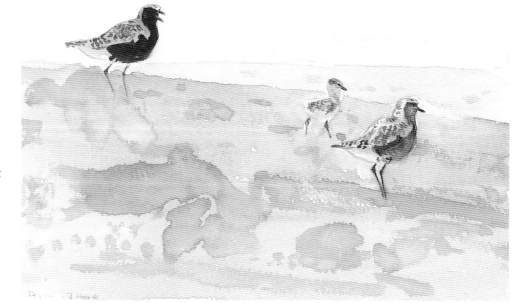

THE YUKON-KUSKOKWIM DELTA, ALASKA

An introduction by Brian McCaffery

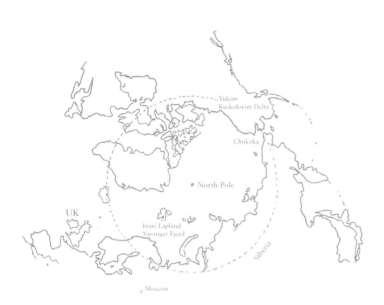

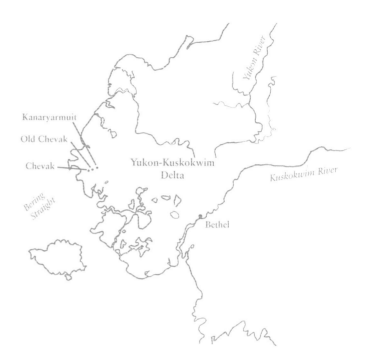

The Yukon-Kuskokwim Delta is a place of superlatives, a sprawling realm of marsh and slough where more land lies within the protective borders of a wildlife refuge than anywhere else in America. Here the Yukon River carries 100 million tons of sediment into the Bering Sea every year and 4,100 kilometers of shoreline are broken by 22 major river mouths and 13 bays. The breathtaking abundance of lakes and ponds still defies enumeration by the most advanced technologies available, and the intertidal mudflats alone cover over 3000 km2. The biomass of large breeding water birds may surpass that of any comparable area in North America, and the largest expanse of wetlands on the west coast of the continent supports the highest density and diversity of breeding shorebirds in the New World.

The Delta is a place of wonder. Gyrfalcons nest inside extinct volcanoes and bluethroats breed in ancient glacial valleys. The Yukon and Kuskokwim, two of the largest rivers in North America, feint to within 40 km of each other, then diverge to meet separate destinies nearly 400 km apart in the Bering Sea. Here mystery, exploration and discovery are a daily part of a biologist's life, and questions cascade endlessly like the headwaters of a river; the wild, wistful cries of loon and crane pierce the lavender stillness of summer twilight; surging pulses of salmon track obscure olfactory currents to their natal streams and brightly-clad Native women stoop over the tundra to harvest the bounty of late-summer berries. The winter's silence is broken only by the buzzy chatter of redpolls and the brittle, wind-swept rustle of diamondleaf willow.

The Delta is a place of contrasts. The flashing black-and-white of a Sabine's gull ripples in the shimmering heat reflected from a frozen spring landscape. Massive brown rivers, the colour of well-creamed coffee, are fed by alpine streams so clear that one can see the scutellations on the legs of wading tattlers. The mournful whistles of courting scoters echo across a lake below sea level while, just a mile away, snow buntings sing among the ice-shattered boulders on a summit 600 metres above sea level. The glorious colours of fall - poplar gold, blueberry maroon, bearberry scarlet - erupt in a paroxysm of blazing passion then fade before the immaculate imperative of winter. Some answers are earned through sweat and study and sacrifice, while others arrive as pure grace, borne on the breezes that stir the leaves of aspen.

The Delta is a place of connections, a complex tapestry in which invisible threads reach out to the far corners of the world. Clouds of godwits disappear into the autumn sky, and do not touch down again until reaching New Zealand. Northern wheatears, returning from a season on the plains of East Africa, bounce and hover across the stony tundra. Blackpoll warblers raise their young in shaded nests, then cross the entire continent and a wide swath of the Atlantic Ocean en route to the forests of South America. Grey whales cruise offshore within sight of brant colonies, then months later rendezvous with them in the lagoons of Baja, and anadromous salmon carry within their flesh marine nutrients from the north Pacific into the bright, gravelled riffles of the Andreafsky wilderness.

Other kinds of connections are made on the Delta as well. Strangers meet and friendships are forged. Such was the case for me in 2004. I have been a wildlife biologist on the Yukon Delta National Wildlife Refuge for 20 years. During the course of my field work, I have welcomed many colleagues from over a dozen countries to share in our research or to initiate their own. But learning about and conserving the wildlife and habitats of the Alaskan Arctic is not just a role for scientists. Without artists bringing their own special crafts to bear, only part of the wonder and mystery of the northland can ever be captured. So, over the

years, we at the refuge have also welcomed writers and photographers to our field camps but before 2004 never a painter. Thanks to a fortuitous connection, that was about to change. A colleague from Anchorage, Bill Eldridge, e-mailed me in late 2003 to let me know that he had briefly met a talented and energetic Englishman who was interested in visiting the Alaskan Arctic. Bill wondered if I might have room at any of our field camps for an extra volunteer during the coming field season. During my career, I have usually supervised projects focused on non-game birds, and these rarely attract the funding of waterfowl or big game projects. As a result, I'm always on the look-out for talented volunteers, so I followed up Bill's lead, and in December of 2003 sent an e-mail to England. Thus began my connection with James McCallum.

After corresponding for several weeks it became clear that James' field skills and my personnel needs dove-tailed beautifully. He had extensive experience of field surveys and I was more than willing to provide time in his schedule for sketching and painting. We began planning for James to spend May and June on the Yukon Delta National Wildlife Refuge, to witness spring migration and the nesting efforts of western Alaska's rich breeding avifauna.

James had big shoes to fill, literally. We always supply hip-waders for our field crews, so, in early spring, before his arrival, James e-mailed to let me know that he would need a pair of size 13 waders. We had none on hand at the refuge (few personnel ever need such large waders), so I had to place a special order. Weeks later, when I visited our local airport to pick James up, I was looking for someone of Sasquatchian proportions. Finding no such suspects, I focused my attention on a slim red-haired man who didn't seem to know anyone else at the terminal. Playing a hunch that the red hair might be associated with a Celtic surname, I approached a much smaller-footed man than I had anticipated with a tentative, "James?" Turning, he smiled, shook my hand, and the connection was made. Our shared arctic adventure had begun.

James visited two of our camps that spring, Kanaryarmiut and Old Chevak and I had the privilege of sharing time with him at the latter camp. Along with two other field assistants and the noted natural history author, Scott Wiedensaul, we spent several weeks trying to unlock the breeding mysteries of the bar-tailed godwit. Unlike many of my colleagues, particularly the younger ones, I spend considerable time in recording detailed accounts of bird behaviour and vocalizations. I encourage my field assistants to do the same, and I quickly discovered that James was an observer of extraordinary competence. Despite a lack of formal training, he seemed to understand intuitively which aspects of behaviour were particularly important and might provide cues to the discovery of nests or an understanding of territorial relationships. To my delight, he recorded his observations in our master field notebooks, not only with clear and concise written descriptions, but also with beautiful field sketches that were both scientifically accurate and visually evocative. His figures were graceful and dynamic; his sketched godwits looked ready to run right off the pages of the notebook and back on to the tundra.

During our weeks together, I never asked James to show me the sketches and paintings that he worked on in his off-duty hours. I didn't want to impose or convey the sense that he needed to 'perform' for us at the field camp. When a crew of visiting researchers stopped by camp, however, they asked James if they might see his work, and he duly obliged. As he cleaned the table in our cramped field cabin and gingerly spread his work before us, I was immediately impressed, not just by the quality of the work, but by the sheer volume of it. To this day, I have no idea how James completed so many sketches and paintings in the time available to him.

I have always appreciated bird art. As I was growing up, I was particularly fond of the realists, artists such as Bateman and Landsdowne who could capture the exquisite contours of avian plumage with such accuracy. They built on the legacy of Audubon and Fuertes and, in turn, mentored a generation of skilled artists who pushed the boundaries ever further, fostering an almost hyper-realism laden with the meticulous detail of individual feathers. But now, due to a technological revolution, work in this genre has become almost anachronistic. The breakthrough of digital photography allows even amateurs to capture the fine-grained minutiae and split-second action that previously only painters could portray.

James' work stands in stark contrast to the images created by both the realists and their technological heirs. His work is raw, rough, and spontaneous, like his avian subjects and the landscape they inhabit. James works almost exclusively in the field, unconstrained by the need to examine museum skins or enhance images on a computer. His watercolours do not devolve into a mosaic of tiny pixels; instead, his brush-strokes bind elements of his paintings together, an inadvertent metaphor for the connections his subjects have with their environment.

Whilst a high-quality photo can amaze us with its details, it also reveals the entirety of what can be revealed from that perspective. There is no mystery, no question left; we see all that the photographer saw at that moment. James' sketches and paintings are different, revelatory as much in what they leave out as in what they include. They draw us in and allow us to wonder. They engage our imagination in a way that detail and realism cannot. Thus, the images that James shares with us in this book can seem unfinished, but they are never incomplete.

I have spent two decades exploring the landscapes and observing the wild creatures of the Yukon-Kuskokwim Delta. Rightly or not, I have developed a proprietary attitude, reluctant to let just anybody share their beauty and mystery with the rest of the world, lest they err or obfuscate in the attempt. When I look at James' paintings, however, I know that I have no need to worry. The golden wisps of sedge, the muted grey shadows of the arctic sky, the dark rippled surface of a pond, the straining, compact energy of a courting sandpiper - James captures these, the details beyond the details. He is a worthy and inspiring guide, one who will indeed reveal the Delta to all who have eyes to see.

Brian McCaffery, Bethel, January 2007

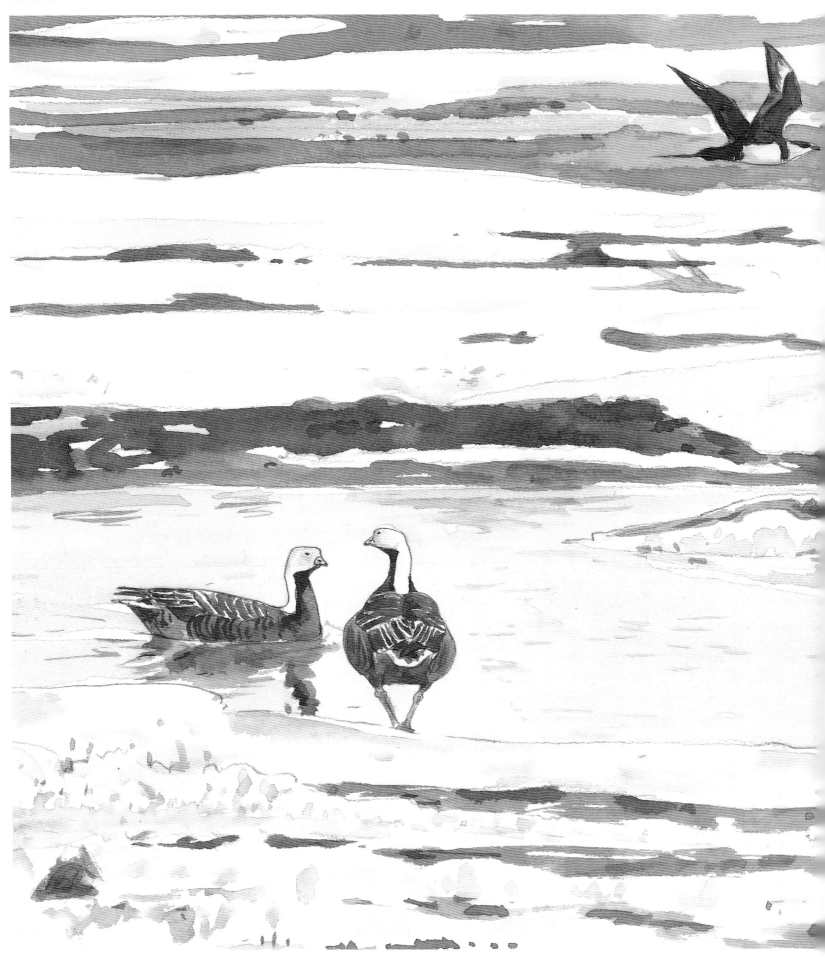

A pair of emperor geese find an ice-free pool in the mighty, but still frozen, Aphrewn River. 3rd May 2004.

3·5·04 Still sunny

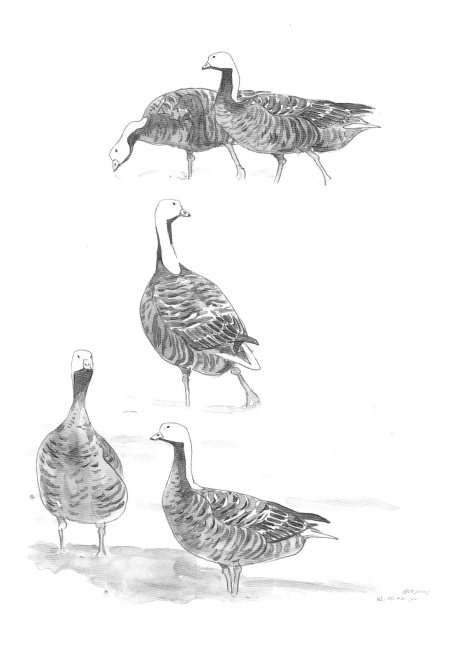

These beautiful and hardy geese winter no further
south than the Aleutian Chain.

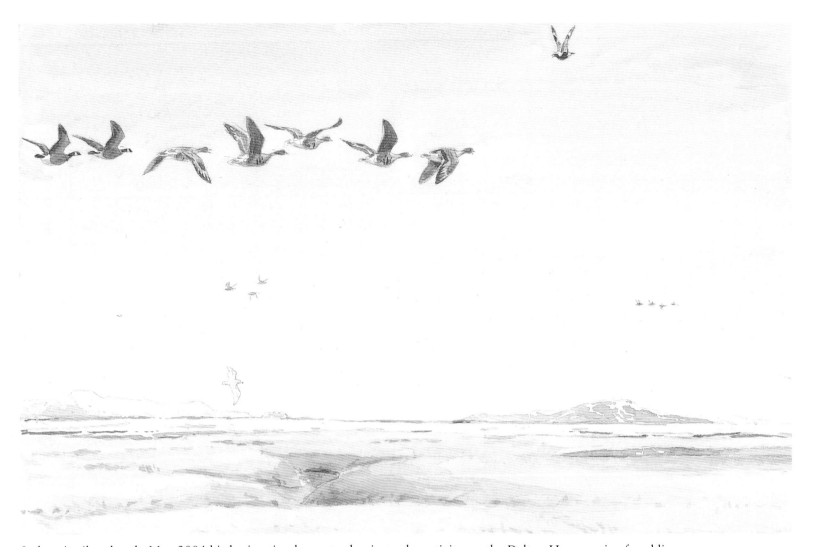

In late April and early May 2004 bird migration began to dominate the activity on the Delta. Here a pair of cackling geese tag on to the end of a group of whitefronts. Overhead a grey plover sings, a young glaucous gull moves through and, on the distant lakes, a pair of whistling swans stop to feed. Kanaryarmuit, 2nd May 2004

I arrived in Anchorage on the 24th April 2004 and was met at the airport by Bill Eldridge. It was good to see him again. Although we had been in correspondence, it was the first time we had met since we were together in Siberia two years previously.

The next morning was my 34th birthday and, as it was cold and clear I was treated to a rare view of Mount McKinley, the highest peak in North America. A young bald eagle flew over and a party of seven snow geese were migrating northwards. On the mountains behind the city, the all-white Dall sheep could be seen clearly against the darker rocks and vegetation.

My stay in Anchorage was short and by the end of the day I was flying out to the US Fish and Wildlife Refuge at Bethel, where I was met by Brian McCaffrey. Brian is an experienced biologist and acknowledged expert on wading birds, and it was he and Bill, who organised my stay on the Yukon-Kuskokwim Delta. I spent the night in the refuge's bunkhouse. Outside was a small feeding station, visited by

many redpolls. Arctic, or hoary, as they are called here, were the most numerous whereas mealy redpolls were scarcer. The differences between the two didn't always seem as clear-cut as they had in Lapland and I encountered several individuals to which I couldn't confidently put a name. At regular intervals, a pair of pine grosbeaks came bounding in to feed and a great-grey shrike flew over the Kuskokwim River, mobbed by arctic redpolls.

I was due to fly out to Kanaryarmiut field station on the morning of the 26th April but low cloud and rain made it impossible to fly until early evening. Along with Sarah, a Canadian girl, who was to study dunlin, I left for Kanaryarmuit in a small, single-propeller plane fitted with skis. Our pilot, George, landed on the frozen lake outside the field station. He was a highly experienced and respected pilot; he was also one of the Delta's characters and was great fun. As we taxied to a halt, we were met by Matthew Johnson who had been studying western sandpipers in the area for several seasons.

So began the first stage of my summer on the Yukon-Kuskokwim Delta. I was to spend two weeks there watching bird migration and helping out, where I could, with the work of the ever-growing number of study groups. We were plagued by some long periods of cold, wet weather with strong winds and gales from the southwest. On most days I was out for long spells but it wasn't much fun getting constantly cold and wet and it was very difficult, at first, to get much field painting done. The field station, however, was extremely well-equipped and so at least it was easy to get warm and to dry my clothes.

It was difficult not to compare the rudimentary conditions at Belyaka Spit in Siberia to the luxury of Kanaryarmuit. Here the range of facilities was impressive and included a water purification system, oil-powered heating and even a system that pumped water from the lake for hot showers.

In common with several other field camps, there was an incinerator for human waste too. In the kitchen there was even a massive gas-powered fridge freezer that was full of a huge range of foodstuffs, including a large amount of ice cream. I will always remember overhearing a radio conversation between Kanaryarmuit and Bethel, when it was asked how things were going, it was announced that the chocolate ice cream was running low! I couldn't help laughing and thought back fondly to my days at Belyaka, cutting out mouldy patches from the bread and drying it on the fire and picking out stones from sacks of rice.

This luxury came at a price as time spent maintaining equipment reduced the time that could be spent in the field. Kanaryarmuit was the base for many of the studies and expeditions in the Delta and there were two large fuel tanks from which planes could refuel. Frequent equipment drops

A party of cackling geese passes overhead. Kanaryarmuit, 29th April 2004.

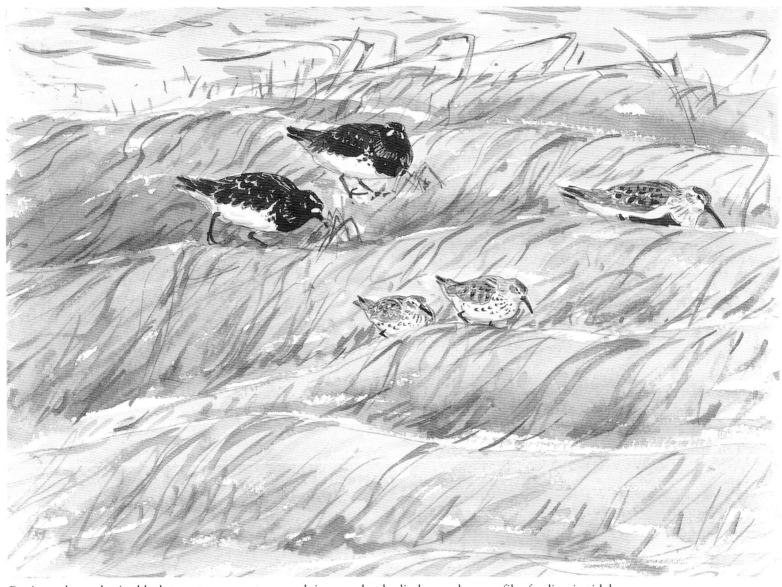

During gales and rain, black turnstones, western sandpipers and a dunlin keep a low profile, feeding in tidal sedges. I painted them from the shelter of the steam-house porch. Old Chevak, 15th May 2004.

had to be dealt with; these included manhandling 30 cc outboards across the ice, through melt-water and across snow-covered tundra. There was a period of about a week, when the ice was unsafe to land on with skis and impossible with floats. George then made occasional food and letter drops, none of which was more impressive than when he flew low over the station and dropped a parcel onto the porch roof. The parcel slid down and landed at our feet. With the regular visits and turnover of people, life was never dull and there were many interesting characters and much good humour.

The bird life was superb; as usual migration was slow at first, but it soon gained momentum. Small numbers of Tavener's and cackling Canada geese were present when I first arrived. The former passed through early and quickly became scarce. Cackling geese are the smallest of the races

of the Canada goose, with some individuals not much bigger than mallards. Wildfowl were to dominate the early part of my stay, with steady movements of whistling swans, white-fronted and cackling geese and smaller numbers of black brant and sandhill cranes. Glaucous and Sabine's gulls passed through in good numbers with occasional glaucous-winged gulls migrating too.

When I arrived rock sandpipers were already on territory and, by the end of April grey plovers, dunlin and western sandpipers were putting in their first appearances. By early May, the numbers and variety of birds were increasing daily. Wilson's snipe, very similar to the Eurasian snipe, were regularly observed performing their drumming displays. In common with their Old World cousins their drumming sound is produced by air flowing over their outer-most tail feathers; these are held out almost at right angles to their

bodies, as they dive downwards at high speed. The Wilson's snipe differs in that it holds two pairs of tail feathers out on each side in contrast to the Eurasian snipe's single pair. This results in a slightly different 'drumming' sound. Ruddy and black turnstones, long-billed dowitchers, red-necked phalaropes and bar-tailed godwits were regular migrants. I was told to listen out for the human-like 'wee-a-whit' whistle of the bristle-thighed curlew, which passes through the area on its way to its breeding grounds in northern Alaska. On May 5th, I heard this remarkably human-like whistle for the first time. I was close to camp and not sure what was making the noise. I then noticed nine whimbrel-like birds heading towards me, calling and singing briefly. I was to hear this whistle several more times during the spring and I saw small groups or single birds passing through but, regrettably, never on the ground.

The number and variety of ducks increased continually. Pintails were the first to arrive, rapidly followed by long-tailed duck, mallard, green-winged teal, American wigeon, scaup, shoveler, black scoter and the occasional canvasback and eider. Savannah sparrows and Lapland buntings were quite common and American tree sparrow and snow bunting were also seen. Accidental migrants, such as a golden-crowned sparrow around the camp and a beautiful male varied thrush sitting on the snow, were welcome treats. Later on I saw cliff, tree and bank swallows and a pair of beautiful yellow warblers. Short-eared owls were regularly seen passing through, as were smaller numbers of rough-legged buzzards, including an impressive black form, which I'd never seen before. One day I heard a pair of bar-tailed godwits warning and watched them mobbing a massive gyr falcon, which was passing through their territory.

Arctic foxes were quite numerous and could be heard calling regularly during the midnight hours. Red foxes were also noted and I frequently saw a dog fox on the far side of a creek opposite the field station. Otters were encountered occasionally and one day I watched a pair on a small lake. The bitch otter came out of the water, curled up and went to sleep only a short distance away. Her mate, having seen me, whistled and snapped but she didn't wake. A beaver had a small lodge built from dwarf willows on a nearby lake. If anyone went too close he would show his disapproval by diving and slapping his tail on the water's surface.

Mink were quite common and one day, whilst doing some repairs to a wooden walkway, I noticed a nest underneath it. The mother, disturbed by my work, went off and made a new nest before returning to move her tiny blind and naked young, one by one to their new temporary home.

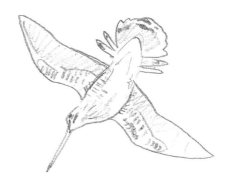

Wilson's snipe drumming, showing two sets of erected tail feathers.

The next leg of my trip began on 14th May. Along with another volunteer, Alice, I was to join Brian McCaffrey at Old Chevak, a field camp nearby. Here we were to assist Brian in setting up a new study on bar-tailed godwits. We set off in the early afternoon by helicopter and made a short but spectacular flight fairly low over the tundra.

Mergansers, scoter, pintail, sandhill cranes, swans, geese and Sabine's and glaucous gulls could all be seen flying below us. Soon the camp came into view; at its centre was a wooden building with two white and pale-orange stripes painted across its roof. This was once used as a Catholic church and was where Roger Tory Peterson and James Fisher had stayed in 1953 and described in their classic book, 'Wild America'. Set apart from the camp, three crosses marked the site of an old Cup'ik graveyard. The wooden caskets had been eroded and permafrost had forced skulls and bones to the surface. We respected the graves of the people buried there and excluded it from our study area.

The camp was also used by a hard-working team making long-term studies of cackling geese. The hut here provided us with a comfortable base; food was stored in a dark outhouse and in cool boxes, while drinking water was collected from the roof by means of guttering and pipes. We set up our tents close to the hut. There were high densities of western sandpipers nesting nearby. Along with savannah sparrows, they soon adopted the tops of the square green tents as song-perches. Outside the tents were marshy pools, favoured by nesting red-necked phalaropes, teal and a pair of long-tailed ducks. Beyond them lay a vast network of huge creeks.

The first stage of the godwit work was to establish a study plot, then to locate all their nests using a combination of field observation and rope-dragging. I didn't enjoy rope dragging which involved two people gently pulling a long rope over the tundra and I found it an uninspiring exercise. Small strings with plastic strips attached to the rope would cause most incubating birds to rise ahead of it.

The godwits seemed to have very erratic behavioural patterns, which didn't appear to fall into any distinct sequence. This made their movements much more difficult to follow and their behaviour very hard to interpret, compared with that of many other waders. On the nest, only their backs and the tops of their heads were visible and they were very well camouflaged. Unusually, for a large wader, they sat very tightly on their nests, rising only if they were about to be stepped on. This, combined with the large size of their territories, and the fact that, although both sexes incubate, they would only change over once or twice a day, made their nests very difficult to find. The days were long and tiring but the work was interesting and it was a challenge trying to work out what was going on.

On the 28th May, after a fortnight at Old Chevak, George came to collect me and take me back to Kanaryarmuit to join a team of people surveying nesting waterfowl. Every year a series of plots is selected randomly from all over the Delta and several teams, each of two people are sent out to locate all the nests and broods of waterfowl and any other species found there. Each of these trips takes up to six hours and each team has to be flown out and picked up again. The small planes can only land at high tide in certain creeks; sometimes the nearest suitable landing lake or creek is some distance away from where a team is working and means that some teams have to camp overnight. As a result each day has to be very well planned and organised.

The days started early; George was first up and cooked a huge breakfast for everyone of bacon, sausages, eggs and pancakes before he flew the first group out. It was a fantastic way to see the Delta, flying over a seemingly endless network of rivers, tributaries, creeks and lakes. Landing on unfamiliar lakes and dropping into narrow creeks is a real testament to the pilots' skills.

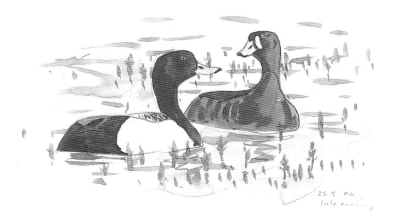

A pair of greater scaup. Old Chevak, 25th May 2004.

Drake spectacled eider

One morning, when flying with George, I saw how he checked out the suitability for landing of a long, narrow, shallow lake by gently skimming across its surface, looking and feeling for hidden rocks before touching down; he often used the cockpit doors as sails to let the wind push us ashore.

One of the high points of this work was seeing spectacled eiders, a species I had missed in Siberia. I saw small numbers of drakes and incubating ducks on some of the study plots. The spectacled eiders were handsome ducks albeit strangely shaped. It is amazing to think that their wintering quarters were unknown until very recently, when it was discovered that the entire world population spends the winter above the Arctic Circle. The eider gather in large groups on pools in the pack-ice, which are kept ice-free by their continual diving and surfacing.

One of my other favourite experiences was visiting the large black brant colony on the Delta at Tutakoke. It was lovely staying overnight in the field camp there with brant, spectacled eiders and long-tailed ducks nests just outside the tent.

On 1st June, the weather was hot and still and there was a mass-hatch of mosquitoes. Apparently this was nearly two weeks earlier than in previous years and provided plenty of food for the first rock sandpiper chicks, the first of the waders to hatch. During the next week I was able to see many more young and by the 9th of June lots of cackling and white-fronted goslings had hatched. This signified the end of the plot work, for our presence would cause too much disturbance. It was decided that I should return to Bethel for a few days before heading out to Old Chevak once more. It was over six weeks since I'd last been in

Bethel and it was incredible to see how much it had changed. Everywhere was green; flowers were in bloom and aspens in full leaf. I think the general idea of my returning to Bethel was to relax for a few days before going back out into the field. I was, however, on a new continent, and now in a new habitat and I couldn't rest.

In the low aspens there was a series of colourful passerines: yellow, Wilson's, blackpoll and yellow-rumped warblers. There were also orange-crowned warblers but, frustratingly I never had a good view of them. Rusty blackbirds, alder flycatchers, varied and grey-cheeked thrushes, American robins and fox and white-crowned sparrows were common. In short grass on a piece of waste ground, I found the nest of a semi-palmated plover and that of a beautifully-patterned spotted sandpiper. Out on the tundra and nearby lakes were two species of wader new to me: lesser yellowlegs and least sandpiper. The yellowlegs were resting at the water's edge and occasionally song-flighted overhead. The least sandpiper was a species I had long wanted to see; being the only stint or 'peep' I hadn't encountered nesting. They were terrific little birds and quite common on the open tundra. Many had broods of young and the adults would fly to the tops of aspens or electricity wires to warn as I approached. Their rhythmic songs were delivered either from the ground or during a song-flight.

Yellow wagtail – song-flight

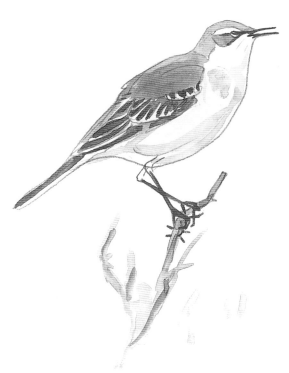

Amazingly yellow wagtails cross the Bering Strait to nest in western Alaska before returning to spend the winter in India!

On 12th June I went on a boat trip with Brian and some of his friends up part of the Kuskokwim, then into the Gweek River. It was a lovely trip. We left at 6am and returned at 3pm, having passed through some rich and varied habitats. Several great horned owls flew from their roosts in riverside trees. A porcupine scrambled up the riverbank and there were several beavers on the river. The highlight for me was the stop we made to visit an area of lightly wooded tundra. Here there were breeding Hudsonian godwits. Males were warning from treetops or display-flighting overhead. They were very handsome, with their deep, dark chestnut underparts and contrasting black underwings.

The following day, I was back birdwatching around Bethel. Whilst watching a Wilson's warbler in a thick alder clump, I stumbled upon something truly special; this was to lead to one of the highlights, not only of my stay in Alaska, but also of my birdwatching life.

The Solitary Sandpiper and the Broken Alternator

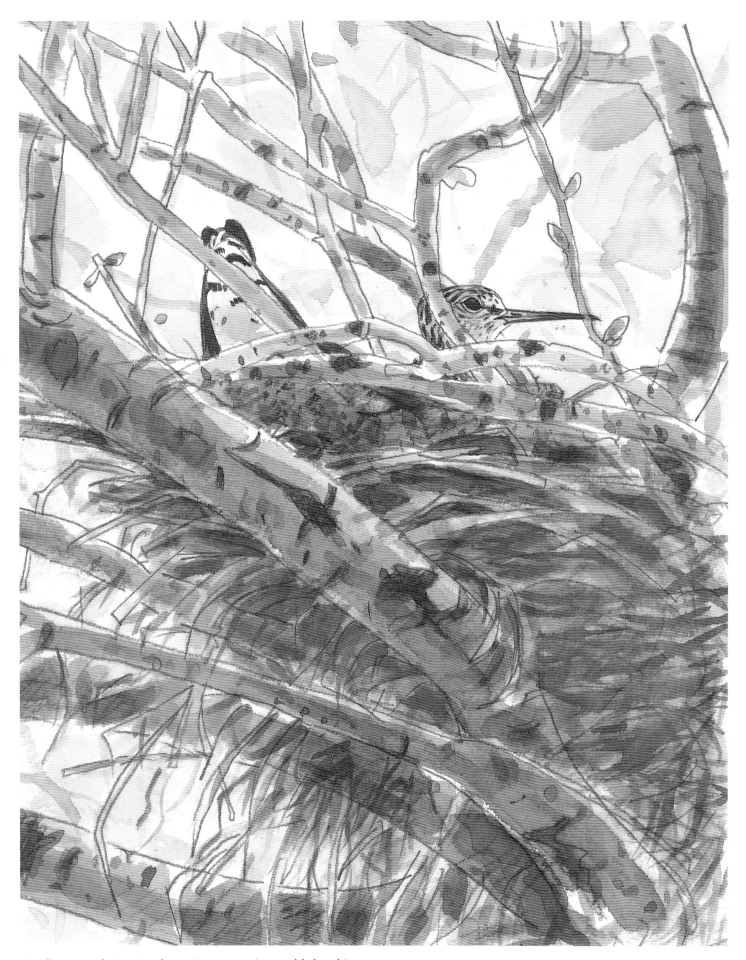

A solitary sandpiper incubates its eggs up in an old thrush's nest.

Sunday 13th June 2004

The day began dull with showers, so I had a long-overdue lie-in and didn't go outdoors until 10am, when it began to brighten up. I began watching a Wilson's warbler singing as it moved through the dense canopy of thick alder scrub close to the bunkhouse. I followed an overgrown track, originally cut for winter snowmobiles, into the heart of the clump. The warbler's movements drew my attention to an old thrush nest, probably that of an American robin. I glanced at it and, to my shock and utter amazement, realised that a solitary sandpiper was incubating its eggs inside. The habit of shorebirds making use of old nests of birds, such as thrushes, in which to lay their own eggs is only regularly recorded in the case of solitary sandpiper and its Old World sister-species, the green sandpiper. It was a fantastic sight, one I thought I would never witness.

Since the sandpiper was relaxed, I decided to stay to make several drawings and paintings, using tripod-mounted binoculars. The weather had turned very hot, there was no wind within the canopy and so a big ball of mosquitoes had gathered around me. They were able to bite through my thin trousers, so I had to pull up my thigh-length waders, put on my raincoat and pull the hood up to stop them from biting. A little insect oil around the rim of my hood and a few dabs on my hands seemed to keep them at bay.

However, the strong chemicals in the oil began to dissolve the painted coating of my pencils and made them stick to my fingers. I cared little at the time, as I was so engrossed in sketching. After a few hours I retreated carefully and went back to camp to get some dinner. When I got in, I chatted with a few people, then started to prepare some food. It was only then that I became aware of a strange stickiness around my waist and bellybutton. I was surprised to find that it was blood. When I reached the bathroom I noticed small patches of blood around my neck too. This explained why people had been looking at me oddly when I'd first come in! This was my first introduction to the small biting flies known as 'white-socks'. I met Brian later that day and showed him the sandpiper's nest. I was surprised when he told me that it was the first such nest he had ever seen and I began to realise just how fortunate I had been to have found it.

Monday 14th June 2004

I was due to fly back to Old Chevak but one of the planes was out of action. There was a lot of equipment to be flown out, a busy flying schedule and so I had to stay an extra day in Bethel. Brian asked if I could check the contents of the nest to see how many eggs there were and what stage they were at. I approached the incubating bird slowly and carefully. The nest was just above head height and the bird sat so tightly that I was able to stroke it gently before it flipped silently off its nest and revealed a clutch

One of the parents sitting high on the nest looking down inside it, indicating that the young are hatching.

of four spotted eggs. They had all begun to 'star'; a series of fractures in the shell radiated out from the place where the chicks inside had begun to chip at the shell. I retreated quickly. Within a minute or two an adult returned silently. It hovered inside the canopy, then landed on a low branch before flying onto another. It then hovered above the nest, landed briefly on the edge of the cup, before dropping onto the eggs. The parent spent a few moments turning the eggs with its bill before shuffling snugly down onto them. I spent the rest of the day birdwatching in the surrounding countryside.

Tuesday 15th June 2004

The over-night storm clouds had cleared and it was set to be another sunny day. I was due to leave by floatplane and had to have my bags ready by 8am. I checked the nest at 7.45am and found that the first fragments of shell had been chipped out and the chicks' bills, each complete with its own egg tooth, were just visible. I would have loved to stay but Brian was keen to get me back to the bar-tailed godwit work. Later I learnt that the plane's alternator had broken and I secretly rejoiced, as I knew it would be the next morning before we would be able to fly. I would now have the opportunity to watch the solitary sandpipers in more detail and hopefully witness the hatch. The next 20 hours were to provide some of my greatest and most satisfying experiences amongst birds.

I returned to the nest at 11am. It soon became very clear from the incubating parent's behaviour that hatching was in progress; it began to sit high and looked uncomfortable on the nest. During the early afternoon it became increasingly anxious and

A fragment of eggshell being removed.

began to call quietly with its bill pointing into the nest cup. At 2pm I went back to have some food and drink. The bird had been giving some alarm calls, so I thought I'd give her some extra space. On my return at 2.45pm, I found the sitting bird removing small fragments of eggshell from the nest and dropping them over the side.

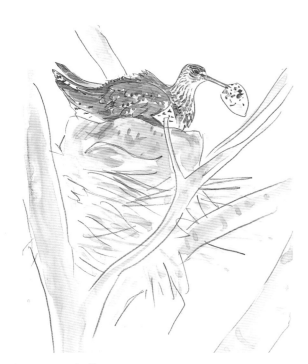

Removing an eggshell.

At 3pm I witnessed the removal of the last eggshell from the nest.

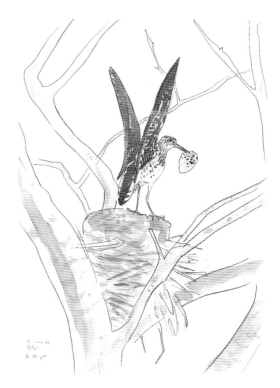

The parent, holding the eggshell in its bill, stands on the edge of the nest, briefly raising its wings and depressing its tail, before leaving.

The parent reached into the nest and then, using its bill to hold the eggshell, it rose onto the lip of the cup. It stood with its wings stretched upwards and tail depressed. It then gave a quiet 'clue-eet-eet' call before it hovered with the eggshell in its bill and flew with it out of the canopy. I'm not sure whether this call signified that it was time for a change over of nest-duties, but one bird returned just over a minute later. From this stage on there was always one parent at the nest and the other could be heard calling from the immediate vicinity.

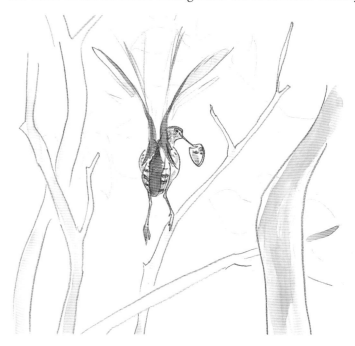

It hovers with the eggshell as it finds its way out of the canopy.

152

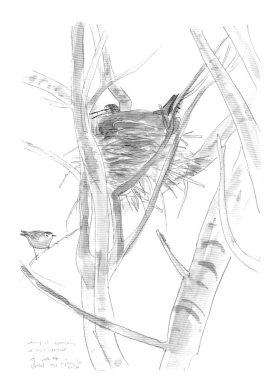

Now that the young have hatched the brooding bird becomes very agitated whenever any other bird, such as, this male Wilson's warbler, comes near to the nest.

The brooding bird was becoming increasingly sensitive to the Wilson's and blackpoll warblers, grey-cheeked thrushes and fox and white-crowned sparrows that passed through the canopy near to the nest and it would alarm-call repeatedly. It probably also now felt uneasy about my presence there and the continuous 'tee.tee.tee…' warning call naturally attracted more curious passerines and a vicious circle developed. Conscious that I might add to this tension, I retreated further into the scrub and found a place where, using my telescope, I had a clear view through the branches. Here I remained, watching and painting, with an ever-present cloud of mosquitoes for company.

At 5.05pm the other parent announced its imminent arrival, for a change-over of nest-duties, with a single 'clue-eet-eet-eet' call. The brooding bird didn't move. I heard a couple more calls but wasn't sure from which bird they came, as the other parent was hovering next to the nest. The brooding bird still refused to move, so, after waiting on a branch close to the nest for over a minute, its partner decided to leave, giving a quiet 'clue-eet-eet-eet-wheet-wheet' call as it disappeared.

At 9.58pm I heard a single call and the brooding bird left. Its mate arrived quickly and landed on a nearby branch. Four chicks were now visible above the top of the nest. The parent began to alarm-call, then hovered and dropped onto the nest. It alarmed repeatedly before settling down but, at regular intervals, it would give a subdued version of this call, particularly when the young became restless. I left the site

some time after 11pm, since the light was fading and the temperature dropping and it seemed unlikely that the young would leave the nest at that time of day.

Back at the bunkhouse I quickly ate some food and set the alarm for 4.30am. I slept poorly, partly due to the excitement and to the worry about over-sleeping, but also due to much snoring from neighbouring bunks.

Wednesday 16th June 2004
When I returned to the nest-site at about 5am the sky was yellow and the clouds golden as the sun began to rise. It was quite cold in the half-light of the alder thicket. I was relieved to be able to make out the shape of a brooding bird and I knew that I hadn't missed the young leaving the nest. As the sun rose, the light begun to find its way through the canopy and birdsong began to ring out; American robins and grey-cheeked thrushes in particular were in good voice. I heard a solitary sandpiper singing over the thicket as the sun became clearly visible above the horizon. When it heard this song, the brooding bird suddenly became alert and, a couple of minutes later, its partner flew in and landed close by. It made two more short flights, re-landed in the surrounding branches and gave some display-type calls before flying off.

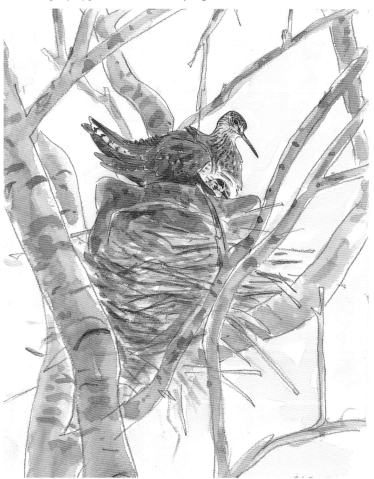

A chick poking its head out from the security of its parent's brood-patch.

153

A parent trying to push the young back into the nest.

At 6.42am the other parent flew in again and gave several quiet, contact calls. The brooding bird, ready to change over, left the nest uttering quiet warning calls, and landed nearby. I caught a glimpse of at least three young before the second parent began brooding. It became very vocal as the young grew increasingly restless, continually moving around and forcing themselves free of their parent's brood-patches to peer out of the nest. It was a nerve-wracking time for me. Although the young looked close to jumping, time was ticking away and I had to catch a plane at 8 o'clock.

The brooding parent leaves the nest and hovers underneath it trying to encourage the young to jump.

It was a tense and incredibly exciting moment when, at 7.06am, the first young jumped.

Young becoming increasingly restless.

At 7.02 am the brooding bird rose from the nest cup, perched on the rim with its wings half-raised and called 'tee.tee.tee.tee....' in rapid succession. It then flew down towards the base of the alder trunk. Three young were standing up in the cup and one other clambered up onto the edge. I could hear one parent calling nearby as the other took off from the ground below the nest. It hovered immediately below the chick, calling 'teu, teu, teu...'; the notes sounded deeper and were delivered in a slower sequence than the previous calls.

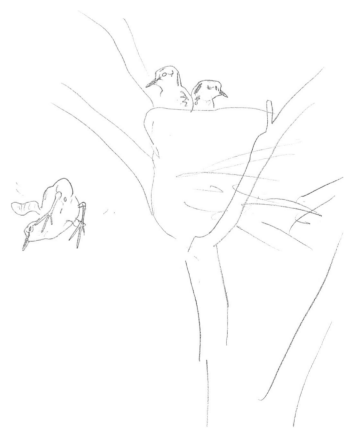

The first chick jumps.

The chick fell lightly, its tiny, bony wings fluttering as it descended. It stayed on the ground with the second parent as the other bird flew up to try and coax the remaining young to jump as well. When it realised the young weren't ready, it hopped back on to the nest and brooded them for a full minute before coming off again, landing on the ground below and calling as before. Two of the young were now visible above the nest when, at last, the fourth sibling raised its head, confirming that the brood was still complete. At 7.10am two more jumped, one directly after the other.

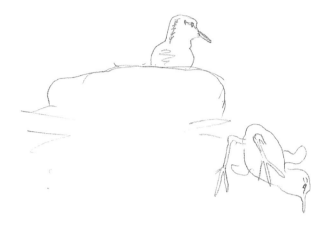

The next chick leaves, followed shortly by the third.

Finally, at 7.12am, the last of the brood plucked up courage and, using its 'over-sized' feet, clambered, clumsily to the lip of the nest before, launching itself into the unknown.

The parents, now silent, remained with their young on the thicket floor. I swiftly gathered my things together and retreated quickly along the overgrown path – the happiest man in Alaska.

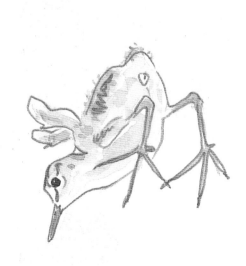

Finally, the last chick leaves the nest and the family gather on the ground beneath the alders.

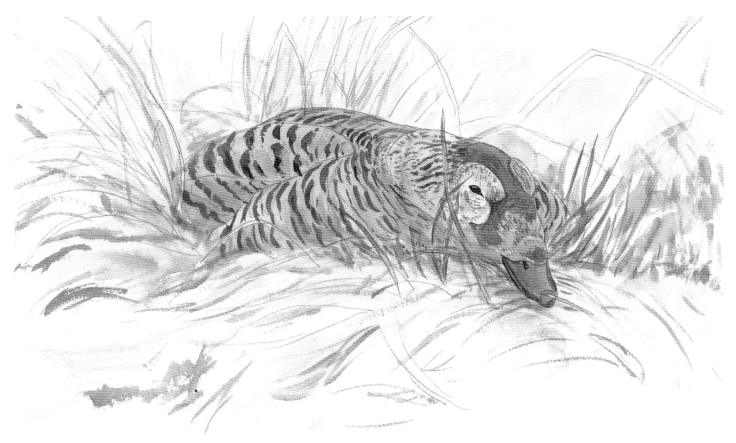

Spectacled eider duck incubating. We encountered many of these strange-shaped but very handsome eiders during our waterfowl surveys. The drakes were very striking, with their large white 'spectacles' and lime-green head markings. I found the ducks equally attractive when seen at close range. When we arrived to record the details of their nests and eggs some birds would allow close approach. This bird was nesting next to the tents at the field camp at Tutakoke and was very used to our comings and goings. A hint of a pale blue-grey eye-ring or iris was just visible in the corner of its eye. 4th June 2004.

Friday 18th June 2004

Old Chevak looked much greener than when I had been there, nearly ten days previously. I had a quick look around before heavy rain set in. The weather remained wet and windy for the next week or so. Alice was still there and had been joined by another helper, Grace. The cackling goose team had largely completed their season's fieldwork and were now winding down. They were set to leave on the 21st so, at about midnight on the 20th, John, one of their team, fired up the sauna. This enabled them to have a thorough clean before heading back to 'civilisation'. We all made use of the sauna and finished off with a dive into a small lake, finding an American wigeon's nest in the process.

As the goose team was leaving, an American writer, Scott Weidensaul, arrived in an old beaver floatplane. He was retracing the steps of Peterson and Fisher, as described in their book *Wild America*, and comparing his experiences with theirs. He proved to be good company and, the following year, his book, *Return to Wild America*, was published.

My time was spent revisiting the godwit study-plot and surveying new areas for broods. It soon became clear that all the nests except one had been depredated, mostly at the egg stage, predominantly by arctic foxes. It was pleasing to

find one brood of three on the study plot. My attention was first drawn to them by the male's aerial attack on a glaucous gull. After the male had driven it off I watched to see where he landed and eventually found the young. On the day when I first discovered the male and brood, there was a female in loose company with them but, unusually for the species, she seemed to lose interest and the male was left to rear the young alone.

During my long hikes over the neighbouring tundra and marshes, I was to find only one additional brood. These were guarded by both parents in a more textbook manner. The remaining godwits had had their first and replacement clutches depredated and had already begun to leave the nesting grounds to find better feeding on the coast, prior to migrating. Other failed breeders, such as whimbrel and a few bristle-thighed curlew, were also on the move. Sometimes whimbrel gathered on the tundra to feed; these were of the Nearctic race, sometimes known as Hudsonian whimbrel, and differed from Eurasian birds in that their general plumage was darker and they had all-dark rumps and tails.

The western sandpipers nesting around the camp faired better, possibly because the foxes had tended to stay away. It was great to watch the fledged young taking their first flights. Although the nests of many species which we had

found during the earlier work had failed, some birds had succeeded and it was good to see the chicks of sandhill cranes, long-tailed skuas, red-necked phalaropes, black and ruddy turnstones and grey plovers.

On the 29th it was time to say goodbye to Old Chevak. We left by boat, under stormy skies, for the native village of Chevak, the present day location of the Old Chevak we had just left. We travelled down the Keoklevik River into Hooper Bay before taking the Ninglikfak River to Chevak, passing on the way many active Inuit fish camps. We arrived just before 1pm and headed straight to the airstrip. This was a short gravel affair with a lorry container to use as a waiting room if the weather was bad. The twin-propeller plane was twenty minutes late and there were people and children walking and driving quad-bikes on the runway just before it touched down. We boarded the plane for Bethel along with six adults and seven native children. It was very stormy during the flight and, as we came in to land, the

plane swung from side to side and shot up and down dramatically. The children loved it but we adults didn't feel quite so relaxed.

I spent a day exploring Bethel with Alice; we watched the boats bringing in huge salmon and visited the native museum. There were some amazing exhibits there, including a raincoat made from walrus intestines, skilfully sewn together, and another made from the skins of summer-plumaged Pacific divers. It must have taken many skins to make it and, although it looked stunning I was glad that it was an antique rather than a present day creation. One lad, Adam, was shocked when I told him that I had never eaten fresh king salmon and he returned that evening with a huge fillet which I cooked for my evening meal. It was absolutely delicious and a welcome change from camp food.

I left Bethel on July 1st; it was hot and sunny but very hazy due to huge fires in Fairbanks. By midday the sun had been

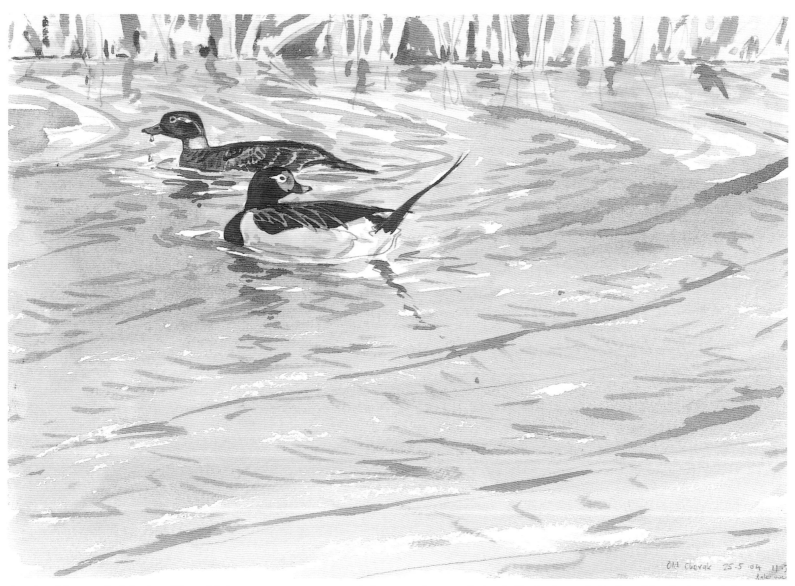

A pair of long-tailed ducks. These birds were common around the coastal camps in both Chukotka and Alaska. The ducks laid their eggs in a snug-looking pocket of dark grey-brown down amongst thick clumps of sedges. Old Chevak, 11.30pm 25th May 2004.

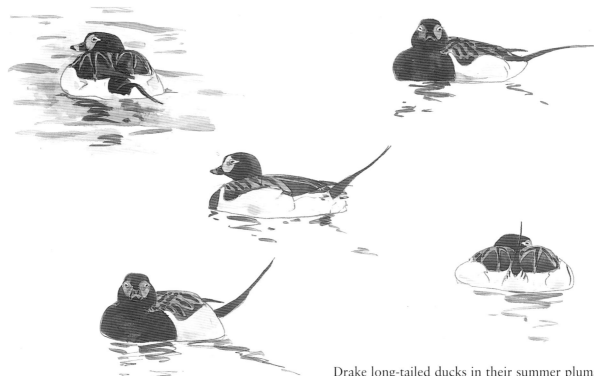

Drake long-tailed ducks in their summer plumage seemed almost to be a different species from winter-plumaged birds.

blotted out and everywhere was a strange golden-brown colour. Brian and his wife saw me off at the airport. Bill was waiting at Anchorage. He greeted me with the words "you're still alive" before asking how I had enjoyed the fieldwork. He pointed out that the Delta was just a small part of Alaska and urged me to try and see some of the rest of it. It seemed that the fires in Fairbanks were really bad so it was pointless visiting the interior.

A research team studying Kittlitz's murrelets in the Prince William Sound needed an extra crew member and Bill had arranged for me to join them. I didn't need to be asked twice and, early the next morning, I was off again, heading to Whittier to pick up the boat from the harbour. The scenery was fabulous the fjords, mountains and glaciers were a huge contrast to the vast, flat Delta. The Kittlitz's murrelets' favoured feeding area was around the melt-water at the foot of the glaciers. We split the area into transects and the number of birds and their behaviour, along with the water conditions and visibility, were recorded. My first task was to learn quickly how to separate the Kittlitz's from the closely-related, and very similar looking, marbled murrelets.

The work was fairly intensive but there was some superb wildlife to be seen when we were not working. On the way out we saw a pod of six killer whales including mature males with huge, square-ended dorsal fins. They regularly slapped their tails on the water's surface and one was seen breaching. There were some large groups of surf, white-winged and black scoters. Harlequins were common, in groups of up to sixty, and I also saw my first Barrow's goldeneyes and black oystercatchers.

I was so taken with the wildlife on the coast that, when I returned to Anchorage, Bill and his partner Donna helped me find out bus times and lent me a tent so that I could continue travelling. I set off for Seward on the 8th and arrived that morning. I set up my tent and then took a six and a half hour boat trip around Prince William Sound, where there were killer and humpback whales, Steller's sea lions and Dall's porpoises. There were exciting seabirds too: parakeet and rhinoceros auklets, horned and tufted puffins, pigeon guillemots and three types of cormorant. Thousands of sooty and short-tailed shearwaters had gathered together to feed and a humpback whale surfaced as we passed through them. It was an excellent day, made even more memorable by the calm seas, the fantastic light and the backdrop of mountains and glaciers set against the dark water of the fjords. I enjoyed it so much that I immediately enquired about repeating the trip the following day. The manageress appreciated my enthusiasm and gave me a free ticket. I was frequently to experience this kind of friendly gesture during my stay in the area.

The next day's trip was equally memorable. Freshly-caught halibut was served at lunchtime and there was so much left over that the crew gave me a bag full so that I didn't have to worry about food for the next couple of days. I next headed to Kodiak Island on the evening ferry. It soon began to get dark, so I set my alarm clock for 3.30am; I wrapped it in my towel to muffle the sound, to avoid waking everyone else, and then used it as a pillow. It was difficult to get to sleep as there were a lot of people on deck. I eventually dropped off and when my alarm went off it was dark and foggy. I reset it for 5am and woke again to clearer skies and I was out on

deck just before the sun began to rise. The highlight of the crossing was over sixty-five whale sightings; all of the ones seen well enough to be identified were humpbacks. Up to seven were seen to spout at the same time and it was occasionally possible to see their long, white, patterned fins, or their flukes. Others could be seen smashing their tails on the water's surface, making huge splashes. It was cold out on deck but I was so engrossed in watching that I didn't really notice. The other highlight was seeing the beautiful ash-grey, fork-tailed petrels pass the ferry.

The ferry arrived at Kodiak in the late morning. It would have been possible to have continued along the Aleutian Chain as far as Dutch Harbour. However, that would have meant missing my homeward flight, so I decided to stay on Kodiak for a couple of days. The weather was incredibly hot and sunny. Getting up at first light was by far the best tactic, since at that time it was much cooler and the wildlife more active. I had some very memorable birdwatching in the forests there and it was very relaxing.

On the 12th, I began the return trip, taking a ferry to Homer where I camped on the beach for a couple of days. It was pretty busy but there were some tame bald eagles and sea otters, so I was able to do some sketching. Offshore were a number of great-northern divers in full summer dress, a plumage I had waited many years to see.

I took the bus to Anchorage and spent the next day winding down, visiting the museum and taking a walk out of the city along Cook Inlet. On the flats there were about four hundred short-billed dowitchers, mostly summer adults and a handful of fresh juveniles. There were also about forty Hudsonian godwits and I could see two beautifully-marked juveniles amongst them. Bonaparte's gulls were common, in a whole range of plumages from breeding adults to freshly-fledged juveniles.

Before I headed back to England, Bill had arranged one last treat, a flight out over the Susitna Flats, Traiding Bay and Redoubt Bay. We flew over twenty pairs of trumpeter swans, one with two cygnets. Two grizzly bears, one pale the other darker, were foraging along the edge of a small creek. They were impressive beasts with huge shoulders and forearms and long muzzles and necks. They seemed massive to me but I was told that they were not particularly large ones.

During the return flight we passed over vast spruce forests, heavily damaged due to the effects of spruce-bark beetle and I saw large areas of dead mature trees. In the distance, the mountains, glaciers and the beginnings of the ice-sheets were visible. Many lakes and rivers could be seen some of which looked really milky due to glacial sediment. This afternoon flight was the perfect end to what had been a great adventure.

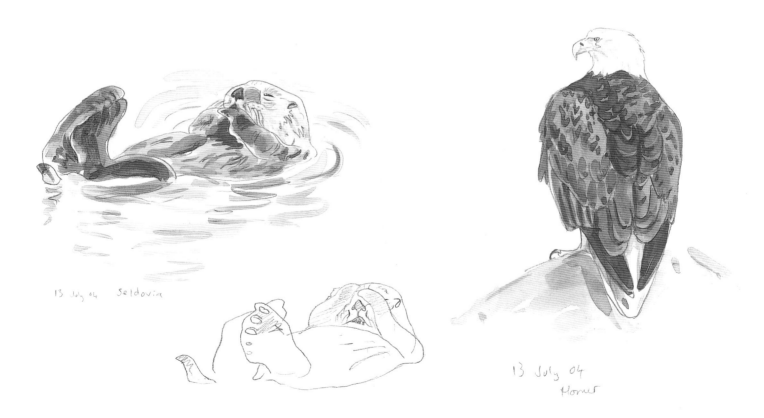

Sea otters. Soldovia, 13th July 2004.

Bald Eagle, Homer 13th July 2004

Sabine's Gull

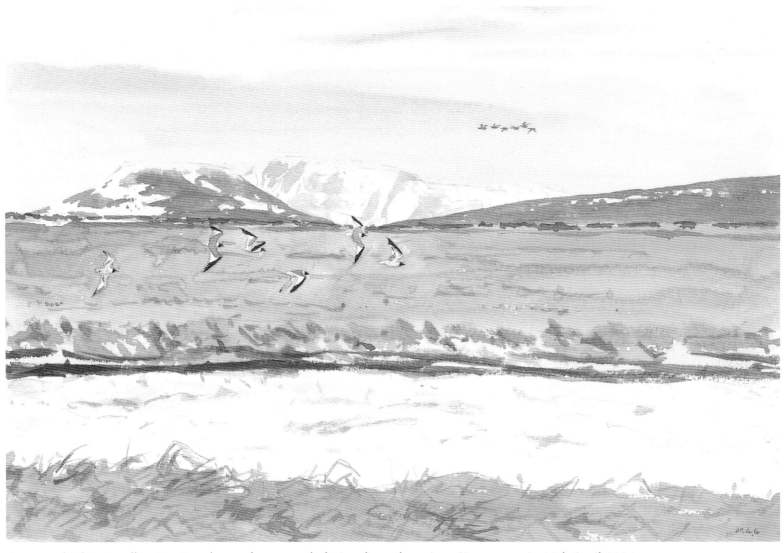

A party of Sabine's gulls migrating along a frozen creek during the early spring. Kanaryarmuit, 30th April 2004.

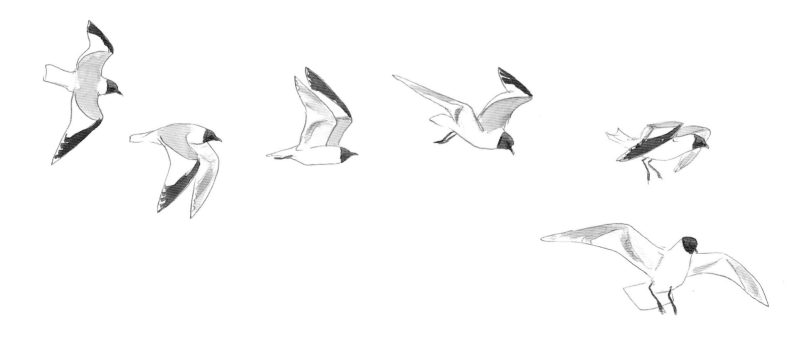

The Sabine's gull is very much a pelagic species, which nests only on the Arctic Coasts of Siberia, Spitsbergen, Greenland, Canada and Alaska. It spends the rest of the year at sea, wintering off the western coasts of southern Africa and the Americas.

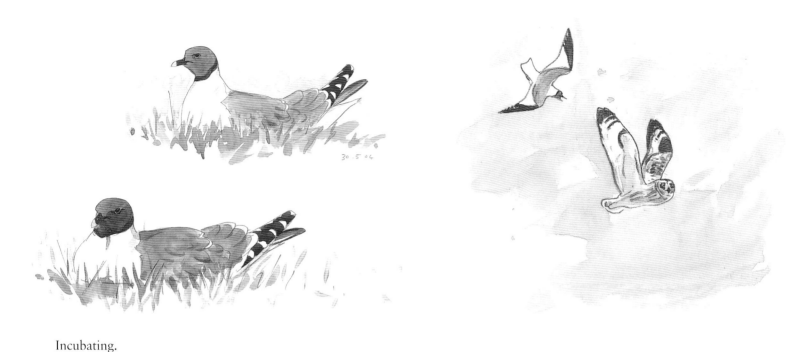

Incubating.

Seeing off a short-eared owl.

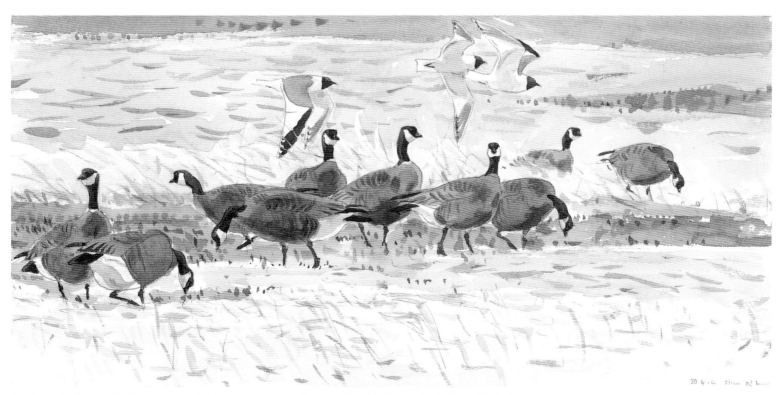

Early spring sees the beginning of big movements of migrating birds on the Yukon-Kuskokwim Delta. Here, Sabine's gulls pass over a flock of cackling Canada geese. This diminutive goose is the smallest of the races of Canada geese. Kanaryarmuit, 30th April 2004.

Rock Sandpiper

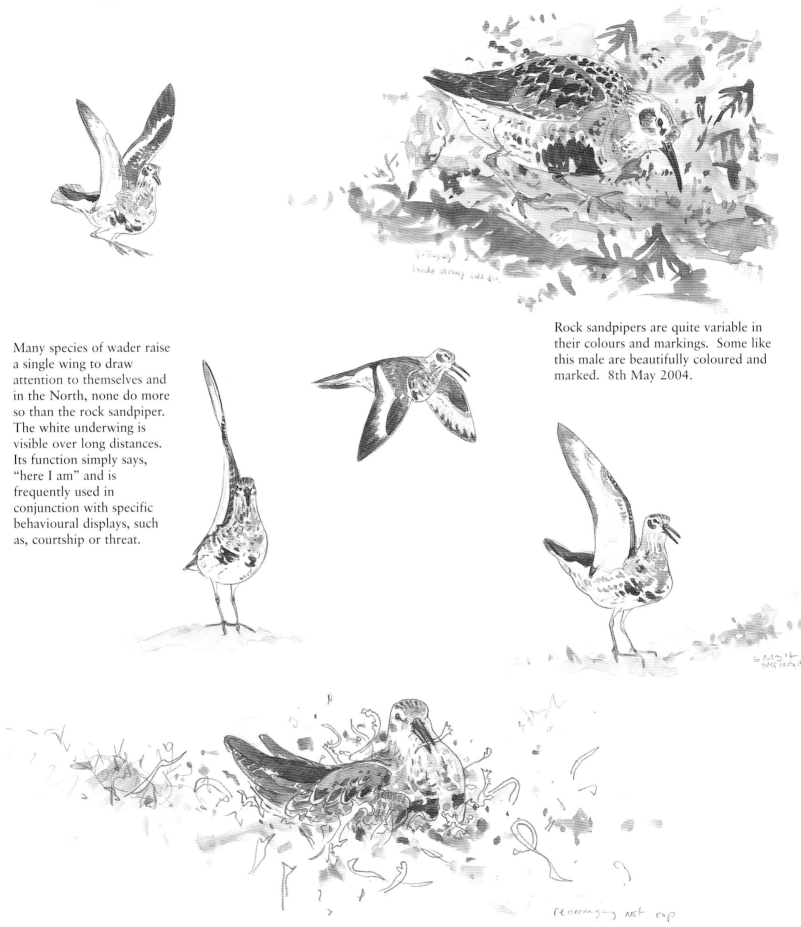

Rock sandpipers are quite variable in their colours and markings. Some like this male are beautifully coloured and marked. 8th May 2004.

Many species of wader raise a single wing to draw attention to themselves and in the North, none do more so than the rock sandpiper. The white underwing is visible over long distances. Its function simply says, "here I am" and is frequently used in conjunction with specific behavioural displays, such as, courtship or threat.

Having built a series of scrapes in the ground, a male rock sandpiper rearranges lichen around the outside of one of them, before he tries to entice a female to inspect it.

162

The rock sandpiper breeds only in easternmost Siberia, western Alaska and on the Aleutian Chain. It breeds on tundra and mountains but rarely far from the coast. Its winter range extends from the Aleutians, southwards along the west coast of North America. It is a close relative of the purple sandpiper and the dunlin. Its total population is thought to be less than fifty thousand pairs.

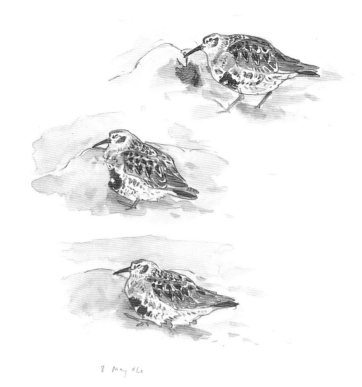

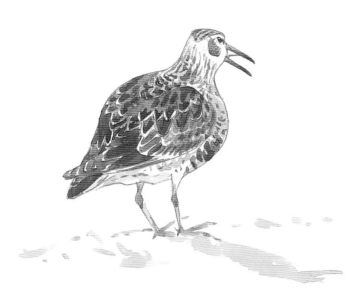

Being such approachable birds often made it possible to watch their lives in detail. When singing, this male's tongue was lifted and the tip rested on its upper mandible.

During a strong, cold, southwesterly gale I witnessed some interesting behaviour. A male rock sandpiper walked up to the sheltered side of a small hummock, removed some lichen and made a small hollow. He then settled down into it as if sheltering from the strong wind. Kanaryarmuit, 8th May 2004.

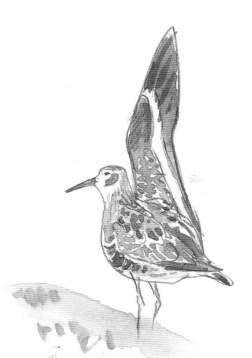

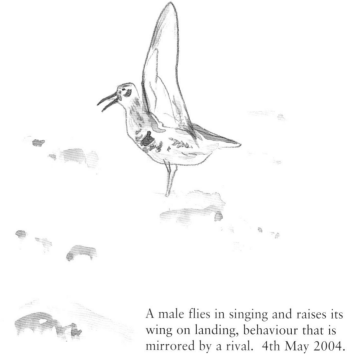

A male flies in singing and raises its wing on landing, behaviour that is mirrored by a rival. 4th May 2004.

Bar-tailed Godwits

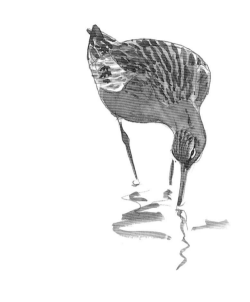

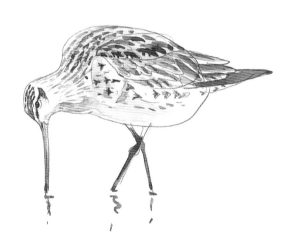

A male bar-tailed godwit calls to its young in a
low marshy meadow of lush grasses, scattered
with flowers of Jacob's ladder and oxeye
daisies. This was a lovely situation to watch
but, in the warm still weather, an uncomfortable
one due to the abundance of mosquitoes!
Old Chevak, 25th June 2004.

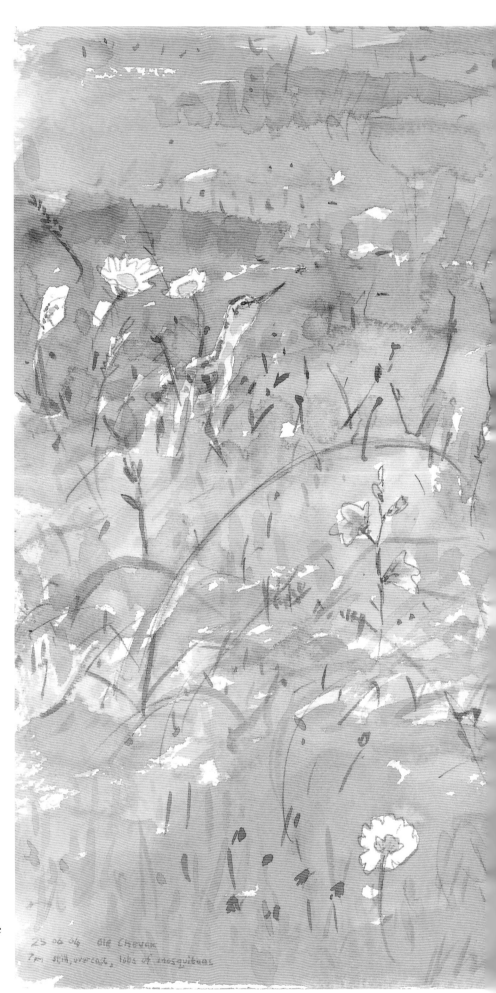

164

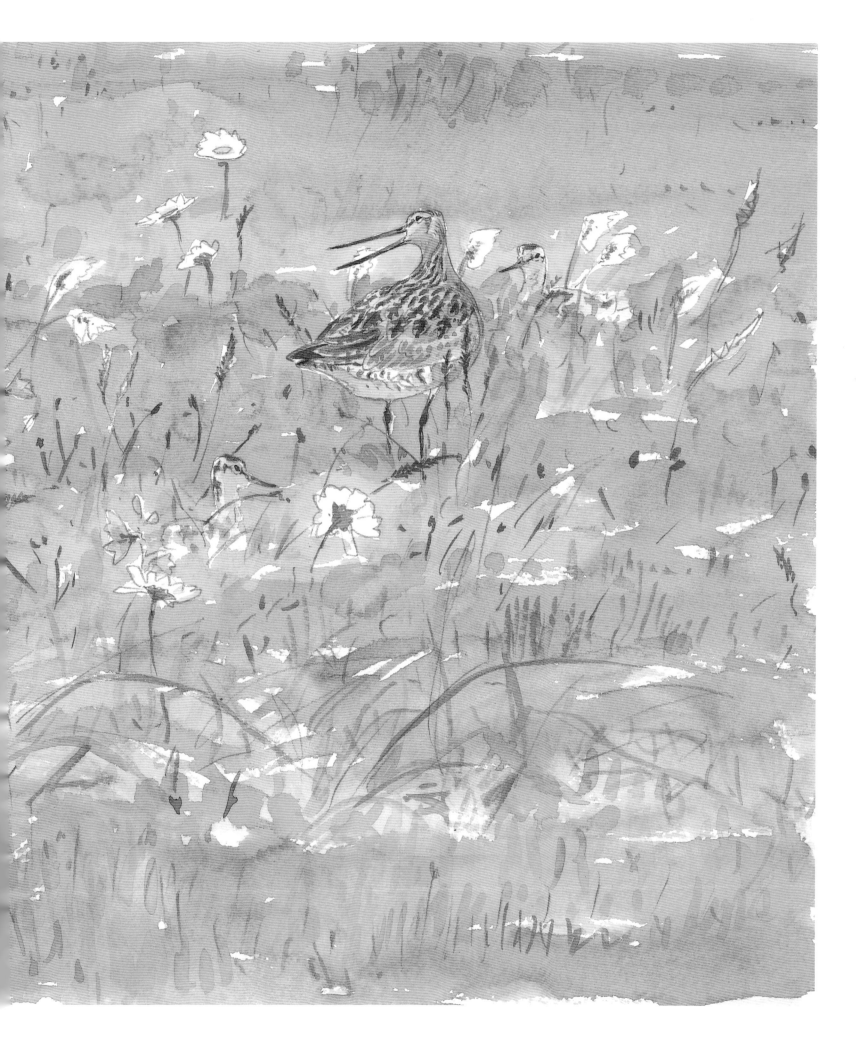

I had first seen this species breeding in Inari Lapland and in Finnmark and gained further experience of them when I helped on a pilot study in Alaska. The study was based at Old Chevak on the Yukon-Kuskokwim refuge where these sketches were completed.

The godwits in Alaska are of a separate subspecies. This race is believed to make the longest non-stop migration of any bird in the world, from its Alaskan breeding grounds to its winter quarters in Australia and New Zealand. On its spring migration northwards it makes a single stop in order to replenish its food reserves. This strategy helps to ensure that, should the coast in Alaska still be under ice and snow, it doesn't face immediate starvation.

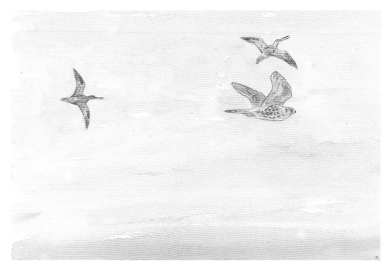

A pair of godwits mobbing a huge female gyrfalcon. Kanaryarmuit, 11th May 2004.

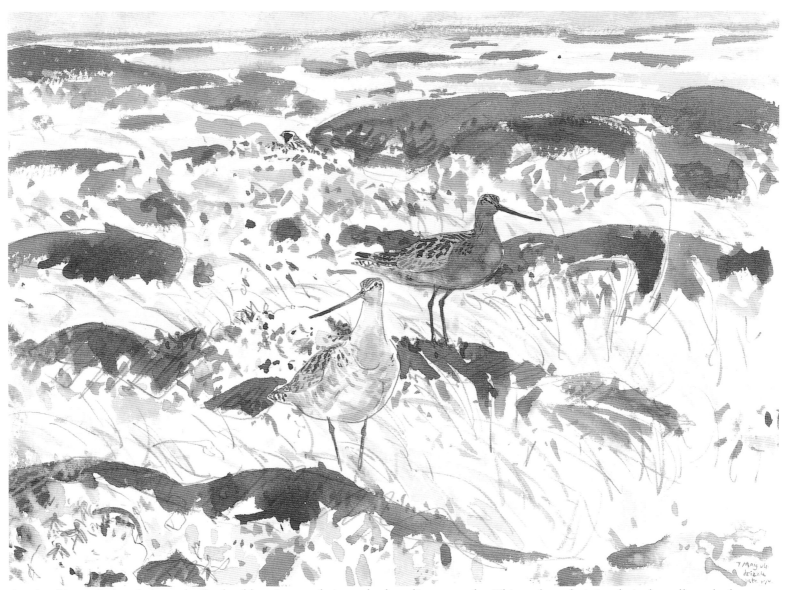

A pair of bar-tailed godwits and a Lapland bunting on their tundra breeding grounds. This male godwit is relatively well-marked; compared to the solid, deep-chestnut of Russian and Scandinavian birds those in Alaska have noticeably paler under-parts, often blotched white at the rear. Kanaryarmuit, 7th May 2004.

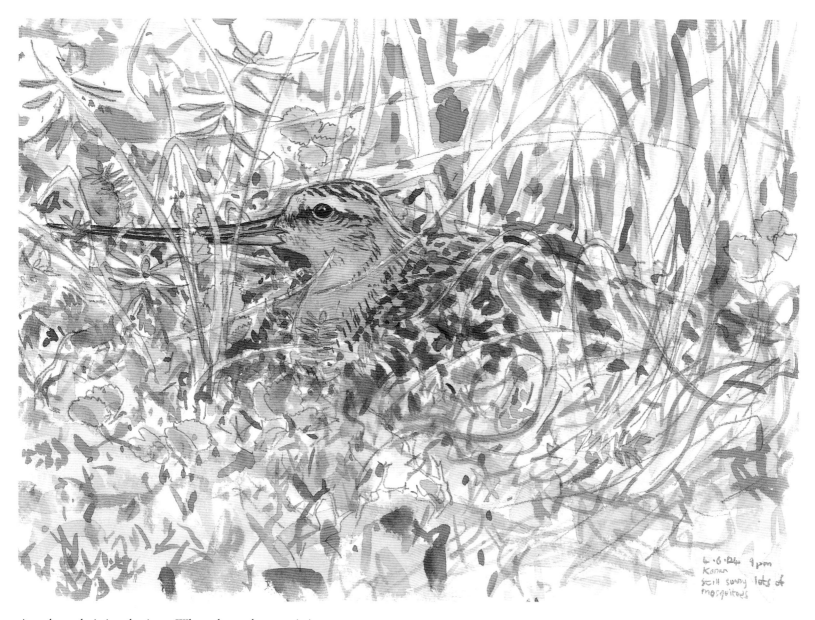

A male godwit incubating. When the males are sitting down on the nest most of their bright colouration is hidden, making them surprisingly well-camouflaged. Unusually for large waders, they sit very tightly on their nests, rising only at the last moment from underfoot. I painted this male, with the aid of a telescope, on his nest on the tundra. He was well-camouflaged amongst lichen, sedges, crowberry, dwarf birch and Labrador tea. Kanaryarmuit, 4th June 2004.

A female incubating amongst the beautiful colours and patterns of the tundra flora. Old Chevak, 18th May 2004.

A pair of godwits team up with a male grey plover to drive an arctic skua out of their territories. Old Chevak, 23rd May 2004.

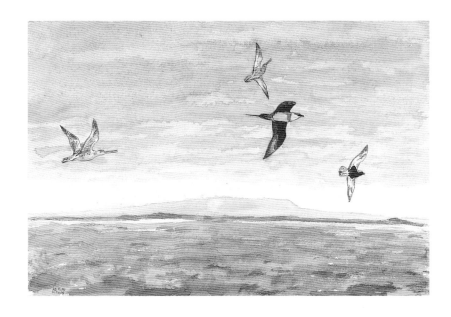

Willow Grouse

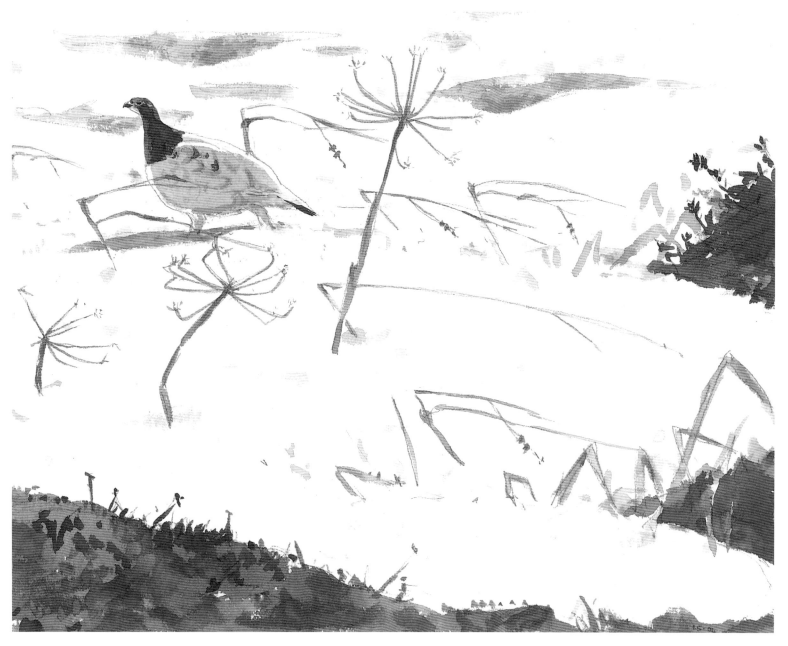

A male willow grouse, in his brown-headed spring plumage, walking through dead grass and angelica stems protruding through the snow. Kanaryarmuit, 26th April 2004.

The willow grouse, or willow ptarmigan, has a circumpolar arctic distribution and in some regions it can be locally common. Early in the spring, before the summer migrants appear, its calls and parachute song-flights help to liven up the snow-covered landscape. In mid-winter, they are completely white, but as the spring progresses, they begin to moult into a browner summer dress. This allows them to remain well-camouflaged as the snow begins to melt.

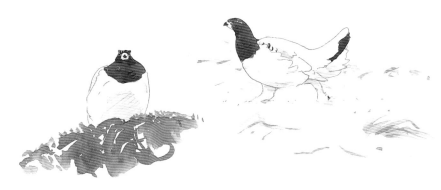

In winter time in the north of Lapland it was common place to find the tracks of willow grouse and places where they had been digging to feed. In their all-white winter dress they can be extremely well-camouflaged. Pieran Marin Jänkä, January 2001.

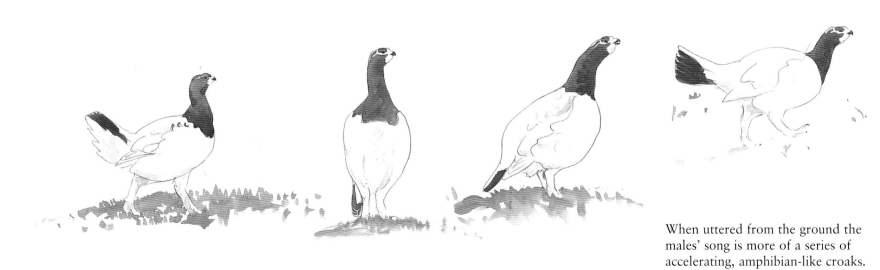

When uttered from the ground the males' song is more of a series of accelerating, amphibian-like croaks.

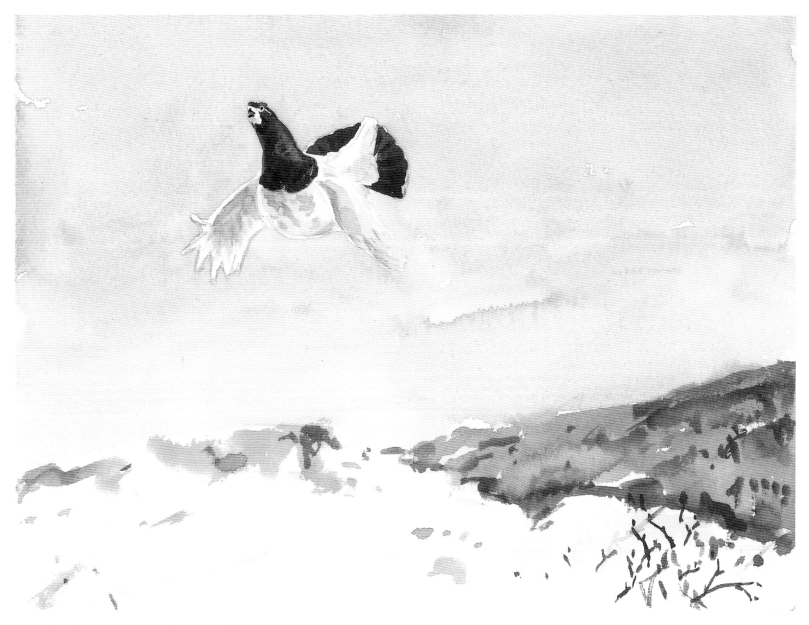

A male willow grouse launches himself into his parachute song-flight. His wings are spread and his tail fanned as he sings his explosive, rattling, song. Kanaryarmuit, 29th April 2004.

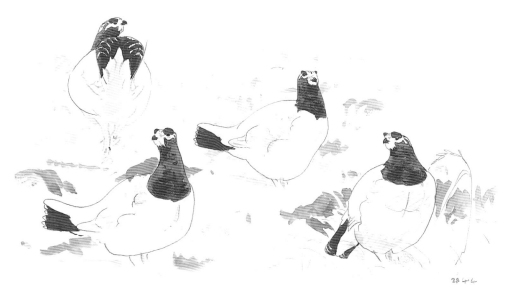

When displaying, the fleshy wattles above the males' eyes are expanded and glow bright red. These are known as 'combs' and close inspection reveals that they do indeed have a remarkable comb-like structure. Kanaryarmuit, 28th April 2004.

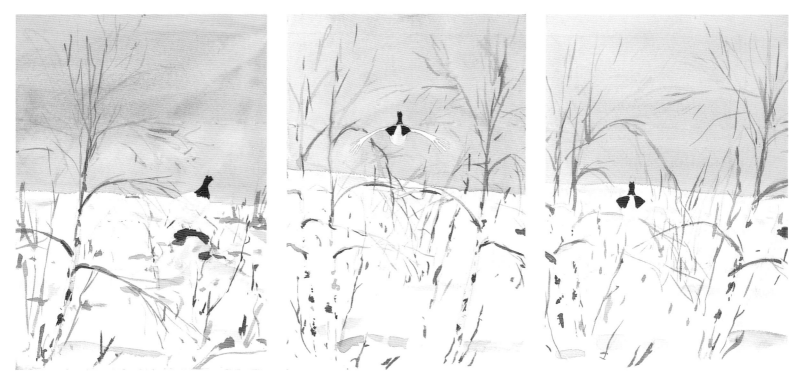

The patterns of the male's brown head and black tail-sides stand out well, even as he glides below the horizon, when his white wings and body are lost against the snow. Kuttura Road, Lapland, 6th May 2000.

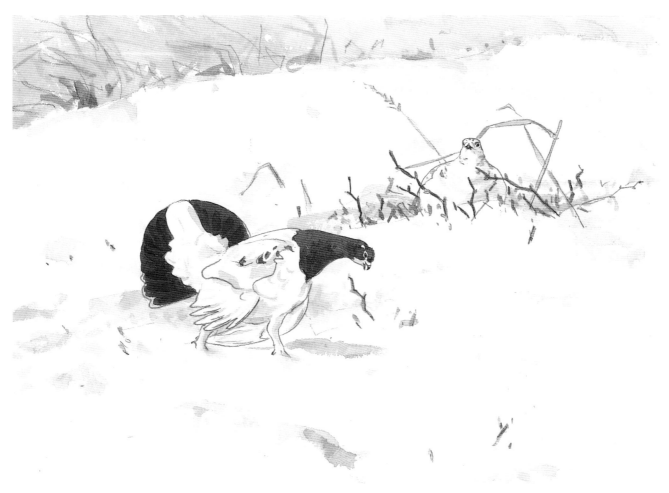

A male courts a female by walking around her, with his nearer wing dragging along the snow and his tail fully-fanned. His head is bowed and his red 'combs' are fully-expanded. Although the female is well-camouflaged against the snow, she is already showing signs of moult and her tawny-brown summer feathers are beginning to show. Kanaryarmuit, 2nd May 2004.

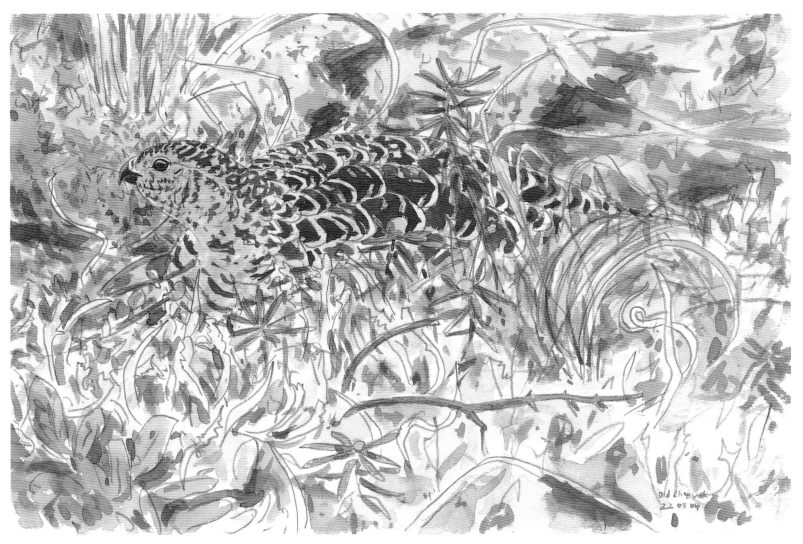

A female on her nest. When completely moulted into her summer dress, she is well-camouflaged against the colours and patterns of the tundra. Most of the nests I found were later depredated, so unfortunately I never saw any young. During the waterfowl plot work, I did accidentally stumble upon a female whose eggs were near to hatching. Having left her nest she turned to face me, her wings spread and tail fanned. Then, 'hissing' loudly, she preceded towards me. Old Chevak, 22nd May 2004.

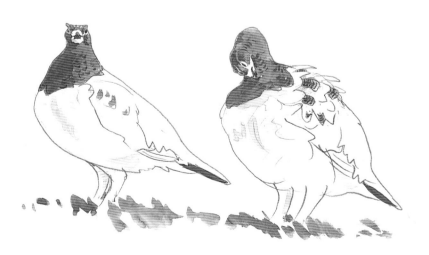

A male sits up on a hummock; as he begins to preen his breast, his back feathers are raised to reveal a series of new, brown, finely-barred summer feathers growing underneath. As he continues to preen lots of white down feathers fly with the wind each time his head is removed from his plumage. Kanaryarmuit, 2nd May 2004.

A Summer with Western Sandpipers

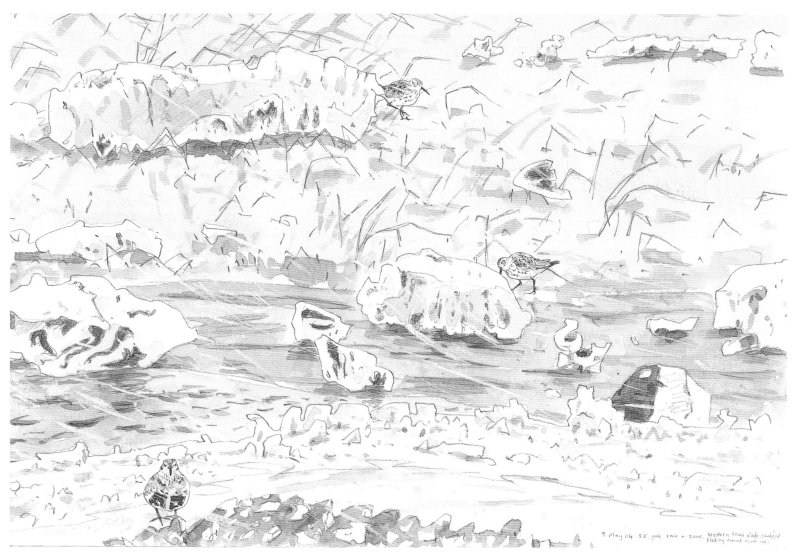

Two western and a single rock sandpiper fluffed up during strong, cold winds, snow and rain showers. These birds often fed on the leeward side of blocks of ice at the edge of a creek. Alaska, 9th May 2004.

In its spring colours this tiny wader is a very attractive bird. The sides of its crown and ear-coverts are a bright chestnut-red. This colouration is repeated on many of its back feathers, which in turn, are finished with dark 'anchor' shaped markings. The breast and underside have a lovely, floury-white look and are heavily patterned with dark grey chevrons. The black bill and legs complete their neat, attractive appearance. They are found in good numbers in Chukotka and Alaska and nest in particularly high densities in the Yukon-Kuskokwim Delta.

I got to know them best at Old Chevak where many nested around the tents, which they frequently used as song perches. The presence of people in this area probably helped to deter arctic foxes and the sandpipers were able to fledge a good number of young. The foxes

were occasionally quite bold, and more than once, I watched one walk in between the tents, nose to the ground, in search of nests.

Some birds with nests close to the tents became quite used to our daily comings and goings and happily sat tight on their eggs as we walked past them. Later, as the young began to replace their down with new feathers, they gathered regularly on narrow pathways to feed. There they frequently ran in front of me and, on several occasions, my movements forced them to try their very first flights. This was always a wonderful sight and continually reminded me how short the northern summers are. The adults would be departing very soon, rapidly followed by the recently-fledged young.

Typical singing posture.

The small webs in between their toes were clearly visible against the snow

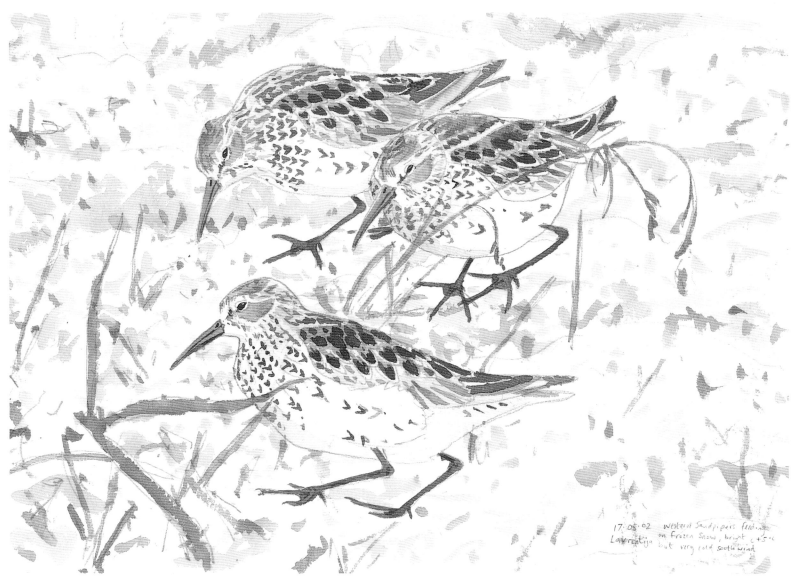

My very first western sandpipers feeding in frozen snow
at Lavrentia, Chukotka. Although it was +5°C the wind-
chill made it feel bitterly cold. 17th May 2002.

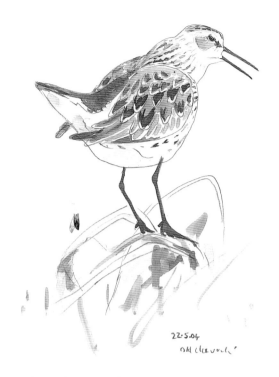

Display-flight.

Singing from the ground.

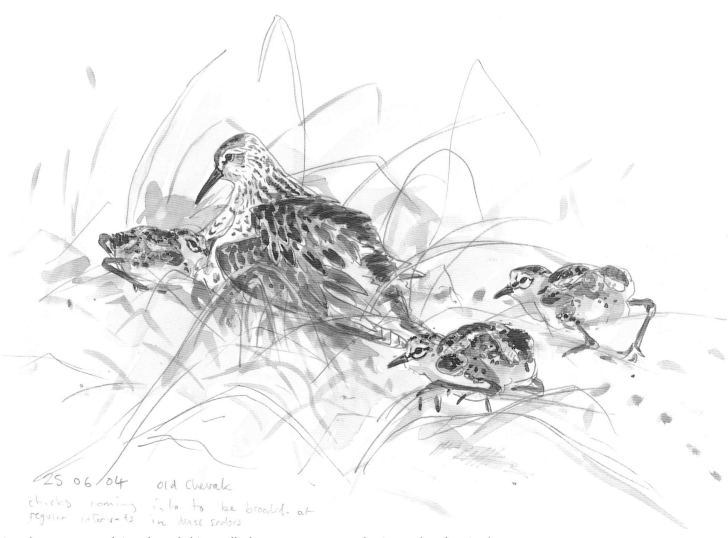

25 06/04 old Chevak
chicks coming into to be brooded. at
regular intervals in dense sedges

A male western sandpiper broods his small, downy young at regular intervals, often in the cover of dense sedges. Old Chevak 25th June 2004.

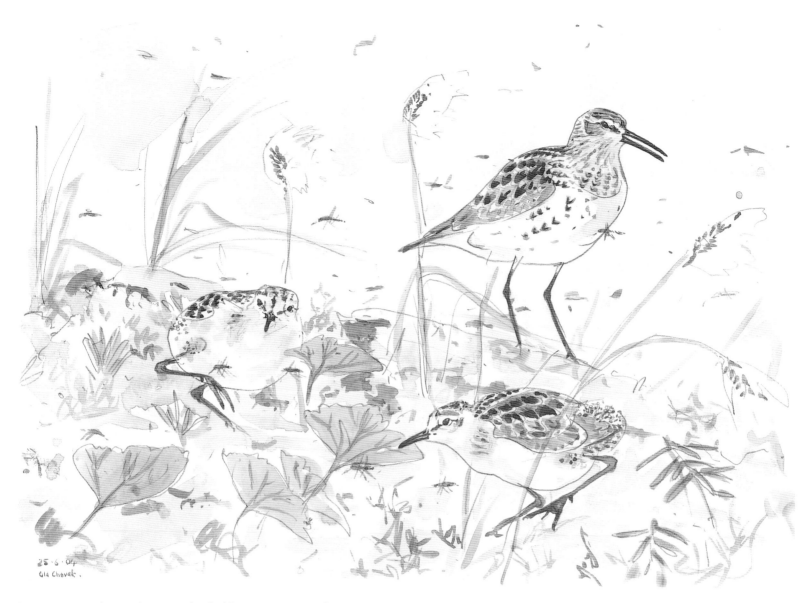

An anxious male watches over his half-grown young who
are feeding on an abundance of mosquitoes amongst sedges
and cloudberry leaves. Old Chevak, 25th June 2004.

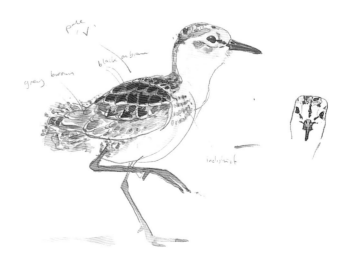

A half-grown young, beginning to
replace its down with its first set
of feathers. 25th June 2004

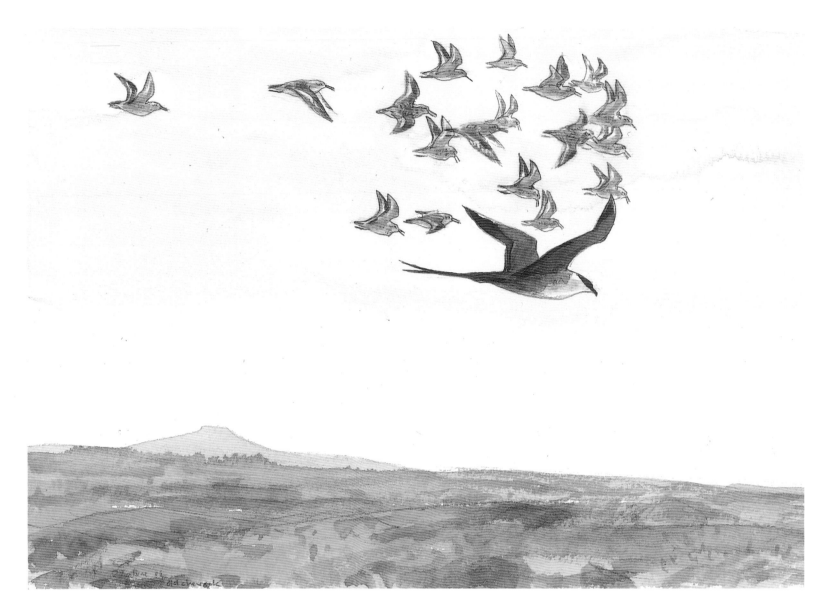

Post-breeding flocks of western sandpipers begin to gather on the tundra prior to their return migration. They frequently mob both ground and aerial predators, such as this long-tailed skua. Old Chevak, 29th June 2004.

A fully-fledged juvenile with just a few patches of down remaining on the back of its head. Although its feathers are still growing, it is capable of strong, steady flight. Old Chevak, 28th June 2004.

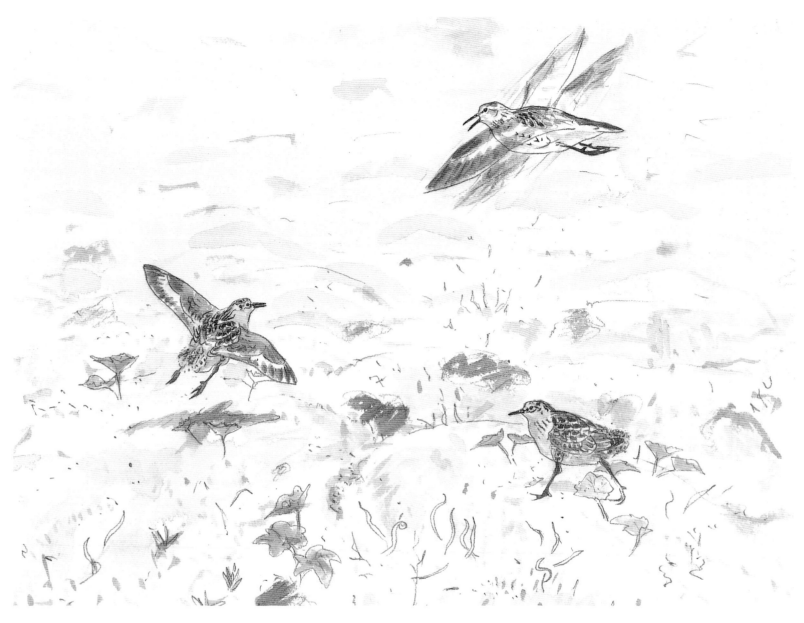

These young western sandpipers were regularly found feeding along a narrow pathway outside the tents. My approach startled one of the young into making its first flight. It was a short, fluttering affair; the male hovered above it, calling, until it landed and ran to safety. Old Chevak, 27th June 2004.

Drawing and painting in the extreme north and Arctic

Drawing and painting birds, in particular their behaviour, outdoors from life is always a challenge. In northern regions there are added natural obstacles to overcome. These include extreme cold and, in the summer months, an abundance of biting insects. It is all too easy to become chilled during bouts of deep concentration. This can be very dangerous when camping in the middle of nowhere, so it is important to keep this fact at the forefront of your mind. At times there can be a problem with paint freezing on the page but this is only usually the case when the temperature is hovering around freezing point. More often than not the temperature is either well below freezing, making it impossible to use watercolours outside, or above freezing, when painting is straightforward.

Later in the summer, often in mid-June, mosquitoes begin to hatch, with numbers reaching their peak towards the end of June and continuing throughout July. On hot windless days they can make drawing difficult. However, when it is windy they tend to stay low. The coastal areas where there is often a breeze, can be mosquito-free.

From late June onwards, mosquitoes can make drawing difficult, particularly on warm, still days. The squashed individuals on this page give an indication of the numbers that can gather around one's face and hands. Despite pulling my hood up and using insect oil around its rim and on the backs of my hands, the beginnings of this sketch of a western sandpiper brooding chicks clearly indicates the moment of my defeat. Old Chevak, 25th June 2004.

Acknowledgements

With such a long and involved project there are so many people to thank.

To Natasha for all her love and support and for letting me disappear into the unknown for months at a time.

To my family, especially my mum who has, over the years, let me get on with things in my own way and not intervened even when some projects and trips seemed a little haphazard and reckless when first conceived.

Special thanks to Heikki and Sinikka Karhu and their two sons Olli and Kalle for inviting me to visit Lapland and opening their home to me. Without their kindness and help, much of this book would not have been possible.

To the other friends I have made in Lapland, particularly Olli, Riitta and Miia Osmonen, Esko and Annikki Sirjola, Juhani and Ritva Honkola and the photographer, Martti Rikkonen.

To Håkon, Grethe and Alma Heggland for their kindness and for giving me the opportunity to stay at their home and experience the magic of Varanger during the winter.

To Evgeny Syroechkovski, Jr. for inviting me to join the expedition to Chukotka and to Christoph Zöckler for all his help and advice.

To Pavel and Vanya for helping to make the time spent on Belyaka Spit so memorable and enjoyable.

To Lena, Gill, Heikki, Chris and Valery for their companionship and to the people of Chukotka for their great hospitality.

Thanks to Bill Eldridge for his invitation and help in visiting Alaska and for his and his partner Donna's good company.

To Brian McCaffrey for all his help, organisation and enthusiasm during my stay on the Delta.

To George for his good humour and flying skills and to Matthew, Jessie, Sarah, Eugene and the goose-plot workers based at Kanaryarmuit.

To Brian, Alice, Grace and Scott and Craig, John and their cackling goose team for their good company at Old Chevak. Also to the numerous people at Bethel, Chevak and around the Prince William Sound for their friendliness and hospitality.

Special thanks to Pavel Tomkovich, Brian McCaffrey and Heikki Karhu for writing an introduction to each main section. Their personal accounts are based on much first-hand experience and have given the text a greater depth than I could possibly have achieved.

To John Walters for all his help and skill in transforming my rough layouts into the finished pages. Trying to summarise paintings, sketchbooks, diaries and notebooks from six separate and often long, intensive trips is not easy. John's help in presenting all this information in an attractive and informative way has proved invaluable.

Thanks also to Roger and Margot Brownsword for their help and suggestions with the text and to Natasha for doing all the typing.

I feel I must also pay tribute to some of the artists and natural history writers whose work continues to inspire me and give me the extra drive to work outdoors and experience wildlife first hand. These artists include: John Busby, Eric Ennion, Robert Hainard, Lars Jonsson, Bruno Liljefors, David Measures and John Walters.

Equally inspiring are the written words of Eric Ennion, Desmond Nethersole-Thompson and Ian Wallace and of the great scientists, such as Niko Tinbergen and Konrad Lorenz, who have not only made many great discoveries but also have the ability to summarise their findings in very readable and digestible accounts in a language that can be understood and enjoyed by all.

Finally thanks to Ian Langford for inviting me to contribute to his impressive collection of titles in his Langford Press 'Wildlife Art Series'. He has been enthusiastic from the outset and his approach of letting authors and artists have control over the look and content of their books has made this a much simpler and enjoyable project.

Bibliography

Cramp, S. et al. *The Birds of the Western Palearctic*, Oxford University Press 1977

Jonsson, L. *Birds of Mountain Regions*, Penguin 1977

Jonsson, L. *Birds of Europe*, Helm 1992

Luhta, V. *Nature Guide to Inari Lapland* Pohjos Lapin Matailu Oy 1998

Nordenskiöld, A.E. *The Voyage of the Vega*, Macmillan and Co. 1882

Peterson, R.T. and Fisher, J. *Wild America*, Houghlan Miffin Company 1955

Sibley, D. *The North American Bird Guide*, Helm 2000

Svensson, L. Grant, P.J., Mullarney, K. and Zetterström, D. *Collins Bird Guide*, Harper Collins 2000

Weidensaul, S. *Return to Wild America*, North Point Press 2005

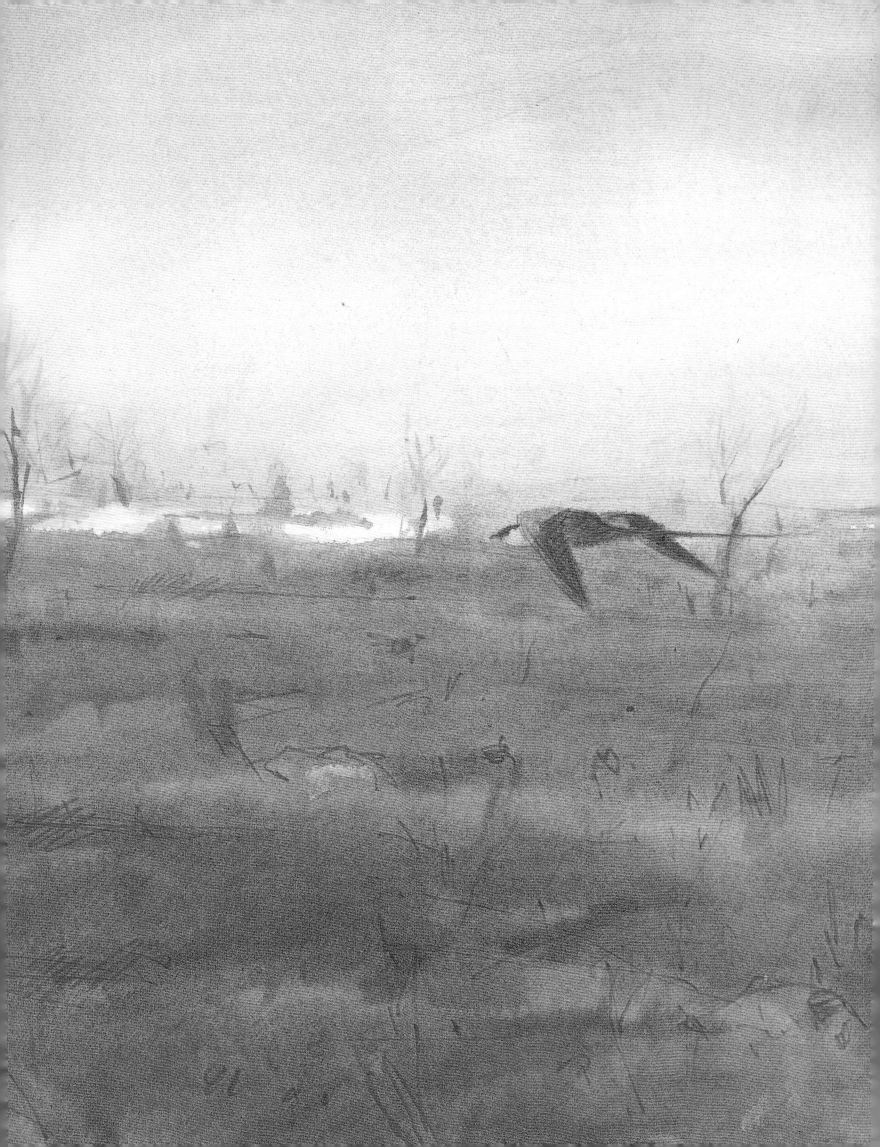